THOMSON
COURSE TECHNOLOGY

Professional ■ Technical ■ Reference

I've Got a Human in My Throat

Create **MORE** Optical Delusions with Adobe® Photoshop®

TheWorth1000.com Artists

ISBN: 1-59863-070-9

Library of Congress Catalog Card Number: 2005929815

Printed in the United States of America

06 07 08 09 10 BU 10 9 8 7 6 5 4 3 2 1

Publisher and General Manager, Thomson Course Technology PTR:
Stacy L. Hiquet

Associate Director of Marketing:
Sarah O'Donnell

Manager of Editorial Services:
Heather Talbot

Marketing Manager:
Heather Hurley

Acquisitions Editor:
Megan Belanger

Marketing Coordinator:
Jordan Casey

Project Editor:
Jenny Davidson

Technical Reviewer:
Mark Abdelnour

PTR Editorial Services Coordinator:
Elizabeth Furbish

Interior Layout Tech:
Bill Hartman

Cover Designer:
Mike Tanamachi

CD-ROM Producer:
Brandon Penticuff

Indexer:
Sharon Shock

Proofreader:
Sara Gullion

THOMSON

COURSE TECHNOLOGY

Professional ■ Technical ■ Reference

Thomson Course Technology PTR, a division of Thomson Course Technology
25 Thomson Place ■ Boston, MA 02210 ■ http://www.courseptr.com

Dedication

Thank you so much to our family and friends. Because this was written and edited by a community, instead of a single person, we can't give singular acknowledgments, so please insert your name where you know it belongs:

Spouse/Companion(s) and Multigenerational Descendant(s): we love you and thank you for the encouragement. Parent(s), we love you and thank you for the encouragement. Ancestor(s), we love you and thank you for the encouragement. Sibling(s), we love you and thank you for all the encouragement. Friend(s), we owe you a beer. Pop Culture Reference(s)/Inside Joke(s), thanks for inspiring us into the men/women we are today.

We'd like to dedicate this book to Worth1000 staff member Tom Ritchie, who passed on shortly after contributing to our first book.

Acknowledgments

To the book staff: Heather, James, Lisa, and the fine folks at Thomson, obviously this couldn't have been done without you. Thanks so much!

To everyone who contributed to this book, especially Robert Schneider for yet another great cover: Thanks!

To the other Worth1000 administrators: Avi, Kirby, RC, Larry, Israel, Kristian, Bruno, Jan, Maggie, Daniel, and Cyn. To our Worth1000 Juror staff, thanks!

And last, but not least, a special thanks to Adobe. That's quite a tool you have there.

About the Author

Worth1000.com, is a highly popular, Photoshop-based graphic design website that sponsors numerous Photoshop art contests, most of which feature humorous, spoof, and surreal images. Worth1000.com receives more than 20 million hits per month and boasts a community of more than 250,000 registered members. Worth1000.com was chosen as one of *PC Magazine*'s top 100 websites online and their images have been featured in media all over the world including *USA Today*, on CNN and *Good Morning America*, and on the cover of the *New York Post*. Worth1000.com was founded by Avi Muchnick of Long Island, New York.

Contents

2 Exploring Photos and Effects105

3 Impressing Your Friends169

Introduction

There used to be a time when a tool was an extension of the hand.

A rusty spade enabled the hand to move dirt. A clay jug allowed a child to quench his thirst, miles away from a fresh spring. A stiff-haired brush enabled the artist to dab colored oils in finite amounts, pulling detail out of a blank canvas.

A tool was an enhancement of the limited abilities of a single individual.

The spade could not draw dirt without the hand to lift it. A jug could not store water without being lifted from the stream. And a brush could not paint the details in a smile without the human eye to guide it.

We're in a different time now, and tools often guide us as often as we guide them.

Tools no longer serve a singular purpose. They can bring together communities of people who use the same tool. Tips and techniques on how to best use those tools can be shared among fellow artisans. Awards can be given to outstanding users of the tools. Others can enhance tools in new ways, for new purposes. Commerce can spring up around the tool in ways it was never intended by the tool's creator.

Photoshop is the prime example of this, and no one should know this more than the group of artists who compiled this book.

Worth1000.com is a huge community of very talented individuals brought together by the power of Photoshop and the desire to use the tool as best as they can. Together as a community, they participate in special themed contests and have created thousands of individual galleries of amazing, humorous, and seamless image montages.

Whether it is increasing the productivity of artists who use what they learn in their trade, decreasing the productivity of everyone else who browses Worth1000 from work, or causing network slowdowns as millions of people forward our images to each other every day, there is no question that we've made a measurable impact on the world of photo manipulation (for good or bad).

Without Photoshop and its range of capabilities to bring us together as a community, this would never have been possible.

We now bring you our second tutorial book, featuring all new tutorials and images from amongst our best artists and writers. We've divided the book into three sections: The first section highlights the basics of Photoshop. It gives a guided tour of the tools and some introductory effects that a novice can use relatively soon in their learning process.

The second section deals with more intermediate tools in Photoshop to create even more realistic images. It also covers the basics of using Photoshop to enhance and tone digital photos.

The third section goes all out and shows the reader the kind of images that will "Impress Your Friends." This section allows the reader to learn the reasoning of certain steps, even though the tutorials are specific to an image. The techniques learned here can be adapted and adjusted to enhance the reader's Photoshop arsenal.

We hope that you'll use this book as a tool to enhance your use of Photoshop.

We hope that you'll use Photoshop and enter a Worth1000 contest.

We hope that you'll join Worth1000 and battle your way into our Photoshop Hall of Fame.

Who knows? Maybe you'll even help us write our next book…

Avi Muchnick
Founder of Worth1000.com

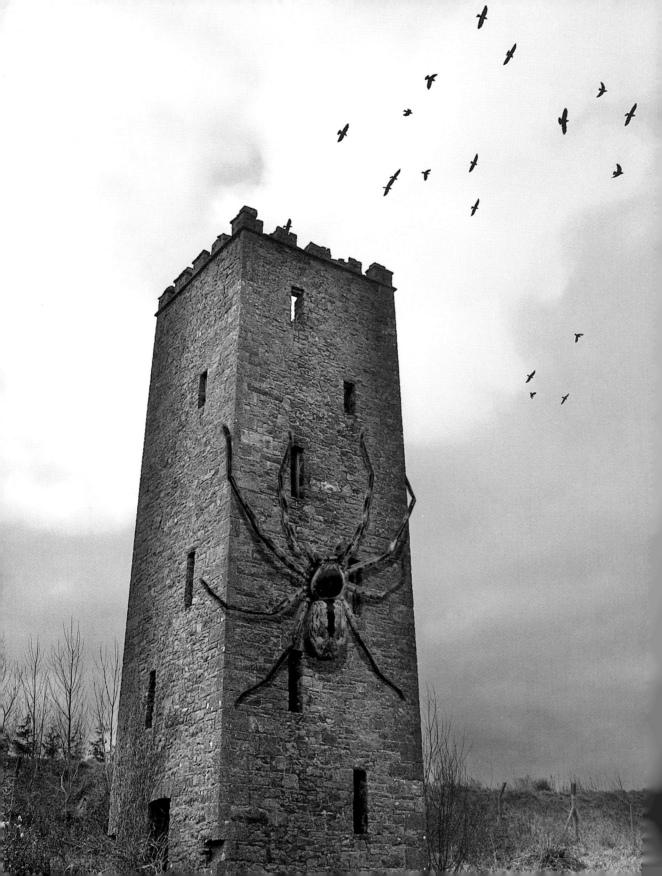

1

Getting Started

In this section, we'll take you on a quick tour of Adobe Photoshop and introduce you to some of its features and tools. Every effect created in Photoshop is built upon these basic techniques. From learning about the Toolbox to colorizing photos and adding lighting to pictures, this is a great stepping stone if you're new to Photoshop, or if you just need to brush up on the basics.

Getting to Know the Toolbar

Adobe Photoshop CS Tools and ShortCuts

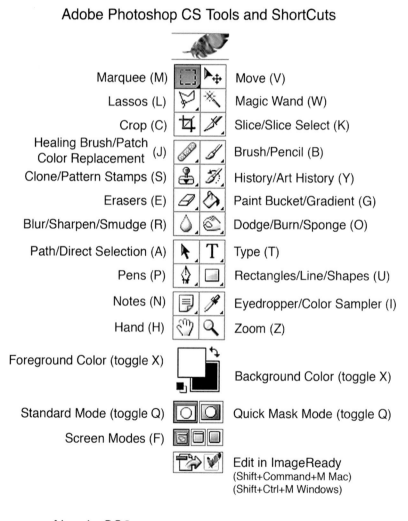

Marquee (M) — Move (V)

Lassos (L) — Magic Wand (W)

Crop (C) — Slice/Slice Select (K)

Healing Brush/Patch Color Replacement (J) — Brush/Pencil (B)

Clone/Pattern Stamps (S) — History/Art History (Y)

Erasers (E) — Paint Bucket/Gradient (G)

Blur/Sharpen/Smudge (R) — Dodge/Burn/Sponge (O)

Path/Direct Selection (A) — Type (T)

Pens (P) — Rectangles/Line/Shapes (U)

Notes (N) — Eyedropper/Color Sampler (I)

Hand (H) — Zoom (Z)

Foreground Color (toggle X) — Background Color (toggle X)

Standard Mode (toggle Q) — Quick Mask Mode (toggle Q)

Screen Modes (F)

Edit in ImageReady
(Shift+Command+M Mac)
(Shift+Ctrl+M Windows)

New in CS2: Color Replacement tool - Shift+B
Spot Healing and Red Eye tools - Shift+J

Alison Huff—Original Source by Alison Huff—Icons are Trademark Adobe Photoshop

Before starting any of the tutorials in this book, it will be handy to know what some of the tools do. When we refer to the Magic Wand, we don't mean for you to perform feats of magic—though your friends will think you have when you show them your finished images. Here we're going to take a quick look at some of the most frequently used tools in Photoshop. This toolbar picture is from Adobe Photoshop CS for Mac, but the toolbars are the same on both the Mac and PC. The letters in parentheses (A) are the quick keys to the tool.

Marquee (M)—This handy tool allows you to select areas in an image. You can select rectangular or elliptical (circular) areas. There is also a Selection tool to select single rows or columns of one pixel.

Move (V)—No surprise here that the Move tool is the mover laborer of the bunch. Selected layers or areas can be moved around the artboard by using this tool.

Freehand Lasso (V)—With the Lasso tool, you can corral your selections more precisely. There are three versions of the Lasso: Freehand, which allows you to create your selection by simply drawing the outline; Polygonal, helping you keep control of your selection by creating the outline point by point; and Magnetic, which will try to interpret your selection and "snap" to border between two colors.

Magic Wand (W)—With just a wave of the wand, you can select all the pixels of one or similar colors. You can control whether the colors are in a continuous area or not.

Crop (C)—The Crop tool allows you to trim an image. You can specify size or resolution as well.

Slice/Slice Select (K)—The Slice tool allows you to define areas in an image where you want to create links, rollovers, or animations. Once you create the slices, the Slice Select tool allows you to resize, move, duplicate, etc.

Healing Brush/Patch/Color Replacement (J)—The Healing Brush and Patch tools both repair imperfections on an image using either a pattern or a sample from the image itself; they both match the texture, lighting, and shading to allow for the best blending. Spot Healing (CS2 only) works in a similar fashion; the difference being that it does not require the user to select a sample from the image. The Color Replacement (CS and CS2) tool allows the user to replace certain colors on the image by painting over them with a corrective color. (It is not available in version 7.0 or earlier.) Red Eye (CS2 only) removes the red from the pupils of photographed subjects with a simple click.

Brush/Pencil (B)—The Brush tool paints freehand brush strokes directly onto the image using a wide variety of preset and customizable brushes. The Pencil tool paints with a preset harder edge, no matter which brush style or shape is selected.

History/Art History Brush (Y)—The History Brush makes a copy of a previous state of an image and paints with it. The Art History Brush works in a similar fashion; however, it utilizes stylized strokes which simulate the brushstrokes and texture of painting.

Erasers (E)—Just as you'd guess, with the Eraser you can erase or restore pixels on an image; the Magic Eraser tool erases similarly colored pixels based on the range of colors set by the user.

Paint Bucket/Gradient (G)—The Paint Bucket fills adjacent areas of similarly colored pixels with a solid color set by the user; the Gradient Fill tool allows the user to create smooth blends between colors using a set or a user-defined gradient.

Blur/Sharpen/Smudge (R)—Using the same brushes available in the Brush Palette, the Blur tool softens areas of the image, whereas the Sharpen tool creates more clarity in the areas where it is applied. The Smudge tool pushes color around in the direction that it is dragged. This is a great tool when masking.

Dodge/Burn/Sponge (O)—The Dodge tool lightens specific areas on an image within a certain range: Highlights, Midtones, and Shadows. The Burn tool works in a similar fashion; however, the Burn tool darkens those areas. The Sponge tool changes the color saturation of the areas to which it is applied.

Path Selection/Direct Selection (A)—The Path Selection tool displays all anchor points along a vector path within a selected area and allows the user to modify that path; the Direct Selection tool allows the user to manually adjust individual anchor points within a path.

Type (T)—This tool allows you to place typed text onto an image (this tool creates the text on a new, separate layer); the Type Mask tools create a selection in the outlined shape of the text.

Pens (P)—The Pen tool allows you to create and edit vector paths. These paths can be saved as masks or exported into vector-based software like Adobe Illustrator.

Rectangles/Line/Custom Shapes (U)—Drawn on separate shape layers, these tools allow the user to create and edit vector objects.

Notes/Audio Annotation (N) (Shift + N to toggle)—User can attach notes or audio annotations onto the image canvas, which is helpful when an entire group is working on one project.

Eyedropper/Color Sampler/Measure (I)—The Eyedropper tool samples color from an image (or anywhere on the screen) to create a new foreground or background color. The Color Sampler allows the user to create saved samples of the color values on an image, taken from either a single pixel or from the average of up to 5 square pixels. The Measure tool calculates the distance between two points anywhere on the work area and that result is displayed on the Info Palette.

Hand (H)—The Hand tool allows the user to drag an image around the document window.

Zoom (Z)—Use the Zoom tool to magnify or reduce the current view of the document.

Foreground/Background Colors—This display shows two colors at a time, the active color (or foreground) always appearing in the upper square.

Standard mode/Quick Mask mode (Q)—This control defaults to Standard mode for normal editing. Quick Mask mode allows the user to form selections with the Brush tool.

Screen modes—With this tool you can set your preference for the appearance of the workspace. You can view the full menu bar, a truncated version, or none at all.

Jump to ImageReady—This will automatically launch the ImageReady software to edit the current document. ImageReady is useful for creating web pages, animations, links, and rollover buttons.

Basic Layers

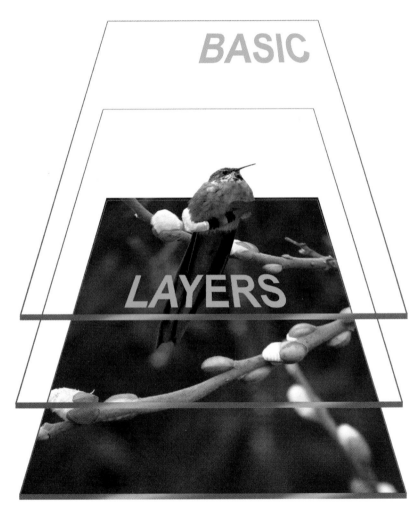

"Intro to Layers"—Bob Schneider—Image Sources: "Humming Bird" by Kevin Tate © istockphoto.com/Kevin Tate—"Budding Trees" by Mark Jensen © istockphoto.com/Mark Jensen—www.istockphoto.com

Creating photo-realistic compositions requires multiple sources and effects, but they all start in one place—the Layers Palette. Layers are the most useful part of any graphics program and fortunately, one of the easiest features to understand. In this short tutorial, we'll illustrate what they are and combine a few photographic elements with some simple masking to show how useful they can be.

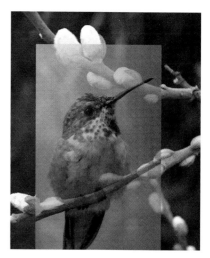

1. One of the simple uses of layers is combining several elements to create a new image. Keeping those elements on separate layers allows you to manipulate each element individually, in any fashion, without affecting any other element. In this example, I combined a background image with an image of a hummingbird and added some text just to make use of another layer.

Note

Visualize layers as though they were clear sheets of glass placed above or below one another. Anything can be placed on a layer—photographs, type, brushwork; in fact, any image that can be imported into Photoshop can be placed on a layer. By default, any image that is opened in Photoshop is automatically placed on a layer and labeled "Background." A good practice, if you are going to do any manipulation on that image, is to make a copy of that layer for backup. Go to Layer > Duplicate Layer and either name the layer in the window that appears or let it default to be named Background Copy. Layers have the option of being visible or invisible. I make the original background layer invisible by clicking on the small eye icon to the left of that layer in the Layers Palette. If you cannot see a Layers Palette, click on Window > Layers.

2. I opened the background file of the branch and a background layer was automatically created. I then opened the hummingbird file, which opened in a separate window. To integrate that image as a separate layer into the background image, I clicked Select > All then Edit > Copy. I activated the background image by clicking on it and then clicked Edit > Paste. It appeared as a new layer over the background layer. If you double-click that layer name, you can change it to whatever you feel is descriptive. This is a good practice. When working on files with many layers, it will be a great help.

I activated the bird layer (by clicking on the layer) and reduced the opacity of the bird layer 65% using the Opacity slider at the top right of the Layers Palette. I then moved the bird image by using the Move tool from the toolbox. I moved the bird to line up the feet with the branch I wanted to place him on. The bird can be moved or manipulated without affecting the images on any other layer.

Tip

You can also use the keyboard shortcut to the Move tool by holding down the Ctrl key. This will access the Move tool from almost any other tool mode you might be in and restore it to that tool when Ctrl is released. You can also push the V key to change to the Move tool, but it will not restore automatically.

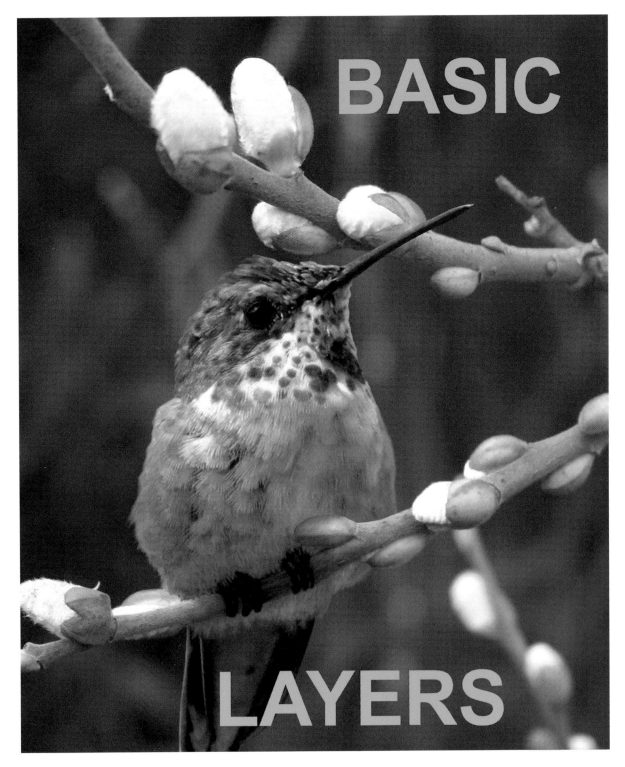

BASIC

LAYERS

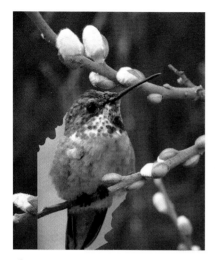

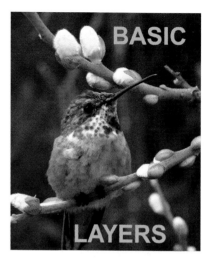

3. To remove the background from the bird image, I used a layer mask. I clicked on the Mask icon at the bottom of the Layers Palette (a small, grayed rectangle with a light circle in it). When a mask is applied two things will happen. A small mask window will appear next to the thumbnail on that layer in the Layers Palette and your foreground and background swatch colors on the toolbar will change to black and white. With the black selected, I used a large brush to "paint away" most of the background of the bird image and a smaller brush to remove the areas touching the body. I changed the layer back to 100% opacity before doing the final edge masking.

Tip

Masking does not permanently remove any area of the image; it simply hides it. If you need to restore any masked areas, switch the brush color to white by clicking on the small curved arrow between the black and white swatches. In the Mask mode, black hides the image and white restores it.

4. A small soft brush at 10% opacity was used to finish off the edges of the bird. Using a soft brush at low opacity will take many repeated strokes to remove background traces, but it results in a softer, more blended look. I added a shadow on the branch to sit the bird properly. I created a new layer, Layer > New > Layer and used a soft brush to add a dark shadow color at 10% opacity and built up the density slowly. The low opacity allows me to build up the color density with softer edges and more control over the effect.

Tip

All tools that have density adjustments can have their densities set by using the numerical keys, 1= 10%, 2=20%, etc.

Note

A new layer can also be created by clicking on the square icon with an upturned corner at the bottom of the Layers Palette, next to the trash can icon. New layers will be created directly above the layer currently selected.

5. As a final step, and to add one more layer function to this tutorial I added some text. I clicked on the Type tool, "T" on the toolbox, which turned the cursor into a small box. I clicked and dragged the cursor to form a selection area for adding the type. When the Type tool is selected, small windows appear at the top that allow you to select a font style, size, and color and a new layer is automatically created for the text. I chose Arial as a font, chose Bold as a style, selected a light green color by clicking on the upper color swatch, and typed in the text. I used the Rectangular Marquee tool from the toolbox and selected and moved each word independently into position.

Note

You can move a layer by clicking and dragging it above or below other layers in the Layers Palette. If you have created some layers that you want to delete, just click and drag that layer into the trash can icon at the bottom of the Palette. To hide a single layer, click on the eye icon to make it invisible. To make all the layers invisible except the one you're working on, click on that layer's eye icon while pressing the Alt key. If you need a layer that's a copy of all the visible layers and still keep all your layers separate, create a new layer, then choose Layer > Merge Visible and press and hold the Alt key while doing so. It will create a merged image for overall corrections.

This introduction to layers just scratches the surface. There are more advanced options and techniques such as Adjustment layers, linking layers together, layer sets, etc. However, this should get you started.

Layers

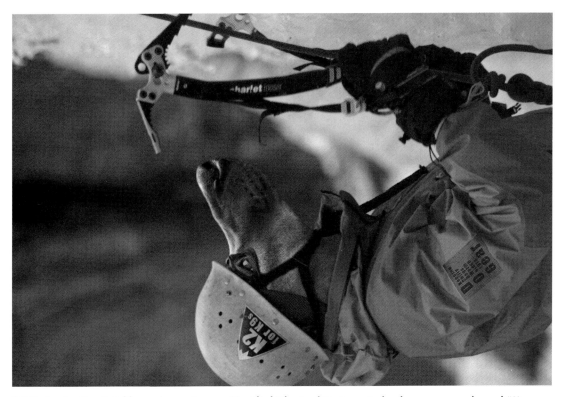

"Chilly Dog"—Alex R. Feldman—Image Sources: "Ice Climb" by Brad Mering—stock.xchng—www.sxc.hu and "Sierra Winn" by Alex R. Feldman

Photoshop Layers allow you to combine the best of two or more images and create something completely original. As in this artist's "Chilly Dog" we can use layers to help a lovable pooch reach new heights without years of training or expensive safety equipment.

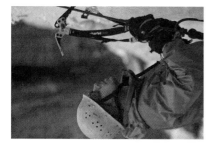

1. Before making any alterations to the photos, I knew I would be using the Displace filter later in the process, so a little preparation early on let me save a few steps. With the photo of the climber open, I desaturated it and saved it as a PSD named "climber displace" in the same folder as my source images. I then closed this file and opened my two source images.

2. First, I inserted the picture of the dog into the picture with the ice climber. I rotated and resized the dog's head to match the shape and direction of the climber's head. Then I duplicated the dog's head and hid the new layer. On the first dog head layer I applied a layer mask and removed any part of the dog that I didn't need. In the next step I removed any parts of the dog that were covered by straps or the glasses. To make the dog's face fit in a little better, I selected Filter > Gaussian Blur with a setting of 1.3 to better match the climber.

3. Next, I unhid the duplicated dog head layer, moved it above the original dog head layer, reduced its opacity to 50% and moved it around until the eye of the dog fell above the area of the glasses lens. I brought the opacity back up to 100%, added a layer mask, and removed any part of the dog that was outside the lens. I changed the hue, saturation, and brightness of the eye to make it appear that there was an orange lens in front of it. On a new layer above the new orange eye, I used a small, soft-edged airbrush at approximately 5% opacity and added the curved, white line over the eye in what I believed was the shape of the lens. I used the same Gaussian Blur settings for the eye as I did for the dog's face earlier, so that it didn't stand out from the picture.

4. With the dog's face done, I moved on to the sticker on the helmet which I created from scratch. I created new layers to work on each part of the sticker. Using the Polygon Lasso tool, I created the white triangle of the sticker, the black areas of the mountain, and added "K2 for K9s" using the Text tool. I linked my sticker layers together and selected Layer > Merge Linked to get them all on one layer.

5. I resized, rotated, and moved the sticker layer over the helmet. Using Filter > Distort > Spherize, I distorted the sticker to match the shape of the helmet. Using a very small, soft-edged paintbrush, I removed a piece of the sticker where it looked like it might have been scratched off. I added some wear and tear to the sticker using the layer mask on the air holes of the helmet. Then, for a finishing touch, I used a soft-edged low-opacity airbrush to add some highlights and shadows to the sticker in order to add some depth. Once again, a slight Gaussian Blur on the sticker layer finished off the look.

6. I created a logo for my fictitious Dog Gear Company. Once I was pleased with the look, I merged all my text layers into one, resized and rotated the text layer to fit on the sleeve of the jacket, and lowered the opacity to approximately 65%. This is where our Displace filter finally came into play. With the logo layer selected, I used the Displace filter (which used the climber displace.psd I made earlier) with my horizontal and vertical scales set to 10. This filter gave the appearance that the text followed the contours of the jacket. I added some texture to the patch and added a Bevel and Emboss layer style to give the patch a little thickness, and that's it! My ice-wall climbing dog was ready for the great outdoors.

Working with Selections

Selecting areas of your image to work on gives you more precise control over your effects. From the Marquee tool to the Polygonal Lasso tool, Photoshop offers a wide variety of ways to make selections. On longer projects, you can save often-used selections in alpha channels and select them again and again without worry of changes or term limits. In this short glance at selections, the focus of our image is so excited to try it for herself, she's trying to escape.

"Climbing Out"—Chris Johnson—Image Source: "Blond Ambition 6" by Joe Gough
© istockphoto.com/Joe Gough—www.istockphoto.com

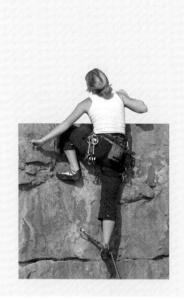

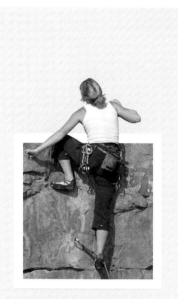

1. After adding a layer mask to my original image, I created a new layer (Layer > New > Layer) and set it underneath the original image. With this new layer selected, I used the Paint Fill tool and a paper texture to give a paper effect to the whole of the layer. The next step was to use the Rectangular Selection or Marquee tool, with the style set to "fixed aspect ratio," to make a simple square selection. Next, and personally I think this is a must when working with selections, I saved the selection to an alpha channel (Select > Save Selection). The selection was now permanently saved with the picture I was working with. This gave me the ability to load a selection at exactly the same coordinates at any time I chose. Plus, I can save multiple selections with the same picture and select and deselect them at will.

2. Next, I inverted the selection (Select > Inverse) so that I could take a big brush and mask out everything but the original square by painting on the layer mask, and with smaller brushes leave anything I wanted to appear to be coming out of the square. Because the selection was inverted, nothing in the square would be affected by the brush. So, I could run down the edges of the selection leaving perfect edges. Now, deselect, save picture, make coffee.

3. Next, I wanted to put a border around the square to make it photo-like. First, I created a new layer. Second, I loaded my selection again, and then using the Paint Bucket tool, filled the area with white. I could now modify the selection by contracting it by 100 pixels and clearing everything left inside the selection. To give the impression that the rock climber was coming out of the picture, I simply masked out the border to reveal the rock climber.

Dear Dad,

Just a quick note to say hi,
and to send you a photo
of our latest adventure.
See you all soon.

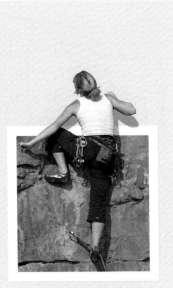

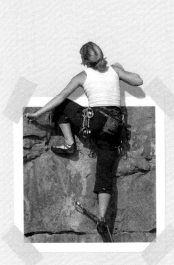

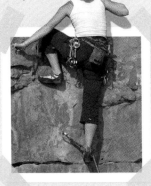

Dear Dad,

Just a quick note to say hi,
and to send you a photo
of our latest adventure.
See you all ... soon.

4. I added a shadow below the climber for some depth, but instead of using an inflexible drop shadow, I went back to my selections. I loaded my alpha channel saved selection, and I once again inverted the selection. Now by using the rock climber layer, I could copy everything that's on that layer outside of the original square. The top of the rock climber's body was now copied, and I could set this on its own new layer beneath the original rock climber layer. With this new layer highlighted, I used the Magic Wand tool to select all of the copied upper body and arms of the rock climber. I now had a selection the same shape as the top of the rock climber and used this to make a realistic shadow. All I needed to do was fill this selection with a dark gray color, deselect, apply a Gaussian Blur (Filter > Blur > Gaussian Blur) of about 4, and I had my shadow to work with.

5. Then, I wanted to stick the photo to the letter with tape. Again I used selection techniques to help to make the tape. With the Polygonal Selection tool, I made a tape-sized selection. Using the Polygonal tool, I made the rough edges on the ends of tape. Next, I used the Transform Selection function to place the selection in the right place over the photo and to make it proportionally correct. To make the tape, I created a new layer and then filled the tape selection with a light gray. Then, I deselected and duplicated this new tape layer. At that point, I had two light gray tape layers. I set the top one to Layer blend mode Luminosity at 88% opacity; I set the bottom layer to Layer blend mode Screen and set the opacity to 24%. I duplicated this process for the other three bits of tape.

6. The last stage was to tidy up the picture and to add some text to the letter. Because I had to mask out all the rock from around the climber, I ended up masking out some of the climber's hair. To replace it, I used the Smudge tool set to about 70% hardness and about 70% opacity. I then smudged from the hair that was left to create the wispy strands about the head. When adding the text, I placed it just above the paper texture layer and adjusted it to give the illusion that the climber was holding on to the text to escape the photo.

Tip

To make the photo effect more realistic, I put a tight drop shadow around the bottom and right hand edges of the square. An easy way to do this is to create a new layer beneath the photo layer. Load my saved selection, modify it by contracting it by 2 pixels, and flood fill (any color) the modified selection. I now have a square hidden under the rock climber layer I can put a drop shadow on. Then I just align the shadow tight onto the photo.

Selections

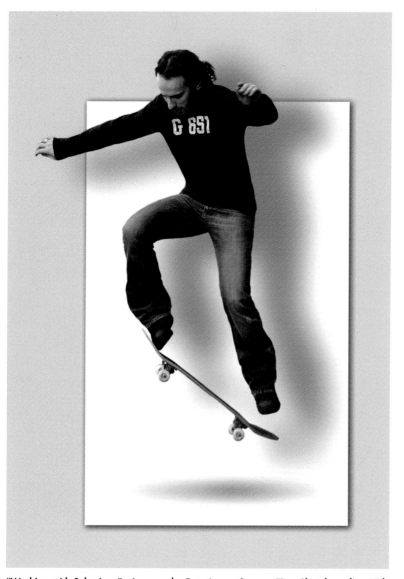

When starting almost any project in Photoshop, you'll want to select areas of an image to apply certain effects to. There are a number of different ways to isolate an area, whether you're a superstar and want to use the Marquee tools, or more of a maverick and stick to the ole Lasso, or even a Photoshop Wizard waving your Magic Wand, here's a quick overview of some of the selection tools and their uses.

"Working with Selections"—Ivo van der Ent—Image Source: "Boy Skateboarding II" by Andrea Leone © istockphoto.com/Andrea Leone—www.istockphoto.com

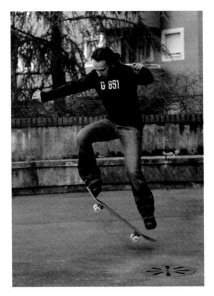

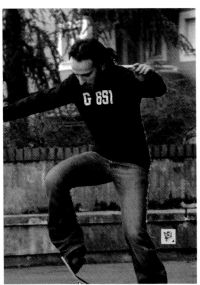

1. I looked at the original image to decide which selection method to use. The selection tools are in the top-left part of the toolbar. The options are:

Elliptical Marquee: makes an elliptical selection (circular or oval-like), so not very practical here.

Rectangular Marquee: makes a rectangular selection (or square), so not very practical here.

Magic Wand: allows me to select pixels from a similar color, very suitable for selecting even colored areas, like the pavement in this image.

Lasso: allows me to make a selection by freehand drawing. This is very hard to do with a mouse, or even with a tablet. I never really use this tool.

Polygon Lasso: allows me to make a selection by creating a series of straight lines.

Magnetic Lasso: allows me to create a selection by automatically selecting the boundary lines between different areas of the image. This only works well if the boundaries are very clear.

2. In this case I started with the Magnetic Lasso to select part of the skater. The boundary edges between the guy and the background were very clear, so the Magnetic Lasso had no problem identifying them. I selected the Magnetic Lasso tool and clicked somewhere on the edge between the guy's sleeve and the background, then moved the cursor along the edge of his sleeve. The selection snapped to the edges quite easily. To finish the selection, I had to finish where I started.

Tip

In some cases, you'll find that halfway through your selection you'll want to change selection tools. Just close your current selection, press Shift (a plus sign will appear along with your selection cursor), and make a second selection with the tool of your choice, overlapping the first one. When you close this selection, you will notice that the two selections are joined. You can add as many selections as you want. In the same manner, you can subtract parts from your selection by pressing Alt (a minus sign will appear alongside your cursor).

3. After the first rough selection, it was time to zoom in a bit. I noticed several places where the selection didn't fit the image exactly, like the tail of the skateboard. I simply added this part to my selection with the Polygon Lasso tool (again holding down Shift).

4. When I had the entire skater selected, I saved the selection by selecting Selection > Save Selection. It was then time to copy the skater to a new layer; I used Ctrl + C and Ctrl + V to copy and paste the skater onto a new layer. I also created a new white layer behind him to get a better look. The original photo should stay intact in the background. You never know if you'll need it...

The result was a very sharp cut-out. Way too sharp to look good. A good cut-out will blend slightly into the background.

5. I got rid of this new layer and made the white layer invisible. With my background layer active, I loaded the selection again (Select > Load Selection). My original selection appeared. I added a soft edge to this selection before I cut out the skater. In the Select menu I selected feather. A pop-up appeared which let me control the size of the feather (I used a 2-pixel feather). There was no visible change in the selection, but after copying and pasting the skater, I could clearly see a softer edge. This edge, however, was a bit too smudgy.

6. I went back again to my original selection and made it 2 pixels smaller before adding the feather. I selected Modify > Contract from the Select menu and entered 2 pixels in the pop-up. Now my selection was 2 pixels smaller than before. I applied the 2-pixel feather and copied and pasted the skater again. Very nice!

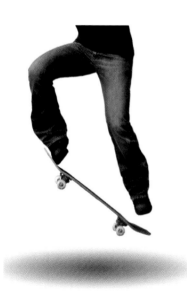 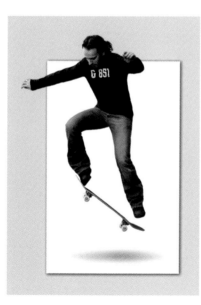

7. For the shadow underneath the skater, I used an Elliptical selection on a new layer, filled this with black, and applied a Horizontal Motion Blur (Filter > Blur > Motion Blur) and a Gaussian Blur (Filter > Blur > Gaussian Blur).

8. I changed the white background to blue and added a white square to give the effect that the skater is jumping out of the scene, making the image more dynamic. Now the image looked like this:

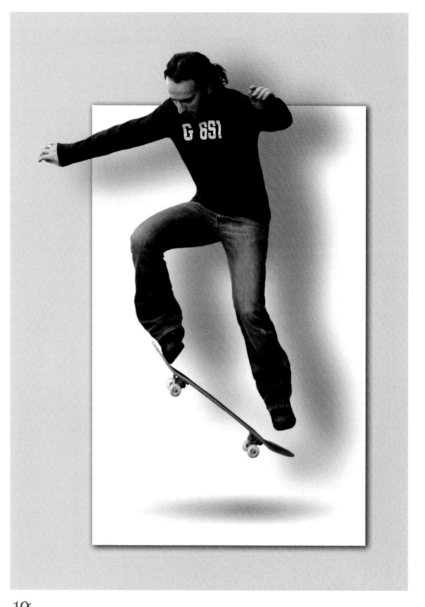

9. Almost done, but I think we need a shadow behind the skater for extra depth. For this shadow, I clicked on the image of the skater in my Layers Palette while holding down Ctrl. This selected everything on that layer (in this case, the skater), a very useful and quick feature. On a new layer below the skater I filled this selection with black. If I make the layer with the skater invisible, I can see the shadow.

10. I applied a Filter > Blur > Gaussian Blur and lowered the opacity of the shadow layer. And there he is, skating right off the page.

Brightness and Contrast

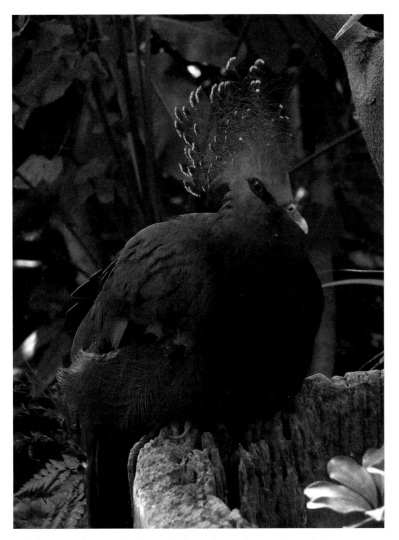

"Brightness and Contrast"—James Goheen—Image Source: James Goheen

Whether you're creating a new composite image, or adjusting your family snapshots, nothing ruins a scene like flat light. In these two tutorials on brightness and contrast, you'll see how adjusting light enhances a photo and helps create believable composites.

1. This beautiful bird's photo was taken in less than optimal conditions: indoors at a zoo, in the shadows of a dimly lit greenhouse. As a result, the image is underexposed and dull. This can be fixed in a number of ways, the most basic of which is a brightness/contrast adjustment.

2. Rather than make permanent, irreversible changes to the image directly, I always prefer to work with adjustment layers, so that the settings can be changed in the future. Here, I added a brightness/contrast adjustment layer, and increased the brightness setting (brightness was set to +55).

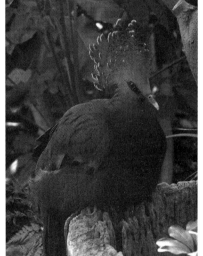

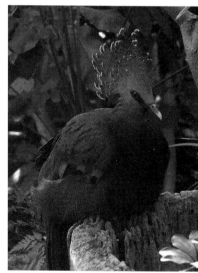

3. Increasing the brightness improved the overall darkness of the photo, but it did nothing to help the washed-out low contrast between light and dark tones. Here, I increased the contrast setting on the adjustment layer, which increased the range of brightness values throughout the image (contrast was set to +50).

4. My last step was to use the Unsharp Mask filter to slightly enhance overall crispness. This gives a bit of "pop" to the few highlights in the image, and the catchlight in the pigeon's eye.

Quick Adjustments with Brightness and Contrast

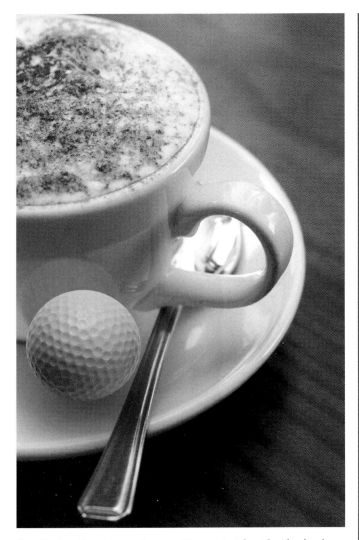

"Fore!"—Zac Blais—Image Sources: "Cappuccino" by John Shepherd © istockphoto.com/John Shepherd—"Golf Ball" by Cynthia Tjong © istockphoto.com/Cynthia Tjong—www.istockphoto.com

Brightness and contrast is only one of the many ways Photoshop allows you to adjust the lights and darks of your images. For most professionals, it's also the last choice, preferring the fine-tuning capabilities of Image > Adjustments > Levels or Image > Adjustments > Curves. Since cappuccino and golf balls are found together normally in the wild, I've decided to combine the two here as they would be in their natural state, as an example of using brightness and contrast.

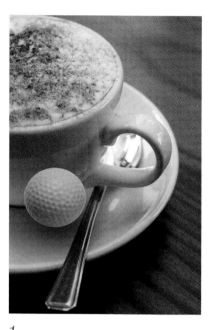

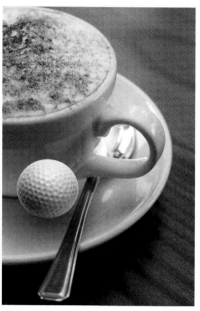

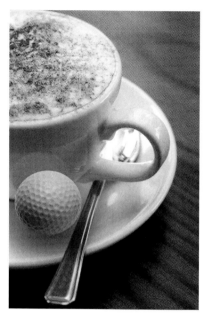

1. After making a selection of the golf ball and copying it into the cappuccino file, I discovered that the ball was much too bright for the picture, though it should be slightly brighter than the cup. I added a Brightness/Contrast adjustment layer to the ball layer. To darken the golf ball, I used a brightness of –61.

2. After matching the overall shading of the two images, I wanted to match the highlights and shadows of the cup to the golf ball. By adjusting the Contrast slider on the adjustment layer back and forth, I found the right shade for my darker areas. As the contrast increased, so did the brightness of the lighter areas. Decreasing the Brightness slider gave me the balance I was looking for between light and dark.

3. For added realism, I added a reflection of the ball to the cup. I duplicated the golf ball to a new layer, rotated it about 180 degrees, and flipped it horizontally. Then I put the reflection layer beneath the original ball layer, set opacity to 50%, and used Free Transform to reshape it and tweak the rotation to match the shape of the cup. I selected Filter > Blur > Gaussian Blur to soften the reflected image.

Learning Curves

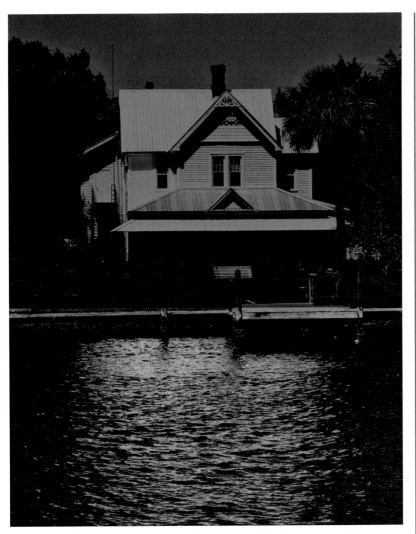

"Curves"—Jeff Davis—Image Source: Paul Kempin—stock.xchng—www.sxc.hu

As with all graphic software, there's a learning curve, and Photoshop is no exception. One of the most functional tools for color correction and manipulation is the Curves tool. It is highly versatile. Whereas the Levels tool allows for the adjustment of three variables—highlights, shadows, and midtones—the Curves tool allows you to adjust as many as 16 values. You can adjust each value independently along a 0 to 255 scale. This allows for very precise control over your image. The Curves tool is also useful for adjusting the color balance and contrast of the image.

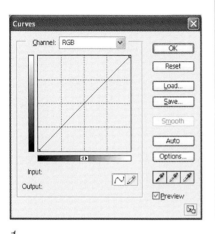

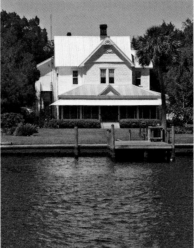

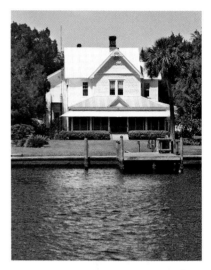

1. The Curves dialog box is accessed via Image > Adjustments > Curves. The horizontal axis of the graph represents the original intensity values of the pixels, also known as the Input levels. The vertical axis represents the new color values or the Output levels. The default mode is a straight diagonal line with all pixels having the same input and output values.

This is the case for RGB images. The intensity values which can range from 0 to 255 display the shadows on the left side. For Lab Color or CMYK images, the curve displays percentage values from 0 to 100, with the whitest highlight on the lower left. The darkest shadow is on the upper right.

2. You can click on the diagonal line and drag for finer detail. The points you click will remain fixed while you adjust the remainder of the line. You can adjust the line by dragging the line or by clicking on the Pencil icon and drawing the shape you want. Moving the line up will lighten the image and pulling the line down will darken the image.

Note

Pressing Alt/Option while clicking the grid will make an even finer grid.

3. Here is a lovely photograph of a historic, turn-of-the-century river lodge along the Homosassa River in Florida. I have done a slight adjustment to the curves by grabbing the diagonal line in the center and moving it to the upper left. This shows an improvement in the contrast of the image.

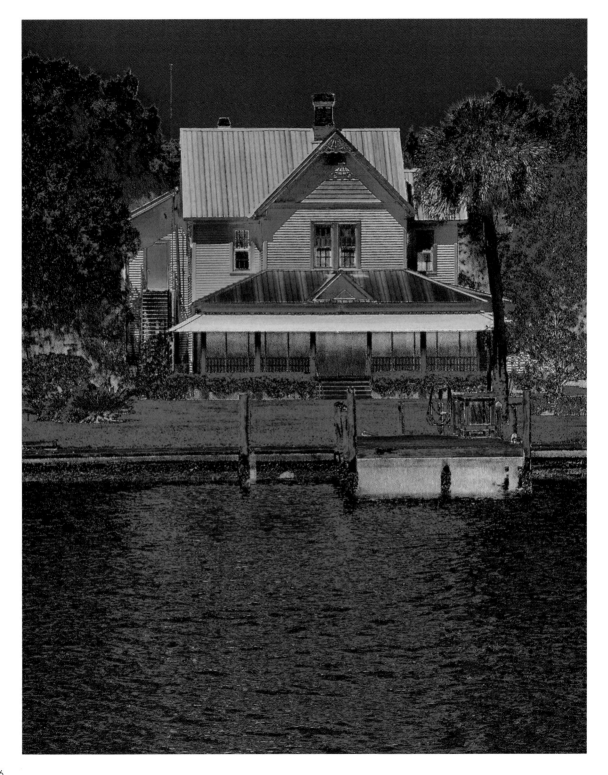

4. In this picture, I selected the highlights of the water using the Magic Wand tool, and copied them onto a new layer. I then adjusted the curves of the water highlights to a lighter setting by moving the Curves line to the upper left. On my original image, I adjusted the curves to the lower right, darkening the image. Now we have an image that could be used to start a nighttime image. I upped the highlights of the water to make it look as if the moon is being reflected.

5. In this image, I adjusted the curves of the color channels instead of the entire RGB image. This curves adjustment gives the image the feeling of sunset. Experimenting with the curves of each Color Channel can achieve many different effects.

6. You can also just go crazy and create an image that is hardly "photo-realistic" but could be plain fun. This could also be useful if you are trying to create an alien landscape. As you can see, the Curves tool, although very powerful, is quite easy to use. After a few uses it will become almost intuitive.

Levels

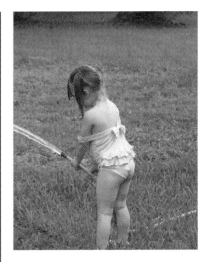

"Playing in the Grass"—Dorie Pigut—Image Source: Dave and Darlene Anderson

Adjusting levels is a great way to very quickly improve your images. With just a little adjustment to the sliders, you can make your colors more vibrant and remove unwanted color casts. The Levels menu has a very powerful "auto" feature that will often do all the work for you. Every image you work with in Photoshop could use a bit of levels enhancement.

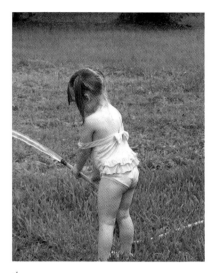

1. I have a snapshot that has an obvious red hue that I wanted to remove. I chose Image > Adjust > Levels to access the Levels Adjustment Panel. First, I tried the Auto feature to see if it would give me the results I wanted. Many times, you will never need to take any further steps. I clicked Auto; however, it didn't correct the image's red hue problem, and the image actually darkened. I needed to adjust the sliders by hand. Holding down the Alt key, the Cancel button changed into a Reset button, which allowed me to revert to the original state.

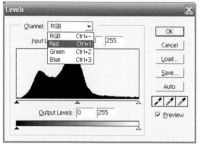

Note

The histogram shows where all the color information is in an image. The far left of the histogram is the black point. The far right is the white point. In between the two ends is where all of your color information is located. Every picture has a unique histogram. Night scenes or dark images will have "mountains" on the left side of the histogram. Very bright images will have their "mountains" on the right side. Normal pictures will have their mountains in the center area. Underneath the histogram there are three triangles on a line. The left-hand black triangle is the black point slider. The far right white triangle is the white point slider. The center gray triangle is the mid-tone slider. You can adjust the overall image in the RBG channel, or you can adjust each color channel individually. Look at the channel drop-down box and you'll see RGB—Red, Green, and Blue.

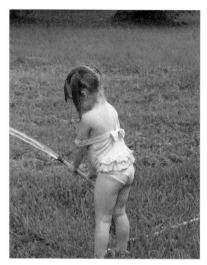

2. I adjusted the color channels individually, starting with red. I chose Red from the Channel drop-down menu. The histogram does not extend all the way to the left, so I moved the black point slider to the place where the histogram starts to have color information.

3. Already I saw improvement, but the skin tones were still much too pink. Adjusting the mid-tone slider helped remove the red hue I was having trouble with. While in the individual color channels, I adjusted the mid-tone slider to the left, adding more of that color to the image. Adjusting the slider to the right removed that color from the image. I wanted to remove the excess red, so I moved the mid-tone slider to the right a bit.

4. Now for the green channel. I chose Green from the channel drop-down menu and moved the black point and white point sliders to places on the histogram where the color information started. Since this image has so much grass, I added a little extra green to the image by moving the mid-tone slider a little to the left.

5. And then there was the blue channel. I selected Blue from the channel drop-down menu, and with this image, the blue histogram extends all the way to the edges, so I didn't have to adjust the black point or white point sliders. However, the image seemed a bit cold. I moved the mid-tone slider slightly to the right to remove some blue from the image and warm it up. With these adjustments finished, I clicked OK.

6. Although this particular image did not require any lighting adjustment, I want to show you that you can lighten and darken an image in the RGB channel if needed. Moving the mid-tone slider to the right will darken an image.

7. Moving the mid-tone slider to the left will lighten an image.

Blending Modes

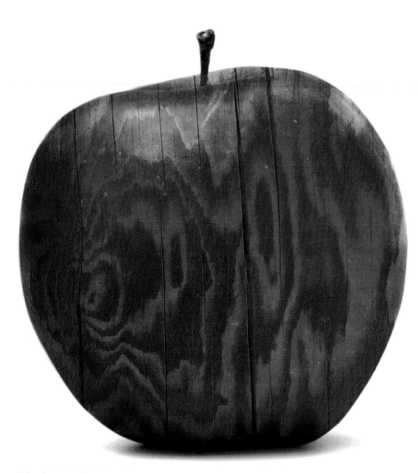

"Blended Apple"—Derek Ramsey—Image Source: "Apple" by Tina Rencelj

Blend modes can be useful for many different applications in image editing. You can find the different blend modes at the top of the Layers Palette. Now, the Photoshop user's manual does an excellent job of explaining each of the blend modes. However, those explanations are incredibly technical and fly way over the head of a beginner or even an average user. What I am going to do now is try to explain these different blend modes in easy terms so everyone, regardless of skill level, can understand and utilize them. Each explanation is accompanied by a graphic of an apple with a woodgrain texture layered on top of it. This is to help you visualize the different blend modes in Adobe Photoshop.

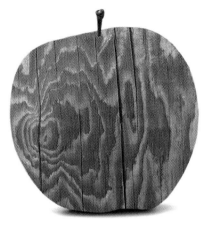

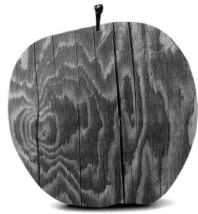

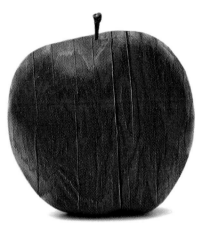

Normal—Not much you can say about this blend mode; it is just that simple. What you see is what you get. Normal is the default blend mode.

Dissolve—This is one blend mode where reading the explanation in the manual will make you more confused than before. Dissolve only affects semi-transparent portions of an image. Areas that were semi-transparent change into little speckles of color, which blend into the layers beneath it. Really, just looking at this blend mode in action provides the best explanation.

Darken—Darken puts the different layers of an image in competition with each other. It looks at the corresponding pixels in each layer. The darkest pixel becomes the dominant pixel. This leaves the new image with the darkest combined pixels from the two layers. The opposite of Lighten.

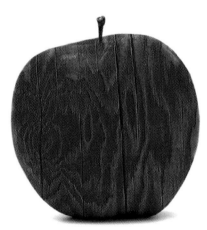

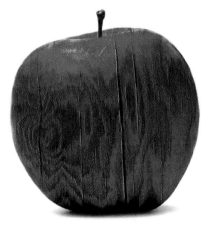

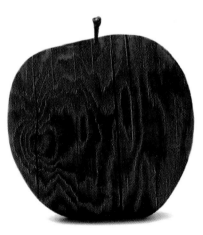

Multiply—Think of this like it was math class. Multiply takes the colors from the base image and multiplies them with the colors in the blend layer. The resulting image will typically be darker in value. Black multiplied by any color is always black, and white multiplied by any color always leaves that color unaltered. All the shades in between have a similar effect considering where they fall on a value scale.

Color Burn—the colors of the blend area applied to light areas of the base layer remain unchanged, while the colors of the blend area applied to dark areas of the base layer become dramatically darker. The opposite of Color Dodge.

Linear Burn—Linear Burn was introduced in Photoshop 7. If you use a version of Photoshop prior to version 7, the Linear Burn blend mode will not be available. Linear Burn gathers information from the channels of an image. To quote the User's Manual, Linear Burn "darkens the base color to reflect the blend color by decreasing the brightness."

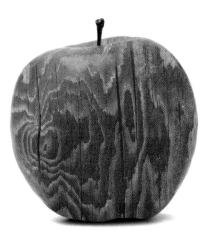

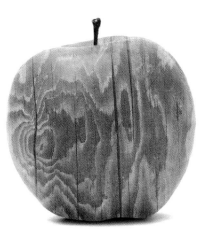

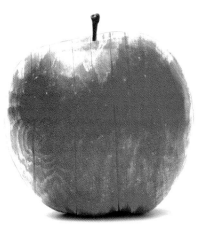

Lighten—Lighten puts the different layers of an image in a slightly different competition with each other. It looks at the corresponding pixels in each layer. The lightest pixel becomes the dominant pixel. This leaves the new image with the lightest combined pixels from the two layers. The opposite of Darken.

Screen—Screen uses information from the channels of the image. It takes the inverse of the colors in the blend and base layers and multiplies them together. I realize that last sentence was about as simple as a Rubik's cube, so just look at it like this: The lightest parts of the two layers get a great deal lighter; the darkest parts get only slightly lighter; and the sections that are pure black remain unchanged. Nothing in the image gets any darker while using the Screen blend mode.

Color Dodge—Color Dodge looks at the channels of the image and makes the base layer lighter to reflect the blend layer. This means that all of the light areas in the blend layer will make the corresponding areas in the base layer lighter. It is almost like shining a flash light with some sort of filter on it on an object. The light parts of the object will reflect the light, so they will be really bright. The darker areas will also reflect the light, but to a lesser degree, whereas the black parts of the object will absorb the light, which makes the light barely visible in these black sections. The opposite of Color Burn.

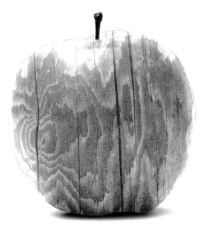

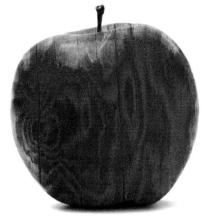

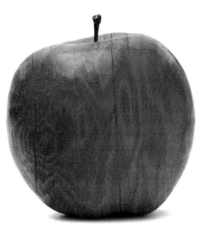

Linear Dodge—Linear Dodge was introduced in Photoshop 7. If you use a version of Photoshop prior to version 7, the Linear Dodge blend mode will not be available. Linear Dodge gathers information from the channels of an image. Linear Dodge lightens the base color to reflect the blend color by increasing the brightness. The opposite of Linear Burn.

Overlay—While a bit more difficult to explain, Overlay is, in my opinion, one of the most important blend modes in Adobe Photoshop, especially when it comes to photo manipulation. Overlay will either darken or lighten the colors in the blend layer, depending on the colors in the base layer. It is the best blend mode for applying texture to a grayscale image. Just try it out and you will see what I mean.

Soft Light—If a color in the blend layer is lighter than a fifty percent gray, the corresponding areas of the base layer are lightened. If they are darker, then the exact opposite takes place.

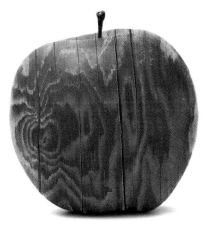

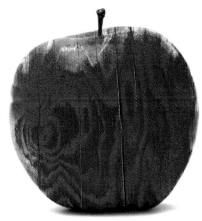

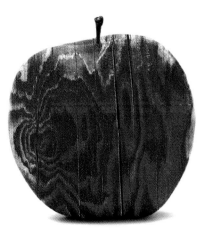

Hard Light—If a color in the blend layer is lighter than a fifty percent gray, the corresponding areas of the base layer are lightened in the same manner as the Screen blend mode. If they are darker, then the corresponding areas of the base layer are darkened using the same manner as the Multiply blend mode. This provides a similar effect to that of Soft Light but it is much more dramatic.

Vivid Light—Vivid Light was introduced in Photoshop 7. If you use a version of Photoshop prior to version 7, the Vivid Light blend mode will not be available. Vivid Light dodges or burns colors in the base layer depending on whether the colors in the blend layer are brighter or darker than fifty percent gray. This is similar to linear light but vivid light affects the contrast rather than the brightness of the colors in an image.

Linear Light—Linear Light was introduced in Photoshop 7. If you use a version of Photoshop prior to version 7, the Linear Light blend mode will not be available. Linear Light dodges or burns colors in the base layer depending on whether the colors in the blend layer are brighter or darker than fifty percent gray. This is similar to Vivid Light, but linear light affects the brightness rather than the contrast of the colors in an image.

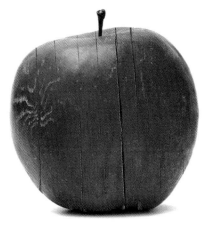

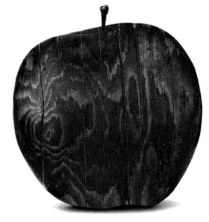

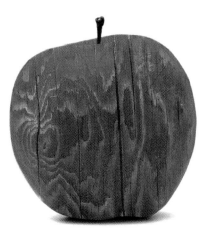

Pin Light—Pin Light was introduced in Photoshop 7. If you use a version of Photoshop prior to version 7, the Pin Light blend mode will not be available. Pin Light replaces the colors in the base layer depending on the brightness of the colors in the blend layer. If the blend color is lighter than fifty percent gray, the base colors that are darker will be replaced by the blend colors. If the blend colors are darker than fifty percent gray, lighter base colors will be replaced by the blend layer colors.

Difference—Back to math class with this one. Difference looks at the colors in the blend layer and base layer and subtracts the blend colors from the base colors. Blending with white will invert the color value because white has a value of one hundred percent—it is the lightest color you can get, after all. So, if you are thinking of this as you would numbers in a math class... when you subtract a larger number from a smaller number, you get into negative numerical values. Black carries a value of zero. Therefore, it would be like subtracting zero from any number—the value, or in this case, color, remains unchanged.

Exclusion—Exclusion operates under the same principles as the Difference blend mode, only the result is not as dramatic because Exclusion does not use as much contrast in the application of its effect. This is one of those things where doing it yourself really helps you understand what it truly means.

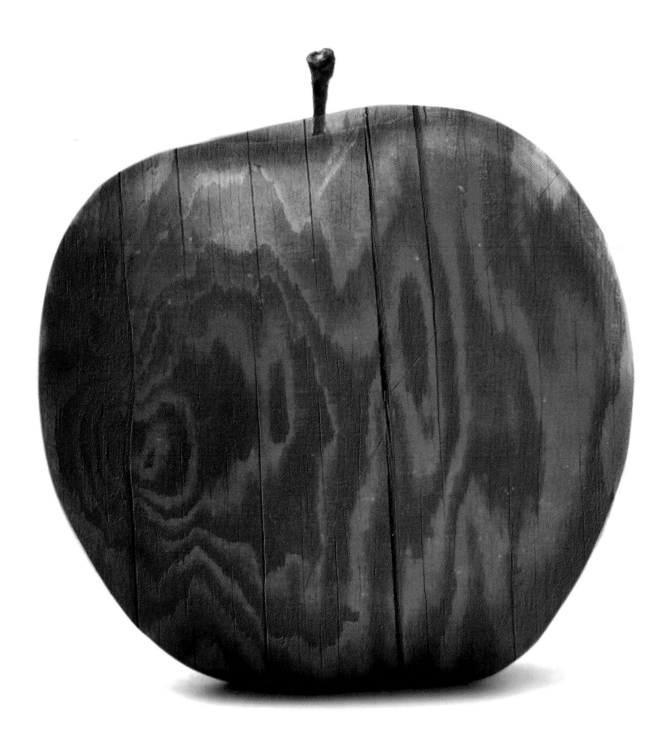

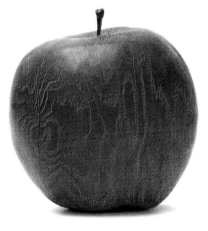

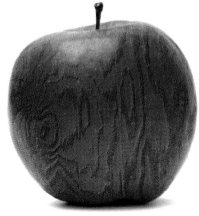

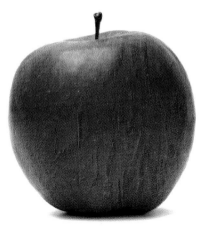

Hue—Combines the hue of the colors in the blend layer with the brightness and saturation of the colors in the base layer. The colors in the blend layer take dominance without affecting the brights and saturation of the base layer.

Saturation—Combines the saturation of the colors in the blend layer with the brightness and hue of the colors in the base layer. The colors in the base layer take on the saturation of the colors in the blend layer while leaving the brightness intact.

Color—Combines the hue and saturation of the colors in the blend layer with the brightness of the colors in the base layer. The colors in the base layer take on the hue and saturation of the colors in the blend layer while leaving the brightness intact.

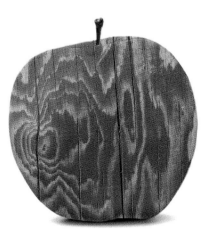

Luminosity—Only uses the brightness or darkness of the colors in the blend layer. The different hues and saturations are ignored. This makes certain areas of the base layer brighter or darker depending on the value of the colors in the blend layer.

Layer Masks

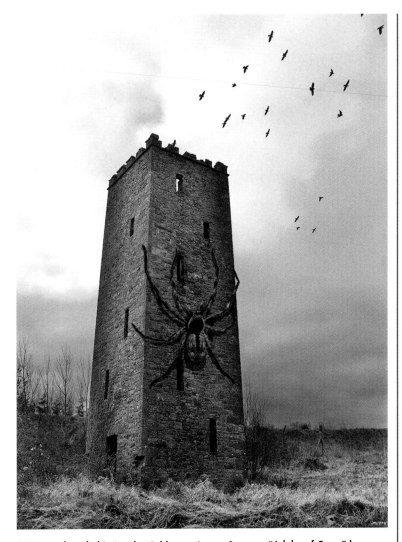

"MEGArachnophobia"—Alex Feldman—Image Sources: "Adobe of Crow" by Steve Ford Elliott and "Huntsman Spider" by Mac Brown—stock.xchng—www.sxc.hu

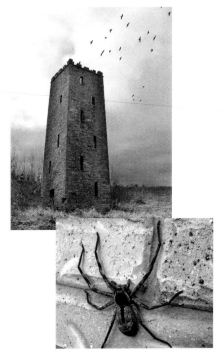

Layer masks give you the ability to hide portions of a picture, without actually erasing the portions and deleting the picture information. They are forgiving, reversible, and extremely flexible, allowing you to use most of the tools available in Photoshop to adjust the mask. Our spider is ready to start climbing the tower, so let's not stand in its way.

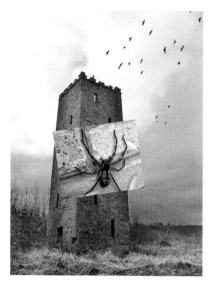

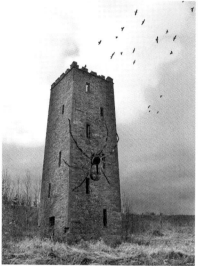

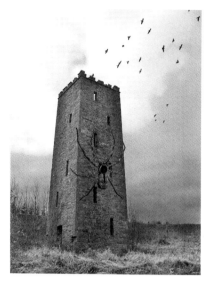

1. After finding two pictures with similar lighting and perspectives, my first step was to insert the picture of the spider into a new layer above my castle picture. With that done, I resized, flipped, and rotated the spider picture so that it fit the scale and direction of the castle picture.

2. With the spider in place, I selected Layer > Add Layer Mask > Reveal All. After zooming in so I could see the spider very clearly, I chose a small, soft-edged brush and painted over the portions of the spider picture that I didn't want to show up. (Painting in a layer mask with black hides the picture information; white reveals.) If I accidentally painted out part of the spider, I switched over to Uncovering, so I could paint the spider back in. This method proves to be more forgiving than using the Eraser tool, as it allows you to touch up any mistakes without having to use the Undo option. When I was happy with what was left of my spider picture, I applied the layer mask (Layer > Remove Layer Mask > Apply Mask), and all the extraneous wall was deleted from the layer.

3. Unfortunately, the spider I chose only had 6 of the 8 legs it is supposed to have. I copied the portion of the back leg that was complete and pasted it into a new layer. After flipping and rotating (Edit > Transform) it, I placed it partially over the leg stub and added a layer mask. Again using a small, soft-edged brush, I covered over the part of the leg that was already there, enough so that the two pieces of leg slightly overlapped. Once I was happy with how it looked, I linked the two layers and selected Layer > Merge Linked. Now I had a 7-leg spider. I used the same technique for the remaining leg and now my massive spider was on all of his feet again.

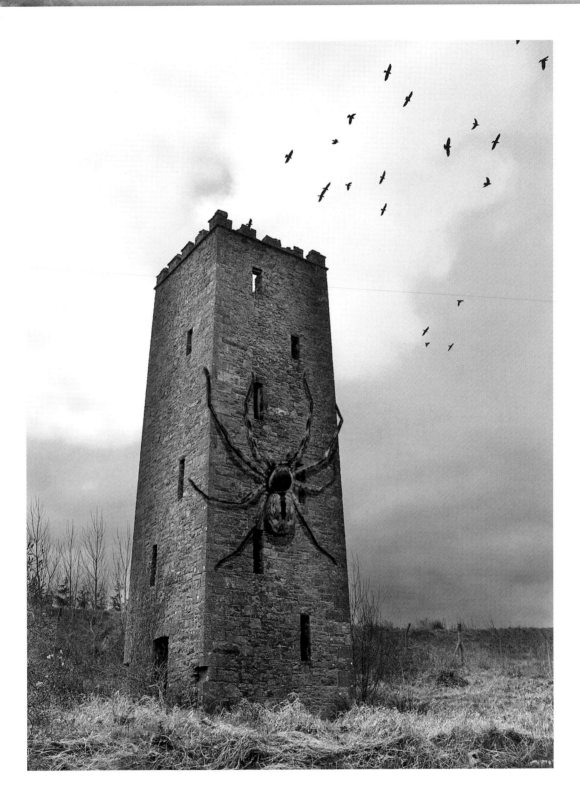

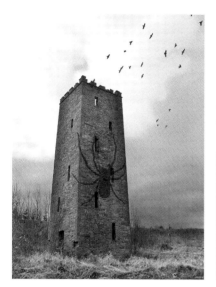 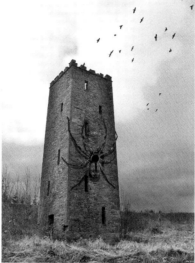

4. Then it was time for the shadow. The shadow ties your photo manipulation work to its environment and adds realism. To do this I duplicated my spider layer, selected everything on the lower of the two spider layers, and filled it with black. I hid the top spider layer so I could see my shadow layer. I wanted the shadow to be slightly below it, but I connected it to the contact points of the spider on the wall. I used Filter > Liquify, and with a big brush, I moved the main part of the spider body shadow down. With a smaller brush, I moved the legs down as well, making sure not to move the very tips of the legs. I removed the portion of the shadow that was over the sky, set the shadow layer to multiply, and gave it an opacity of about 50%. This is probably darker than the shadow would have been in real life, but because the spider's coloration was so close to the color of the castle, I wanted to make it really stand out.

5. Now that the shadow portion of the picture was done, I wanted to add a few highlights to the top of the spider, to make my harsher-than-it-should-be shadow look more realistic (because brighter light casts a harsher shadow). So with a small, soft-edged airbrush set to approximately 3% opacity, and the color set to white, I added highlights to the top of the spider's head, abdomen, and legs. Voilà! We have a giant spider climbing a tower wall. I would hate to be one of those birds, because he looks hungry.

Adding Texture

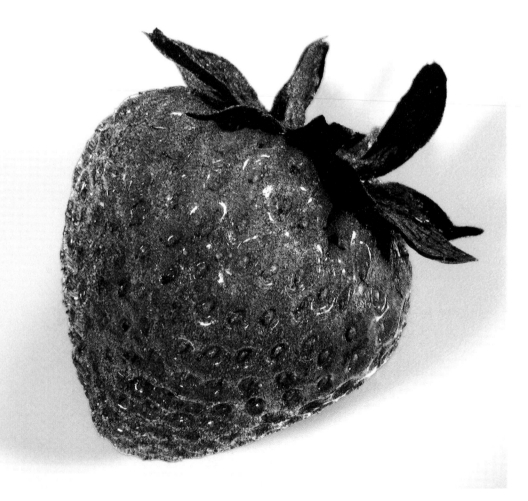

"Stone Strawberry"—Derek Ramsey—
Image Source: "Strawberry" by Andrew F
Kazmierski © istockphoto.com/Andrew F
Kazmierski—www.istockphoto.com

Adding a texture to an everyday object is a useful skill in your Photoshop arsenal. Though some would say your average strawberry has enough texture on its own, adding a splash of metal and rust gives this squishy treat some strength.

1. I opened the strawberry image, and, as a precaution, I duplicated the background layer to a new layer. On the new layer, I desaturated the image to –100% saturation (Image > Adjustments > Hue/Saturation), then increased the brightness and contrast (Image > Adjustments > Brightness/Contrast: brightness +5, contrast +30) for a more dramatic transition between the shades.

2. I then copied the desaturated layer to a new image file, and pasted it into the new file. After applying a slight blur with the Gaussian Blur filter, I saved this new file, calling it Map.psd. I'll use this file in the next step as a Displacement Map. After saving this blurred duplicate image as Map.psd, I closed it.

3. Working again on my original strawberry image, I opened an image of a rusty texture and pasted it into my document as a new layer, filling the image with the texture. Using Free Transform (Edit > Free Transform), I resized the rust image to cover the area of the berry. After resizing the texture, I applied a bit of sharpening to it. (You can also choose one of Photoshop's default textures.) Then, with the texture layer active, I chose Filter > Distort > Displace. I used the default Displace settings, and selected my Map.psd file as the source for my displacement map, and applied the filter. This will take the texture and wrap it over the lows and highs (darks and lights) of the image. I then changed the texture layer's blend mode to Overlay.

4. Changing the texture layer's blend mode to Overlay allows some of the texture of the strawberry to shine through and increases the contrast of the dimples on the skin, but I'm not quite done yet. The texture bleeds over the edges of the berry onto the shadows. To correct this, I added a layer mask to the texture layer, so that the texture will be visible only where the berry appears. I activated the desaturated berry layer from Step 1, then with the Magic Wand tool, I clicked on a white area in the background to create a selection around the background. Then I inverted this selection so that the berry was selected. I then activated the texture layer, and added a layer mask (Layer > Add Layer Mask > Reveal Selection).

5. I duplicated the texture layer and changed its opacity to 50%, adding depth to the texture's colors. Different textures and displacements will require different tweaking of brightness and color depth. Don't be afraid to play around. When I desaturated the berry layer in Step 1, subtle hues in the shadows were lost. I decided to restore them by masking out the desaturated layer's shadows. I activated the desaturated berry layer, and used the same Magic Wand technique as in Step 4 to select the background. This time, without inverting the selection, I added a layer mask (Layer > Add Layer Mask > Hide Selection). And with that, I've restored the original full-color image's shadows to my newly retextured strawberry.

Replacing Text

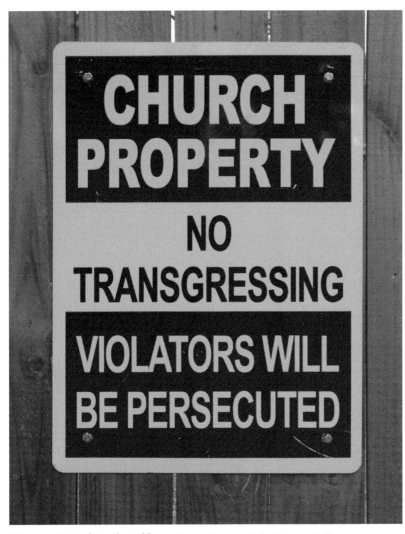

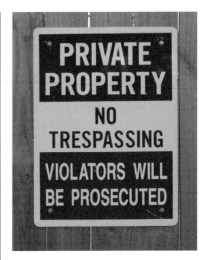

Working with text is easy in Photoshop, and with thousands of fonts available, your opportunity for hilarity is endless. Typical warning signs may fade into the background of everyday life due to their prevalence. In this tutorial, we'll work with the text features of Photoshop to transform an innocent Private Property sign into one with a much more cosmic deterrent.

"Seems a Bit Harsh"—Alex Feldman—Image Source: "Private Property!"
by Erran Yearty © istockphoto.com/Erran Yearty—www.istockphoto.com

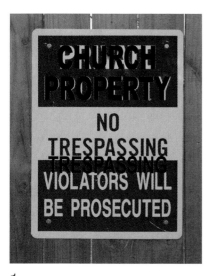

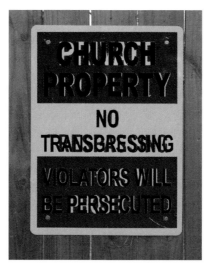

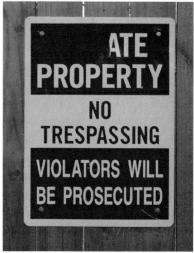

1. So, I thought to myself, how can I make this mild-mannered sign more exciting? Well, I first created a duplicate layer of my original image, a good step. It gave me something to fall back on in case of catastrophe. I used the Text tool to create a new text layer and typed "PRIVATE PROPERTY." Yep, I know, it already says that, but this would allow me to cycle through my font library until I found the one that matched perfectly. I used the Character Palette to adjust my font size and kerning (space between characters). Once I had a match, I replaced the word "PRIVATE" with "CHURCH." I also adjusted the leading (space between the lines) to match the original text. If I didn't have the exact same font (which in this case was Arial Black), it wouldn't matter. Since I was going to remove all the original text, the viewer would have nothing to compare it to.

2. Now I was starting to get somewhere. I continued the same steps as before but with the lower text. These had slightly different settings than "PRIVATE PROPERTY," so I adjusted the text settings. The letters were a slightly narrower font and the kerning was much lower (see how the letters are close together?). Now that I had all the letters arranged, it was time to give them a nice clean sign to sit on.

3. I hid the text layers (by clicking the little "eye" next to each layer on the Layers Palette) and set about removing the original text. I selected the Clone tool and used samples from the sign layer to obscure the original letters. Cloning, instead of creating new colored boxes, allowed me to keep slight variations in color and texture of the original.

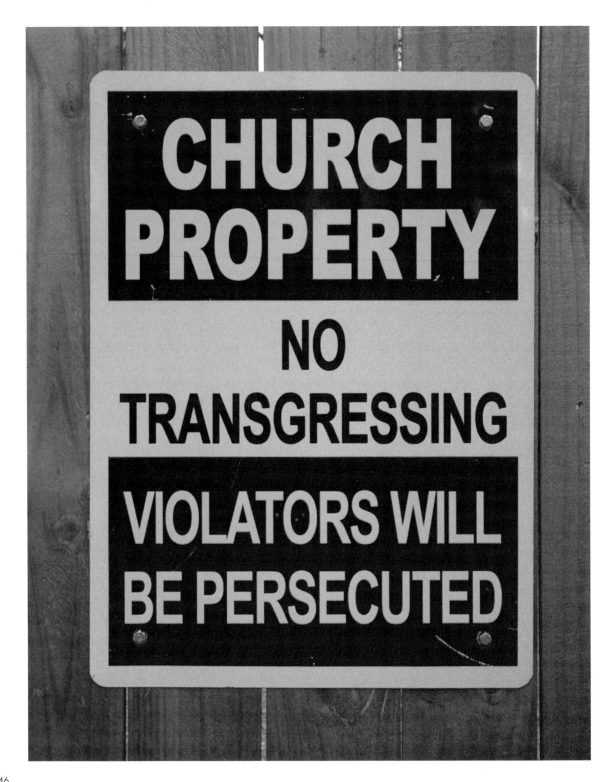

CHURCH PROPERTY

NO TRANSGRESSING

VIOLATORS WILL BE PERSECUTED

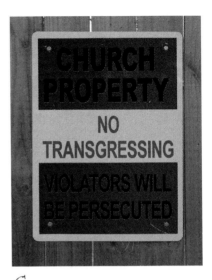

4. Once the cloning of the original text was complete, I was left with a blank slate, still having all the "personality" of the original sign, on which to add my own text.

5. Now it was time to bring my new text back. I made copies of my text layers (for later) and then grabbed the Eyedropper tool. Since the sign already contained the two colors I'd be using, I selected the white from the sign, highlighted "CHURCH PROPERTY," and clicked on the color box in my Character Palette. The white, it turned out, was actually a light gray. I repeated this with the bottom text and selected the red from the sign for the center text. I also wanted to add some soft texture to my letters to help them match the original texture. I chose Filter > Noise > Add Noise and chose Uniform Noise at 1.5%, a very low setting. Then I chose Filter > Blur > Gaussian Blur with a setting of 0.7% to make the letters slightly less sharp. Now for the fine details.

6. I revealed my black letters. I used those to re-create the depth of the original sign. There is a faint black line on the left edge of the white letters and on the right edge of the red letters in the original. I moved them behind my colored text layers. Those behind the white lettering were moved 1 pixel to the left, while those behind the red were moved 1 pixel to the right. I adjusted the opacity of the dark letters until they looked just right and voilà! A perfect sign ready to warn the transgressors.

Blending with Layer Styles

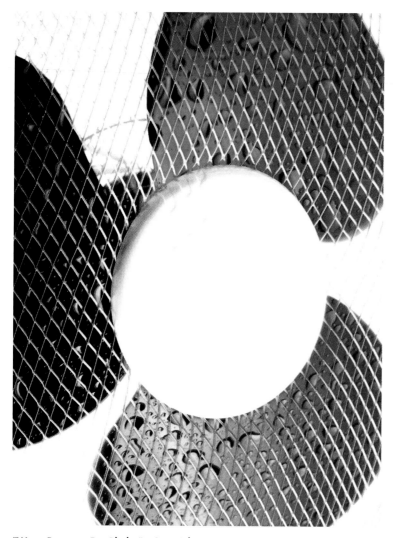

Whether you're new to Photoshop or an old hat, occasionally you'll see an image and think "wow, that must have taken A LOT of time." Sometimes careful masking is necessary to achieve your desired results, but, as this lesson shows you, Photoshop is full of helpful (and sometimes hidden) ways to cut your creation time in half without sacrificing quality. Kids, don't try this at home. Remember, electricity and water DO NOT mix.

"Water Drops on Fan Blades"—Greg Schnitzer—Image Source: Murat Cokal—stock.xchng—www.sxc.hu

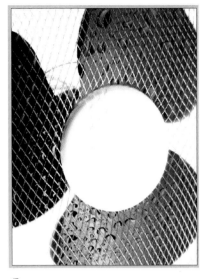

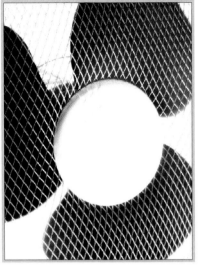

1. There are many ways I could have achieved my desired goal, but I was looking for speed and didn't want to invest a lot of time masking or erasing the diamond spaces in the fan shroud. There is an often-overlooked super-tool located in the Layer menu that helped me do this in only a few moments! I went to Layer Menu > Layer Style and used the first item listed there, Blending Options. This tool is often overlooked because it looks like a header for the list below it. I prepared my layers by putting the water drop picture on the bottom of the stack so it could be the background. The picture of the fan will lie above the water drops as layer one.

2. Then I made the fan layer the active layer and went to Layer > Layer Style > Blending Options. Within this dialog box, you will see several options. Let's focus in on the middle section, leaving the boxes in the left section unchecked. The top selection in the center section offers blend modes, the same blend modes found in the Layers Palette. I used the default setting of Normal. The only thing I changed was the slider (second from the bottom) titled This Layer.

3. The range of this slider is from 0 to 255. When I grabbed the black arrow on the left and slid it to the right, I saw the water drops replace the fan blades, but the result was a bit gross. I set it at about 100. Voila!—the exact effect I was looking for with the water drops behind the mesh shroud.

Tip

I can hold down the Alt/Opt key and the arrow will split in half and give me much finer control. Instead of just one brightness value to blend through, you can choose a range of brightness values (or color values) to blend through the layer.

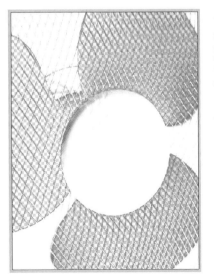

4. When I turned off the water drop background, the fan image looked like the above photo. Note that only the dark areas have been faded out of the picture. I can use this tool on light areas or specific color areas as well. It can also be applied to the active layer or the layer below it and allows for the use of blending modes just like the Layers Palette. It works well with complex stuff like lace or wire mesh or sheer cloth. This is one powerful tool!

History Brush

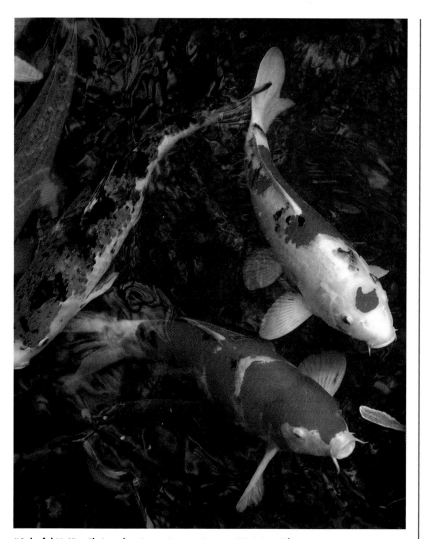

The History Brush, together with the History Palette, allows you to retrieve parts of an image from a previous stage in its editing. You can apply filters and color enhancements at different places in the process, then emphasize portions of them with the History Brush. This is one of the many ways Photoshop lets you travel back in time.

"Colorful Koi"—Christopher Ross—Image Source: "Koi Carp" by Torsten Wittmann © istockphoto.com/Torsten Wittmann—www.istockphoto.com

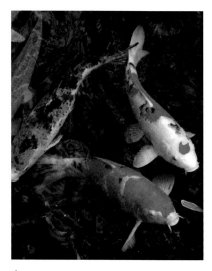

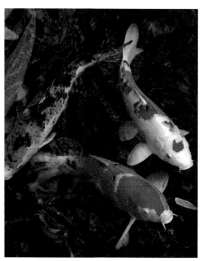

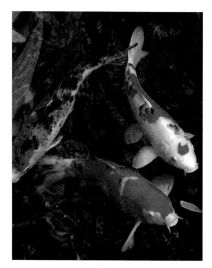

1. I wanted to accentuate two particular Koi while forcing everything else into the background. I used the History Brush to return color to specific areas of a blurred grayscale image. I began by creating a "New Snapshot" to save the original image state. I clicked on the Camera icon at the bottom of the History Palette. A new image snapshot was created, named Snapshot 1, and placed near the top of my History Palette. Now, I wanted to remove all of the color information from the image by selecting the Image > Adjustments > Desaturate option from the menu.

2. I selected the saved image state (in this case Snapshot 1). I used Snapshot 1 as my source for the History Brush by clicking in the box to the left of the snapshot in the History Palette. I selected the History Brush tool from the toolbox and chose a medium-sized, hard-edged brush. As I brushed, I "painted" color back into my image. In general, I was just returning the brushed portions to a particular state. In this case, I returned portions of the image back to the original color state at the time I created the snapshot.

3. I continued bringing color back to the two Koi by selecting appropriately sized brushes, with varying edge hardness for the particular areas of the image. If I happened to return color into the wrong area, all was not lost. By clicking the box to the left of an earlier step, therefore selecting a new source in the History Palette, I was able to use that step as the historical source and return portions of the image back to that state. I selected a source prior to the point in which I made the coloring error.

Tip

The History Palette is usually grouped with the Actions Palette and the Tool Presets in Photoshop's default layout. It can also be accessed by selecting Window > History.

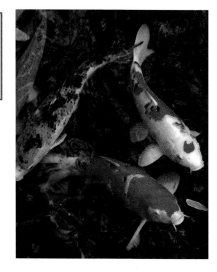

4. I continued adding and removing color information from the image as I touched up the edges by selecting various history source points in my History Palette. In general, I could have used the History Brush to return portions of my image back to any previous step in my history. This can be useful when applying any change to an image, for example, when I wanted to selectively apply a filter to my image. In this case, I was applying a Gaussian Blur, with a radius of 4.0 pixels to the entire image to deemphasize the background. I then selected a pre-blur source for my History Brush and "painted" portions of the Koi back to their original sharpness to make them stand out even further.

Art History

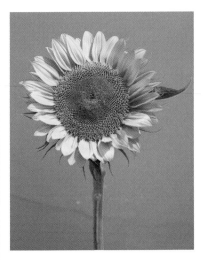

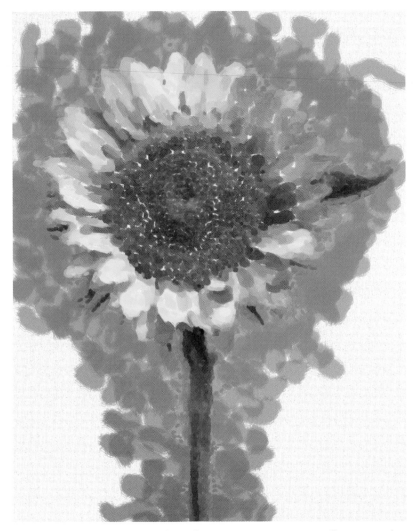

Photoshop has a variety of methods for painting. Here, we'll demonstrate how you can paint with a previous version of an image or composition. Utilizing the full arsenal of Photoshop's included brushes, you can achieve quite an artistic effect without spending one afternoon in front of a nude model. Well, you still can, if you like.

"Sunflower on Digital Canvas"—Christopher Ross—Image Source: "Sunflower on a Blue Wall" by Lise Gagne © istockphoto.com/Lise Gagne—www.istockphoto.com

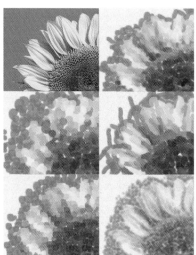

1. I created a new layer, named it canvas, and placed it on top of my original photograph. After selecting the new canvas layer to make it active, I selected Edit > Fill and used a canvas pattern to fill the contents of the layer (Custom Pattern > Artistic Surfaces > Canvas).

2. I then created a new layer, named it painting and placed it above the canvas layer. I temporarily turned off layer visibility for the canvas and painting layers. With the original layer selected, I created a New Snapshot by selecting from the pop-up menu on the upper right of the History Palette. This saved the current image state. From the dialog window that appeared, I chose to create my snapshot From: Merged Layers. A new image snapshot was created, named Snapshot 1, and placed at the top of my History Palette. I then turned on layer visibility for my canvas layer and set the layer opacity to 75%, because I still wanted to be able to see the original photograph through my canvas so that I could accurately outline the original photograph. I also turned on layer visibility for the painting layer, and selected it to make it active.

3. I selected the saved image state, in this case Snapshot 1, to use as my source for the Art History Brush by clicking in the box to the left of the snapshot in the History Palette. I then selected the Art History Brush tool. The various style options for the Art History Brush produce significantly different results, so I began my painting by examining the results produced by each style choice and then selecting the option that best fit. Some examples of Art History Brush styles: (clockwise from the upper right) Tight Short, Loose Medium, Dab, Tight Curl, Loose Curl.

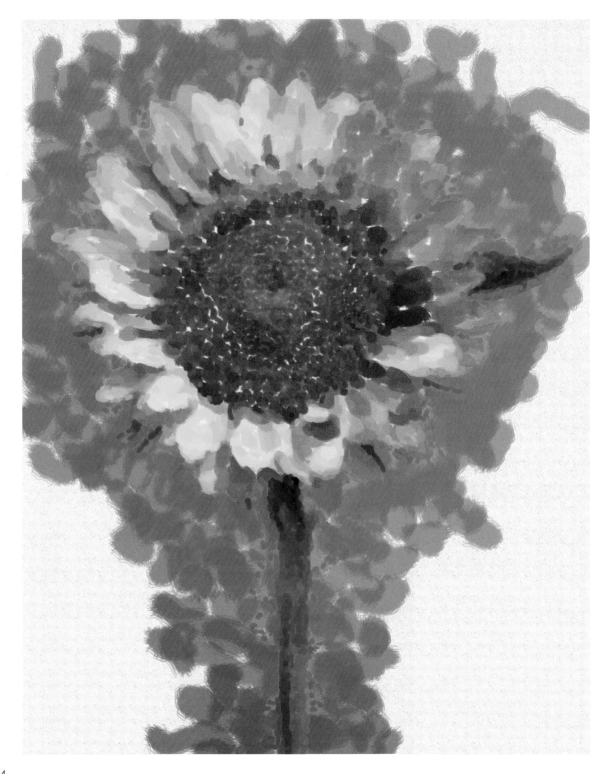

4. I chose a charcoal brush (size 100 with 70% opacity, Tight Medium style). I began painting the blue background from around the sunflower's petals and stem onto the painting layer. The larger the brush size, the more pronounced and coarse the brush strokes appear.

5. By changing to a smaller sized brush, and over-painting certain areas, I painted with more detail as I worked my way into the center of the sunflower. I began at the outer edges of the petals and stem with a size 46 brush.

6. As I worked my way into the center, I wanted to show even more detail, so I decreased the brush size again.

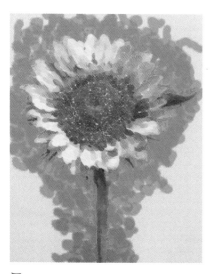

7. After filling in the center of the sunflower, I did some final touch-up work in the areas that needed more definition. I reset the brush to size 20, set the style to Tight Short, and decreased the tolerance to 30% for a more intense coverage.

8. Now, satisfied with the overall look of my painting, I changed the opacity of the canvas layer to 100% to completely obscure the photograph beneath, showing the final painting.

Healing Brush

"Fountain of Youth"—Kim Hudgin—Image Source: Kim Hudgin

It is the best friend of photographers and supermodels. Hiding on your toolbox, underneath the unassuming Band-aid icon, you'll find this little gem. Many shy away from using it because, when used improperly, it can result in a blurred, smeary mess that can make the most beautiful subject look artificial and alien. But, when used with patience and subtlety, it can be the most powerful tool in Photoshop's bag of tricks. Trying to put someone else's head into an "Old Master" painting? Use the Healing Brush to import the texture, tone, and color value of the canvas onto the person's face. Want to make a modern-day Medusa? Use this tool to import snake scales onto the skin of a lovely lady.

2. I started by softening the lines around her mouth. I selected the Healing Brush and chose a small brush size for the detailed work. I used Normal mode and made sure my Source was set to Sampled and unchecked Aligned. Holding down Alt/Option, a target icon appeared, and I chose part of the skin on her cheek as my source. This is what I'll use to "replace" the lines. I used a small, controlled stroke and followed the darkest part of the line.

> **Note**
>
> After "healing" over a line, I selected Edit > Fade Healing Brush and moved the slider until the opacity merged my newly painted area into the original image.

To work on the left side of her mouth, I changed my source to her left cheek and repeated the process that I used on her right side. I didn't totally remove the lines; I just softened them. By leaving a trace of the lines I gave the final image a more realistic look.

1. My mother agreed to be my guinea pig for this little tutorial and was quite shocked at how awful the photo I took of her looked. Just to set my mother's mind at ease, I'll inform all of you that I did alter the levels and color balance of this photo to make it as unflattering as possible. Now that Mom's been appeased that you know she doesn't normally look so bad, we shall unveil the healing process.

4. To get rid of the frown lines and mute the shine on her forehead, I used only the left cheek as my source. I did the same thing to the highlights beside the lines to even out the skin tone. To get rid of those little dark dots at the top of her nose, I dabbed my brush on them still using the Normal setting.

The frown lines fled and no waxing was used to get rid of those little dark bumps! With the lines in her face softened, I took a look at the whole image, de-magnified. If I found a line that I missed, I just went back and fixed it.

3. Next, I went to work on the eyes to lessen the impact of too much work and too little sleep. I used the same settings and sources to work on the crow's feet. To remove the dark blotches under her eyes, I again used the Normal mode. I moved the brush in small, tight circles and removed a bit of the dark blotches at a time. Mom started to look more rested and relaxed already!

5. Even though the lines were gone, there were still some unflattering shadows around her mouth and a highlight on the tip of her nose. I removed the shadow by selecting Lighten as the mode for my brush. Still using the left cheek as my source, I used the "little circles" technique to lighten the darker areas. I also used the brush to dab out any dark spots that drew my eye. To tackle the glare on her nose, I switched my Brush mode to Darken and used the same source and eroded away the highlight using those "little circles" and opacity changes as needed. While I had the brush on Darken, I used it to dab out any light spots around her nose and lips that popped out at me.

6. Next, I wanted to tone down the redness on her chin. I switched my Brush mode again, this time choosing Color. I used the same sources and filled in all the red on her chin. The next job on the agenda was to get rid of those pores and even out the skin texture. Starting with the dark spots first, I went back to Lighten mode, dabbed my brush over all the dark spots on her chin and around her lips, and adjusted the brush opacities from 60–100% to help the areas blend with the image.

Tip

Varying the blending mode of your paint-brushes gives you almost unlimited control and variety over your effects. Using a different layer for each change gives you more control and more room for error.

7. Her cheeks were still a bit blotchy for my liking. Starting with the right cheek, I changed my Brush mode to Multiply and selected an area just below the right cheek as my source. I brushed in small circles in the areas where the tone and texture didn't quite match to blend them together. The Multiply mode brings out the darker values in the light spots and evens the skin tone. For the left cheek I switched my Brush mode to Screen and used a spot lower down on the left cheek as my source. The Screen mode works the opposite way from the Multiply mode, bringing up the lighter tones in dark areas.

8. To smooth out the pixels and lines around the lips, I switched my Brush mode to Luminosity and chose a spot on the lips as my source. Then I dabbed around the perimeter of the lips, switching opacities as needed, to blend them with the skin around them. Next, I switched back to Normal mode and, using the same source, blended the color and pixels within the lips.

9. Now that the fine-tuning was done, I duplicated my working copy and named the new layer, fluff. In a separate file, I took a separate image of her skin and added a sepia tone (Actions > Sepia Tone). I selected a large, evenly toned piece of skin from this image and pasted in a new layer above my fluff layer. I used this as the source for my Healing Brush. Working on the fluff layer, I brushed over her entire face with a large soft Healing Brush set at 60–70% opacity. I decreased the brush size for more detailed areas, like around the eyes. Think of it as covering the face with make-up powder. The effect was soft and smudged and "alien-like."

10. Making sure the fluff layer was above my working copy, I adjusted the opacity of the fluff layer to let enough of the working copy through to show depth and texture, but allowing the fluff layer to even out the tone and soften her features. I hid all layers but these two, then merged the fluff layer and working copy.

Tip

Save files periodically with different names (image01.psd, image02.psd) as you're working on them using File > Save As. This is especially helpful before you merge layers, as you have a backup copy of the file in its previously layered state.

11. With my image nearing completion, it was time to adjust the overall color tone of her face. I chose Image > Adjustments > Color Balance to adjust the tonal range. In this example, I lowered the midtones and shadows and increased the highlights slightly to lessen the shadows and brighten her face.

Note

Remember, it's the fiddling with small areas, attention to detail, and changes in opacity that make the difference between a smudged mess and a great image. So have fun and go out and experiment with the wonders of the Healing Brush!

Dodge and Burn

Photographers have regulated exposures of images to adjust their light and dark tones. Photoshop gives you the Dodge and Burn tools to do the same job. The Dodge tool lightens areas of an image, and the Burn tool darkens areas. Here's a quick technique to adjust tones of a photograph without changing one pixel of the original image.

"Dodge and Burn"—Greg Schnitzer—Image Source: Bianca de Blok—stock.xchng—www.sxc.hu

1. I wanted to enhance the light dynamics of this picture so that the light/dark areas popped out a bit more, but I didn't want to do the Dodge and Burn on the image itself, because I wanted to be able to undo any part of it at any time.

2. I used the Dodge and Burn tools with a soft-edged brush set to 100 pixel size and exposure for both tools set at 18%, as a little bit goes a long way. The Burn tool was set for Shadows and the Dodge tool was set for Highlights. Because I did this on a separate layer and not on the image itself, I held down the Alt/Option key while clicking on the New Layer icon at the bottom of the Layers Palette. A box opened in which I selected Overlay mode, and as soon as that was chosen, an option to fill the layer with 50% neutral gray was offered. I checked that box, too. With the new layer selected, I started burning the shadow areas around the links and dodging the highlight areas. Turning off the original image, which was now the background layer, showed my Dodge and Burn layer to look like this.

3. Then came the fun part. If I don't like any of the shading that I've done I can turn off the background layer so that I can see exactly what has been done on the gray layer. To remove or undo any of the shading, I need only paint over the unwanted part with a bit of gray sampled from the gray layer! Turning the gray layer off and on will allow me to do an A–B comparison of the two.

Displacement

Just pasting a pretty picture over a particular texture won't give you the realistic results you're after. With the Displace filter you can overlay a design or text on an irregular surface (such as the gift bag in this example) giving the illusion that it was printed onto the object. The pixels of the displaced layer shift in one direction for highlights and the opposite direction for shadows in the displacement map layer. The angle and amount of pixel movement depends on the intensity of the lights and darks.

"Holiday Gift Bag"—Mike Brucato—Image Sources: "Christmas Surprise" bag image—Ronald Bloom © istockphoto.com/Red Barn Studio—"Christmas quilt/ pattern"—Lisa Trick © istockphoto.com/Lisa Trick—www.istockphoto.com

1. My brown paper gift bag was a little boring as is, so I thought I would make it a little more festive by adding a colorful seasonal design and maybe a little text. I first selected the entire gift bag with the Magnetic Lasso tool with a 2-pixel feather and subtracted the bow from the selection. I saved this selection to use later for cropping.

2. I first had to create a displacement map with good highlights and shadows. I duplicated the background layer and increased the contrast a little using Levels. I moved the outermost Levels sliders slightly inwards until the highlights and shadows of the bag were increased. I then applied just enough Gaussian Blur to the layer to reduce the surface texture of the bag. (This is important with highly textured surfaces.) I then saved the image and called it map.psd. After saving, I made this layer invisible, since it was only used for the creation of the displacement map and not for the final image.

3. Next, I found a colorful holiday gift paper design and pasted it over the bag and turned the opacity of the layer to about 70%. Using Rotate and Distort, I moved the design into the proper position over the bag. Since I was using Photoshop CS2, I also took advantage of the Warp function to bend the paper to the general contour of the bag. I allowed the paper to overlap a little since I would crop it later.

4. On the holiday gift paper layer, I applied the Distort > Displace Filter and selected 10 for the Vertical and Horizontal Scale values. I checked Stretch to Fit for the Displacement Map and Wrap Around for the Undefined Areas. In the next window I opened the displacement map file I created in Step 2 (map.psd) and the holiday gift paper distorted nicely to the folds and creases of the gift bag.

5. I loaded the selection that I made in Step 3, inverted it, and pressed delete to crop the paper around the bag and bow. I then changed the Layer blend mode from Normal to Overlay to set the design on the paper. (I also tried Multiply and Hard Light but I liked the Overlay mode the best in this case.)

6. Next I typed a holiday message and rasterized this text layer so that I was able to position it on my gift bag using the Transform tools and distort it with the Displacement filter. I applied the same techniques to the text as I did with the gift paper and selected Overlay for the layer's blending mode. I was now ready to put this one under the tree and wrap up another one.

Cloning

"Autopilot Motorbike"—Joan Charmant—Image Sources: "Stunting" by Don Wilke
© istockphoto.com/Don Wilke—www.istockphoto.com and Dmytro Doblevych—
stock.xchng—www.sxc.hu

As of this printing, the United States Supreme Court has not ruled on the legality of using Photoshop's Clone Stamp tool. It's possible they don't know it exists, and we'd like to keep it that way. It's an invaluable tool in your photo manipulation arsenal. Using the Clone Stamp tool is like painting with the image, giving you control over the brush size and opacity. By holding down the Alt/Command key, you select the area of the original image that you're going to clone. The best part of mastering the Clone Stamp tool is how your friends will start thinking you just "erased" someone out of the image, letting the background show through.

1. I started by looking at the overall image and the different types of features to reconstruct in order to totally remove the stuntman. I identified monochrome planes, straight lines, gradients, and complex detailed parts. I created a new layer, since everything can and should be done without altering the original. I always kept the Use All Layers option of the Clone Stamp active. I started by looking for the easiest part: planes and lines hidden behind the subject.

For this, I used a hard Clone Stamp—very small, at full opacity. I toggled on the Aligned option and left it that way for all the work. I targeted an area containing the line. At that point I zoomed at the maximum that allowed me to see both the origin and goal targets. I started applying the cloning stamp just before where the stuntman covered that same line. Using a line can help retain accuracy.

2. I went on, without changing the source target of the Clone Stamp, and covered the chest, leaving in the motorbike shape. When some cloning duplication patterns occurred, I changed the source target and covered those with the appropriate color.

3. Using the same technique, I cloned out the lower leg, taking care to perfectly match the bricks' lining. The initial stamp is crucial here. There was some trial and error before getting a perfect fit, but once it's accurate, the rest goes effortlessly. It's convenient to zoom and unzoom often; it will not alter the Clone Stamp source.

4. For the head and the other leg, I didn't clone right away since there was no area to use as a direct source. I selected an area containing roughly the information needed, and pasted it in place before starting any cloning work. To do the window, for example, I copied the one you can see at the left of the picture. It had some leaves left on it. I cleaned them up by using a very small stamp, using sources within the window itself where there was no foliage. Using that same technique, I re-created the window behind the leg. I copied the window seen on the left and flipped it horizontally before cleaning it. To perfectly blend the borders of a "pasted area," I used the Clone tool at a low opacity. I took a bigger stamp, and at 20% opacity, smoothed the transitions between the original background and the additions with successive light touches.

5. Then I went on to the most difficult part, where the motorcycle is hidden by the leg. I located a reference picture of a motorbike similar to the one I was reconstructing. Once I found a picture of roughly the same angle of view, I copied the relevant part into a new layer. I placed it close to the area I was cloning and used it as my Clone Stamp source. I applied the same technique for the hand on the handle.

6. The details integrated were not of the exact same color, so I tweaked the layer's adjustments to get the same hue. I went on with smaller details, using a small, hard Stamp, lengthening lines and structures until they fit in the original. It's often required to draw over the original data in order to comply with the newly integrated layer.

7. Using bricks from the main source picture, I covered the parts of the new details that weren't needed, allowing you to "see through" the mechanics. I also removed the tip of the shoe, using a slightly bigger Stamp at a lowered opacity and dragged color from the nearby yellow area. This was done by selecting a source to clone very close to the final target and Stamping with very light touches. Varying opacity and brush shape often not only allows you to make exact clone areas, but lessens the chance of ending up with obvious repeated patterns.

8. I then removed the shadows cast by the stuntman. On each side of a shadow, the color is generally not the same. I needed to make it transition gradually from one to the other. To do that I used a big Stamp at low opacity and started drawing over the shadow by light touches, as I just did for the shoe.

9. The big yellow area above the seat was done more by hand with the Brush tool. I started by covering it all with the main bold yellow using a hard brush. Then, using different shades and low opacity brushes, I re-created the shading. I used the Clone tool to smooth the transition between the drawn part and the original one. With a big Clone Stamp at low opacity, I dragged the original color toward the new one.

10. To finish up the job, I added a strong shadow between the seat and the newly drawn part. I tried to spot any hard color transition areas that should be softened or any missed spots or unaligned features, and corrected them.

How "Not" to Faceswap

"Lois and Marlon"—Robert Whalen—Image Sources: "Stripey 4" image by Phil Date © istockphoto.com/Phil Date and "Distasteful" image by Amanda Rohde © istockphoto.com/Amanda Rohde—www.istockphoto.com

The following are some observations I have made regarding the art of "faceswapping," a skill that is used primarily in "ModRen" and mating type edits. A seamless faceswap should give a viewer the uncomfortable feeling of "Oh jeez! He's so pretty!" or "Oh jeez, she's hideous!" instead of, "Oh jeez! It's a mutant!" The key to a quality image is recognition of the subject. Recognition relies on the proper matching of your source images, using correct alignment, scaling, and masking.

1. Here are my two source images, we'll call them Lois and Marlon. Notice that the head angle is already close, and unless you are dealing with subjects that only have a few good images, I see no reason to make more work for yourself trying to tweak the images to make the angle look right.

2. This is what I would consider a decent match. The position and scale of the face are appropriate for the underlying head.

3. **Bigface.** The face is just too large for the head. To make it fit, the cheeks and chin of the face were masked out, and to some extent the face became unrecognizable as Marlon. When adjusting the face size, I set the transparency of the face to about 50%. At 50% transparency it is possible to compare the face scale to the face on the underlying head. I used the eyes and jawline as a guide for scale.

4. **Benthead.** My example is a little extreme, but you get the point. The head is pointing in one direction, and the face another. When positioning the face, look at the head. If you can only see one ear, this is the side of the nose you should see. It is a simple task to mirror the face or the head to match the angle. A word of advice about benthead images—avoid using base source images that have the head at odd angles relative to the body. It is guaranteed that even with the best blending, the resulting image will look odd when you are done.

5. **Mutantface.** Again, to improve recognition, I don't advise mixing and matching eyes, nose, and mouth. It's all or nothing. As in my example, the subjects are unrecognizable.

6. **ET head**. This is when the face is scaled correctly, the head angle is correct, but the face is sitting too far forward on the head. Kinda like ET. If you find yourself doing a lot of cloning between the ears and eyes, there is a good chance you are going to end up with an ET head. I set the face transparency to 50% and used the eyes and jawline as a guide to align the images.

Dripping Candles

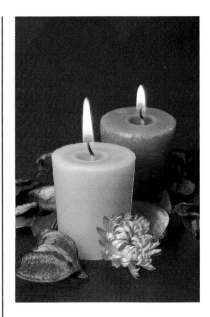

"Candle Drips"—Brent Koby—Image Source: "Candles and Potpourri" by Sang Nguyen © istockphoto.com/Sang Nguyen—istockphoto.com

This is a wonderful technique for "melting" an image. Using only two simple tools (the Smudge tool and the Brush tool) you can create a totally realistic melting effect. Though candles will melt perfectly fine on their own, it's a great image on which to practice this technique. Soon you'll be melting everything, from the furniture, to your neighbor's dog, even your boss. Though only in pictures, okay?

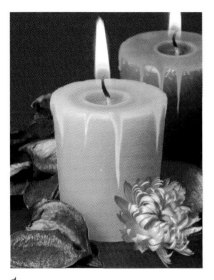

1. First I selected the Smudge tool set in Normal mode with a strength of 80%. Then I clicked on an area around the top of the candle and dragged down with the tool in areas where I wanted my drips to be.

2. Next, I zoomed in and added "blobs" to the end of the drips simply by dragging and drawing with the Smudge tool, using the same settings as per Step 1. They were starting to take on the shape I was after.

3. I then took the Smudge tool and smudged paths from the candle's wick base (the darker, melted areas) to the "drips" to help give the candle a more melted effect.

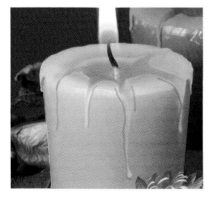

4. Next, I added shadows around the "drips" to help make them stand out against the rest of the candle. I did this simply by roughly drawing in areas where I wanted my shadows to be, using the Brush tool with a foreground color set to a slightly darker shade from the original candle's hue.

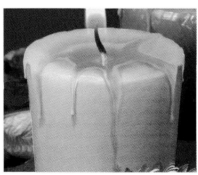

5. Using the Smudge tool set to 50% strength, I pulled and smoothed out the brush strokes to create a more natural and more blended looking shadow.

6. To add highlights, I did the exact same thing as in Step 5, and using white as my foreground color, painted light strokes opposite from where I added the shadows. Just as I did with the shadows, I smudged and blurred the highlights using the Smudge tool still set to 50%.

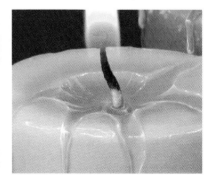

7. Finally, I added some finishing touches to the image. I decided to add more highlights around the base of the wick to give the area more dimension. I did this in the same manner as in Step 6 by taking the Brush tool and adding in basic white highlights; then using the Smudge tool (set at 70% strength), I smudged in the highlights.

Rendering Techniques: Water Droplet

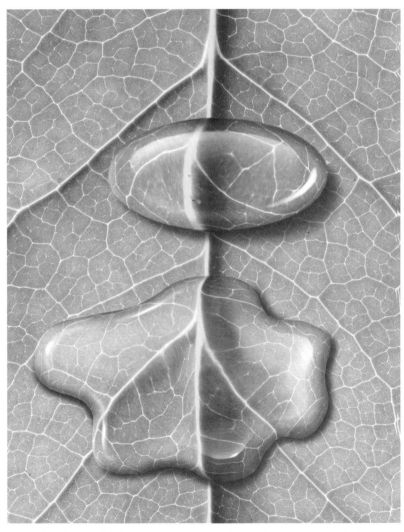

"Water Droplet"—Bob Schneider—Image Source: "Green Leaf" by Frank Tschakert
© istockphoto.com/Frank Tschakert—www.istockphoto.com

There are plenty of third-party filters out there that will create "realistic" water droplet effects for your images. But the technique is so simple and so adjustable, it's a good idea to learn the skill behind this useful effect. You can use these skills to show the aftermath of a rain shower, milk spill, or even a bloodbath. All without installing a single plug-in.

1. This original image of a leaf was chosen because of its obvious texture. It will make the first few steps clearer than using a leaf with a more subtle design. I created two droplets with different shapes. The first step was to create selections for each droplet. On the upper, traditionally shaped drop, I used the Elliptical Marquee tool. On the lower shape, I used Quick Mask and inverted it.

2. I added shadows at this point so the shapes were clear. To create the shadows, I used a dark green/black color and with a very soft brush at 10% opacity, I softly stroked on the interior shadows. I used a medium dark tone on the upper and lower interior areas. Then, inverting the selections, I added a darker cast shadow below both. I used the same brush, color, and opacity. I like building up the density for best control of the effect. Making the cast shadow darker than the shadow side of the drops gives an illusion of a lighter reflection on the water.

3. Reversing the selection again to contain the droplets, I selected Filter > Distort > Spherize to create the magnified effect droplets have. This process didn't give me the full effect I wanted so I followed up with Filter > Liquify, using various sized brushes to manipulate the leaf pattern to a greater magnified effect. With the smaller liquify brushes, I worked all of the edge texture into curves that would relate to the thickness of the droplet and the likely curve necessary on each.

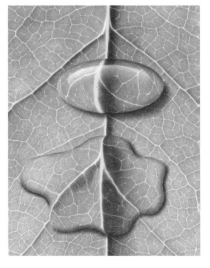

4. To create a highlight on the upper drop, I used the Elliptical Marquee tool, and with a soft-edged brush at 10% opacity, I brushed in the highlight adding more white to the left side since that is the direction of the light. This step could also be done with the Gradient tool, but being a control freak, I prefer the brush approach. I also added a slight light reflection on the left side of the drop.

5. To finish the upper droplet, I brushed on a soft highlight just above the lower edge and a strong sharper highlight on the right side. I created the sharp highlight by brushing on a spot of 80% white and using the Smudge tool to push and pull it into shape. On the lower droplet, I brushed on a soft area of reflection as a start. I finished the lower droplet by brushing on strong spots of white and shaping them with a soft-edged Smudge tool at 40%.

Changing Colors

"Freak of Nature"—Alison Huff—Image Source: Gloria Freeze—wetcanvas.com

A rose by any other name smells just as sweet. But what about any other color? Or many colors? In this example we'll show you how to take an ordinary rose and make it a spectacular freak of nature using simple selections and color adjustments. The result is so beautiful that even Mother Nature will have wished she'd bought this book.

1. I figured that it'd be easiest to start in the center and work my way outward, so I made my first selection using the Lasso tool. Since there are usually several ways to achieve the same desired results when working on an image in Photoshop, I chose just one method to focus on through this tutorial. Some methods often work better on different types of images, so it's a good idea to familiarize yourself with as many as you can.

2. Opening up the Selective Color dialog box (Image > Adjustments > Selective Color), I was able to adjust each of the various colors separately. I adjusted both the red and yellow tones using the available sliders until I was happy with the resulting color. Since I would be selecting several different areas in order to alter the colors of each layer of the flower's petals, I saved each selection as I went along (Select > Save Selection when an area is selected), in case I needed to re-adjust any of them later.

3. To do the next group of petals, I first created my selection around the petals that I wanted to turn orange. But wait... that selected the portion that I already turned red, too! Not to worry, I simply went back to Select > Load Selection, where I was able to choose my saved selection of red petals and Subtract it from the current selection. I used this handy trick to complete each of the following sets of petals by subtracting the selection(s) of petals that came before it. When everything was colored, I tweaked the saturations and hues of everything just a little bit more, using the Hue/Saturation (Image > Adjustments > Hue/Saturation) until I was satisfied with the appearance of the flower.

4. The final step was simply softening some of the sharper edges between the colors with a light-pressure Blur tool.

Selective Desaturation

"Pink Gumball"—Tracey Somo—Image Source: Tracey Somo

"Elisabeth's Angel"—Megan Harmon—Image Source:
"Angel Kneeling on a Grave" by Philipp Baer
© istockphoto.com/Philipp Baer—www.istockphoto.com

Highlighting one subject of an image is as easy as Select > Desaturate. In this combination of techniques, you can see that letting the background fall behind by removing color can really make your main subject pop.

Note

Change the mode of the layer set to Normal so that any adjustment layers in that set apply only to that set.

I added a Hue/Saturation layer in the layer set, right above the background gumballs. Then I moved the Saturation bar all the way to the left, desaturating the background and leaving the pink gumball pink. Using Image > Adjustments > Desaturate on this layer would also work.

1. While the pink gumball in this image stands out well, I wanted it to really pop out. So, I used Selective Desaturation to achieve that. I selected the pink gumball using the Pen tool. The path from the Pen tool leaves a smoother edge than other selection tools.

2. I inverted the selection so that the rest of the image—not the pink gumball—was selected. I copied the selection onto a new layer (Layer > New > New Via Copy) and put that layer in its own layer set.

3. I chose this picture because of the simple, strong lines of the angel... and I'm a sucker for gothic graveyard scenes. I made a copy of the background layer, and all the work I was doing would be on this layer.

4. Using the Polygonal Lasso tool, I drew a selection around the angel and feathered it by 5 pixels.

5. I inverted the selection, then desaturated (Image > Adjustments > Desaturate) the area around the angel.

6. I then adjusted the levels, brightness, and contrast as I saw fit. Keep in mind that the brightness and contrast should be no more than +15 for most pictures. After adjusting the desaturated area, I once again inverted the selection, bringing the focus back onto the angel. I upped the saturation (to +13 to really bring the angel out), and then adjusted the curves slightly, but only for the green and blue—again this was to make the angel stand out. When I was satisfied with the end result, I selected the Polygon Lasso tool, clicked once on the picture to deselect the angel, and admired my handiwork.

Colorization 1

Turning old black and white photos into full color keepsakes is great fun and very easy in Photoshop. In this tutorial we'll use only layer masks and the Hue/Saturation tool to achieve the final product. Practice these steps and you'll dazzle your friends with fantastic, Technicolor images that would make Ted Turner proud.

"Colorization"—Dorie Pigut—Image Source: Dorie Pigut

1. I made a copy of the original using Layer > Duplicate Layer. Then I set the Layer mode to Color. I then colorized the layer a pink color for the shirt by selecting Image > Adjustments > Hue/Saturation to open the Hue/Sat dialog box. I clicked the Colorize box, moved the Saturation slider to 51, and the Hue slider to 331.

2. Now I needed to mask the pink layer to show just the shirt portion. I selected Layer >Add Layer Mask > Hide All. Then I used the Brush tool with the foreground color set to white and painted over the shirt to reveal the pink over the shirt area.

3. A successful colorization mimics real vision, and that means color variety. Every major part of a colorization should have at least two colors blended to help achieve the illusion of real-life color. I repeated step one, copied the original layer, set the Layer mode to color, opened the Hue/Sat dialog box, clicked the Colorize box, and upped the saturation to 50. This time I moved the Hue slider until I found a nice purple color; then I clicked OK. I moved the new purple layer on top of the pink layer and added a layer mask, hiding all. Then I used my Airbrush tool set to 10% opacity and my foreground color to white. I lightly airbrushed over the shirt to reveal some of the purple. I wasn't too exact about my airbrushing and some places had more purple revealed than others. The result mimics real life and the shirt looks like it's been through the wash a couple of times.

4. Repeating steps 1 and 2, I created a gold layer as the base for the skin.

5. I repeated step 3, only this time I made a red layer for variety for the skin. I lightly airbrushed the red layer's mask over the skin, letting more red show through around the cheeks, eyes, fingertips, palm, and places that were in shadow, like the inner parts of the arms.

6. I continued repeating steps 1–3 on the rest of the image. Notice that the greenery in the background has yellows and greens and even some blue spots to mimic the reflection of the sky showing through.

7. Now that my coloring was done, I did last minute color correction using a Levels adjustment layer—Layer > New > Adjustment Layer > Levels. I used the adjustment layer to tone down the red a little and to lighten the overall image.

8. WRONG! This last image is to show you the wrong way to colorize an image. I only used one color on each area of the image. The overall effect is very strange looking and artificial. By varying your colors on each area, you achieve a much more vibrant and realistic colorization.

Colorization 2

"Gene Tierney"—Maggie Brouillette—Image Source: Gene Tierney—www.doctormacro.com

There are many different methods of colorizing black and white images. My method is not very difficult, just demands a bit of time and patience, but, all in all, is very easy. I've chosen this wonderful b/w image of Gene Tierney, a beautiful classic movie actress, to colorize.

1. I chose a black and white image that is clear and of as high a resolution as possible for the best results. If your image is grayscale, change the mode to RGB (Image > Mode > RGB Color). I duplicated this layer and called it skintones. With a fairly large brush set to the Color blending mode, I chose a peachy tone for the skin color (I used R: 253, G: 221, B: 189). I then colored all parts of the skin. In this particular image, her skin shows through the transparent material of her blouse, so I colored those parts too.

2. I chose a lipstick color next, as it would define the color of the blush. Don't be afraid to use a bright lipstick color. With a medium soft brush, always in the Color blending mode (I set my color to R: 178, G: 15, B: 44), I colored in her lips. Next I chose a large and soft brush and set the flow rate to 25% and very softly colored the cheeks, sides of the brows, the nostrils, and along the neck. These are places that blood naturally flows closer to the surface. I selected Image > Adjustments > Hue/Saturation and fiddled with the sliders to make the skin tone as natural as possible.

3. To make the shadow natural looking, I wanted a taupe-like color, but taupe on its own is very flat. So I gave it more depth by using more than one color. With a soft large brush, at 25% flow, I added a lavender color (R: 230, G: 207, B: 240) under the eyes.

4. With the Eyedropper, I picked the color of the surrounding skin tone and with the large brush still at a 25% flow rate, gently brushed over the lavender area. It pretty much covered it all, with a bit of lavender showing through. This allowed me to achieve a taupe color but with lots of depth.

5. I duplicated this layer and renamed it eyes. The eyes are very important. One of the biggest errors made when coloring is leaving the whites of the eyes or teeth uncolored, believing they are white, but they are not. Healthy tooth enamel is a very light cream and the whites of the eyes are very light blue. Zoomed in very close and with a small, soft brush set to about 50% flow, I used a light blue, almost white color (I chose R: 242, G: 243, B: 253). I colored the whites so they were no longer gray. Then it was time to pick an eye color. I chose a blue (R: 95, G: 117, B: 198). With a small, soft brush, I colored the iris. Then in Image > Adjustment > Hue/Saturation, I selected the blue channel and adjusted to my liking. Here I left the hue at 0, saturation at –10, and lightness at –20.

6. Then I used the Dodge tool with a very small, soft brush, set to about 25% exposure and the range set to highlights. I dodged some lightness into the bottom of the iris. Do not dodge the top of the iris where there is naturally shadow from the eyelid. Next, I lowered the exposure to about 12–15% and dodged the whites of the eyes very lightly to clearly define the shape of the eye.

7. The pinks in the corner of our eyes are a salmony color. With a small, soft brush set to Color mode and 50% flow, I colored this area of the eyes. (I used R: 255, G: 175, B: 151). Using the Dodge tool and a brush about 1/2 the size, I dodged the salmon color to make it look moist. Then I set the tool to Burn, exposure to 30%, and range to Shadows, and burned very gently around the contour of this area to define it. I was finished with the eyes and face.

8. I duplicated the eye layer and renamed it background. You can make the background any color you wish, but it is preferable to keep it subtle so that the focus stays on the person. I chose a very unobtrusive grayish-blue color (R:184, G: 184, B: 207).

9. I then duplicated the background layer and renamed it blouse. I chose a very similar blue color (R:199, G:199, B:219) as the background (try to not make the mix of colors too much of an Easter egg combination; the final does not necessarily have to be very colorful, just natural looking). With a medium soft brush set to 50%, I colored the entire blouse, even over all the areas where the skin would show through.

10. I clicked on the layer mask icon (square with circle at the bottom of the Layers Palette). Make sure your colors are black and white. Black will subtract and white will add back the color. Using a medium soft brush set to 10–12% flow, set to black, I pulled in the skin color into the zones where the blouse was transparent. If you pull in too much skin color, switch back to white to retrieve the blouse color.

11. I duplicated the blouse layer and renamed it hair. I turned off the visibility of the blouse layer; then, with a medium soft brush set to 80% flow, colored in the hair in a natural tone. Gene Tierney's hair is a dark brown. I chose a muddy brown color to start (R: 60, G: 39, B: 25). Next, I brushed in some warmer tones to give her hair vitality and life. With a small, soft brush set to 50% flow, I brushed in warmer tones (R: 55, G: 99, B: 33). And again with a different warm tone, I brushed in more warm notes (R: 155, G: 79, B: 33). Using several warm hues but all approximately the same tone will give the hair color natural depth. Zooming in will help you see if any of the colored areas are bleeding into other areas. If so, choose a very tiny soft brush, and with your color picker, select the neighboring color and fix little details. That was easy wasn't it?

Simulating Cast Shadows

"Ocean View"—Mike Brucato—Image Sources: "Caribbean Beach" by Oleksandr Gumerov © istockphoto.com/Oleksandr Gumerov—"Wooden Easel" by Billy Lobo © istockphoto.com/Billy Lobo—www.istockphoto.com

While the ocean has provided inspiration to artists for centuries, it's the sun that shines light on the fruits of their labor. Producing believable shadows is more than just hitting Drop Shadow and saying "done!" It's about understanding the subtleties of light and dark and how they interact in shadow… like waves crashing on the shore.

1. I pasted my easel in a layer above the source image. Since I copied from a white background, I matted the layer using Layer > Matting > Defringe set on 2 pixels to remove the white border around the easel. To soften the hard edge, I used Select > Feather at 2 pixels. I adjusted the Gaussian Blur (Filter > Blur > Gaussian Blur), and lightened the midtone levels to match the outdoor lighting of the source image.

2. In a separate layer, I drew a canvas with the Rectangular Marquee tool and filled the selection with white. I transformed the perspective of the canvas with Edit > Transform > Distort and added a stapled edge to give it some depth. I copied the top canvas rail of the easel and pasted it to a new layer over the top part of my canvas. I distorted it slightly to correct for the perspective in the new location. I copied the bottom canvas rail and placed it above my canvas in its original location. I added drop shadow layers (Layer > Layer Style > Drop Shadow) behind both rails to set the canvas on the easel.

3. I now had to create one cast shadow for my easel, top rail, and canvas layers. I first had to merge the three separate layers together. Then, in the Layers window, I Control + clicked on the thumbnail picture of the new merged layer to select the outline of my canvas and easel. I created a new layer and filled the selection with a color sampled from the darkest sand. I then copied this new layer to the Clipboard. Then I undid my last three steps to get my separate layers back again. I pasted the contents of the Clipboard behind the three layers and set the blend mode to Multiply for my new shadow layer.

4. To create the shape of a cast shadow from the drop shadow, I used Edit > Transform > Distort. I dragged the handles of the selection to match up the shadow layer with the legs of the easel. The shadow now had the correct perspective, getting smaller as it moved farther away from the foreground. I applied a slight Gaussian Blur to the shadow to soften the edges.

5. As shadows move away from the foreground, they also tend to be lighter and more diffuse. To achieve this effect, I duplicated the shadow layer and applied a stronger Gaussian Blur to it. Then I added a mask layer and applied a black-to-white gradient, masking the bottom of the shadow near the legs and moving up towards the background in the angle of the shadow. I applied another black-to-transparent gradient from background to foreground to diffuse the furthest part of the shadow. This is what the blurred shadow layer looks like alone.

6. I applied a similar mask to the focused shadow layer. This time however, the black-to-white gradient mask went from top to bottom to reveal the dark shadow near the legs of the easel. I adjusted the fill and opacity of both shadow layers to get a smooth blend from foreground to background.

7. With a canvas and easel set up, and a view like this, I was inspired to create a painting. I copied a section of the background layer and distorted it to match the surface of the canvas. I applied a Smart Blur to simulate the texture of a painting. I added a shimmering overlay to the surface of the canvas, cloned some sand over the legs of the easel, and my masterpiece was completed.

Shady Techniques

"Sand Hydrant"—Jeff Birtcher—Image Sources: "Hydrant" by Jeff Birtcher—"Desert" by Tracey Somo

Shadows add realism and depth to image composites. But not just any shadow; it's important to mimic the existing shadows to get a good blend. Normally, the desert sun needs no help casting shadows, but when an unsuspecting fire hydrant invades the arid landscape, only a drop shadow layer style and some delicate transformations can incorporate it into the hostile environment.

1. Using basic masking techniques, I removed the hydrant from its original background and pasted it into a new layer above the desert photo.

2. The lighting on the side of the hydrant where shadows should be was too bright. I created a new blank layer and grouped it with the hydrant layer. Using the Brush tool, I painted with black, with the brush set to Multiply to darken the dark areas and repeated with white in the same way to lighten the lighter areas.

3. The first step in creating a shadow is to create a dark cutout of the shape in question. I used Layer > Layer Style > Drop Shadow to create a basic shadow, and selected Layer > Layer Style > Create Layer to edit it as a stand-alone layer of the composite.

4. Ignoring the lighting on the hydrant itself, I used the Edit > Transform Tools (Distort, Rotate, Skew, and Flip) to stretch and move the shadow to create several different variations for the object to illustrate what you can do with a single dropped shadow. Remember to look closely at the light and dark areas of your image to determine what direction the light is coming from. The shadow will naturally be on the opposite side. In this case, my light was coming in from the left, so my shadow should fall on the right side of the hydrant.

5. After creating my final shadow shape, I concentrated on the color and transparency. The blending mode for the shadow layer was set to Multiply by default, with an opacity of 75%, but I usually set the layer to a lower Fill level of around 60%. Use other shadows in the image to gauge what levels of opacity to use.

Day to Night

"Nighttime on West Beacon"—Jeff Birtcher—Image Source: Jeff Birtcher

Who wants to wait around for sunset to grab that perfect nighttime shot? Here, in just a few simple steps, you can take your boring daylight snapshots and give them a starry-night glow.

1. First, I needed to adjust the overall brightness and contrast (Image > Adjustments > Brightness and Contrast) of the image. In this step I changed both values to –70. This gives you a darker look without obscuring the subject of your picture.

2. Since night isn't truly black, I added some blue tones to the entire image. Using Color Balance (Image > Adjustments > Color Balance) and selecting Midtones, I increased the blue tone by +30.

3. Since I removed all the daylight, it was time to start adding the "night lights." Using a small feathered brush at a medium opacity, I added a small dab of light on the street lamp. For the halo effect, I increased the brush size while decreasing opacity until I achieved just the right glow.

4. I added some mood lighting to the windows, giving the illusion of lights on in the house. I zoomed in close to the windows and, using the same basic technique that I used with the street lamp, I added different intensities of yellow, completing each windowpane separately.

5. What's nighttime without stars? Using various sizes of soft brushes I gave the night sky a celestial feel. Be sure not to make the stars too bright, and don't cluster them together. Keep them subtle.

6. I toned down some bright spots by selecting the color of the bright section and using a soft brush with Darken as the brush type. I fine-tuned the image with brightness and contrast again (not too much) and ended up with a realistic nighttime "photo."

Reflections on Reflections

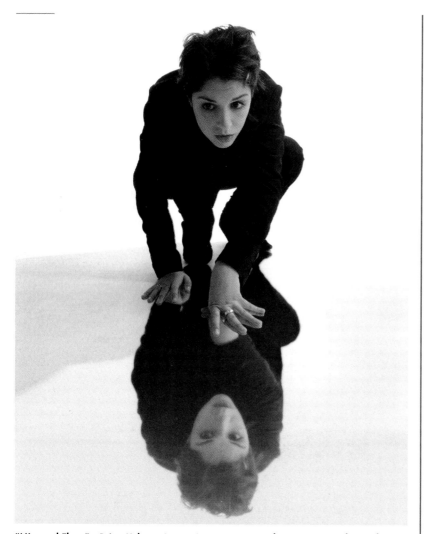

Creating a convincing reflection can often be a relatively straightforward process. But on some images, what at first seems like a simple transformation, as in creating the appearance of a mirrored floor beneath this crouching young woman, turns out to have its share of interesting complications.

"Mirrored Floor"—Brian Kelsey—Image Source: "Approaching Executive" by Paul Piebinga © istockphoto.com/Paul Piebinga—www.istockphoto.com

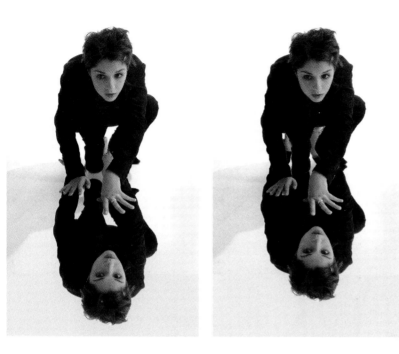

1. I drew a selection around the image of the young woman, then copied and pasted that selection onto a new layer. I flipped the image vertically and aligned it below her image on the background. Immediately it became apparent that I had my work cut out for me. The image simply did not line up to create the illusion of a reflection. But that could be fixed.

2. The problem is that there are four different planes of depth in the image, and each one had to be considered separately in order to create a believable reflection. These four planes are defined by each point of contact the young woman makes with the floor: by her foot, knee, right hand, and left hand. Each of these contact points needed its own layer, so I created four identical reflection layers and named them foot, knee, right hand, and left hand. I hid all the reflection layers except foot, and I aligned it precisely with the foot in the background image.

3. Next, I turned off the foot layer and did the same thing for the knee reflection layer, aligning it with the knee in the background image. Pretty simple so far, but now things are going to get a little trickier.

4. The foot and knee layers are easy to align, but the same process isn't going to work with the hands. Because we are looking down slightly at the woman's hands, the reflected fingers will be mostly hidden behind the background image. To compensate for this, I started with the right hand layer and aligned the wrists of the reflected right hand with its counterpart in the background layer, then erased the fingers where they would be hidden behind the background image.

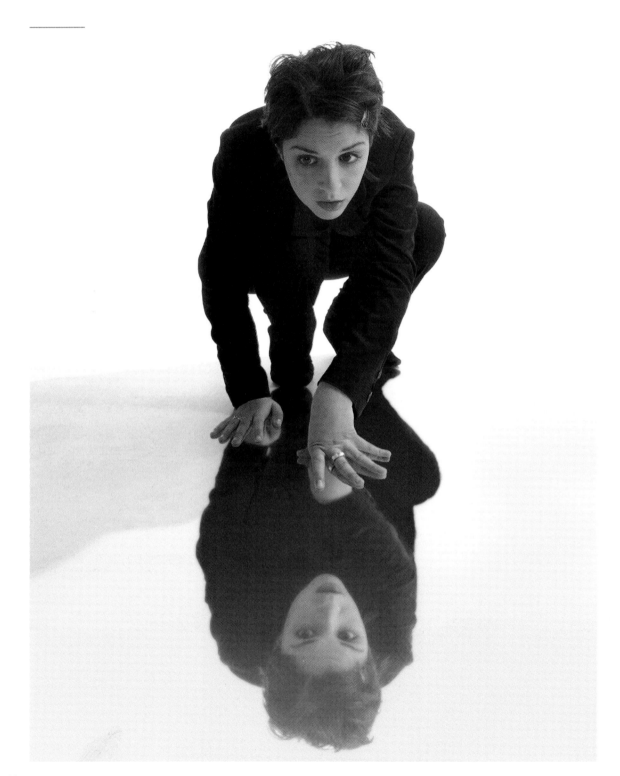

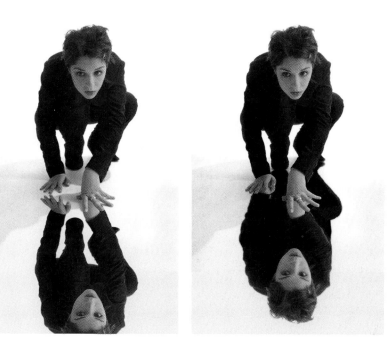

5. I repeated the same process on the left hand layer, aligning the wrists and erasing the reflected fingers where they would be hidden behind the background image. I now had four reflection layers, all properly aligned for their own plane of depth, but if I turned them all on, I'd have a real mess. So it was time to get out the Eraser.

6. I carefully erased the elements of each reflection layer that intruded into the plane of depth of the layer above it. I erased and blended the images into each other until I had one seamless image. I finished by merging all the reflection layers down into one layer.

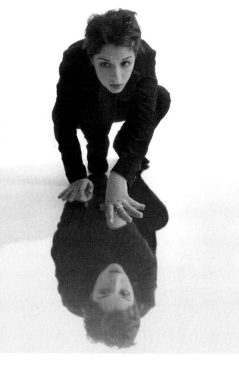

7. I used the Clone tool to create the small but important reflections of the fingers just beneath the hands. I then softened the mirror-like reflection a bit, so that it appeared our young woman was crouching on a highly polished floor instead of a mirror. I selected the reflection layer and used Filter > Gaussian Blur at around 1 pixel. To further soften the reflection, I chose Image > Adjustments > Hue/Saturation and decreased both the saturation by 20% and the contrast by 30%. I applied a Gradient Fill Layer Mask onto the reflection layer so that the image gradually faded with distance, a natural property of a reflection in a polished surface.

Trapped in Glass

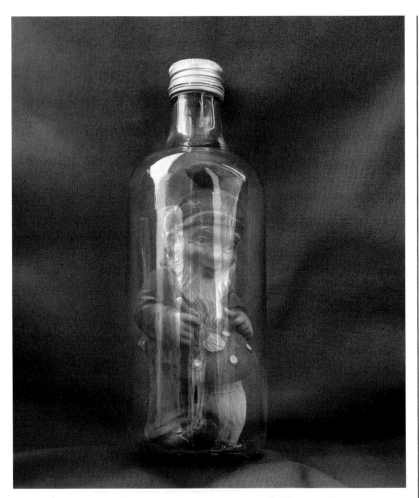

"Trapped Gnome"—Anders Jensen—Image Sources: "Bottle" by Jennie Pettersson—
"Gnome" by Dria Peterson—stock.xchng—www.sxc.hu

Genie in a bottle… message in a bottle… gnome in a bottle, the natural progression. But trapping things behind glass using Photoshop isn't just about transparencies and masking. For a truly photorealistic effect, you need to get the highlights just right. Photoshop's Blend If function is just the tool to get the job done.

1. I decided to put a little gnome inside the bottle (he kept wandering away). The first step was to remove the background from the gnome source image. I used a layer mask to mask out the background.

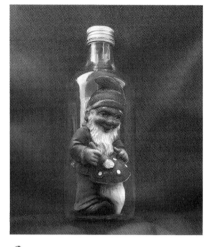

2. I placed the newly freed gnome over the bottle and using Edit > Transform > Scale, resized and positioned it as if it were standing on the bottom of the bottle. I then dramatically increased the contrast on my gnome. I wanted his color to really shine through the glass later on.

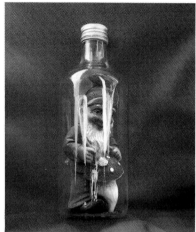

3. Now for the secret to getting the gnome in the bottle. I copied my bottle layer and moved it above the gnome layer. That left me with the bottle as the background and top layer, with the gnome layer in between. I double-clicked my bottle layer at the top to bring up the Layer Style dialog box. The Blend If section is located in the lower portion of the Advanced Blending controls. I adjusted the Blend If values for This Layer by clicking the black slider on the left and moving it to about 160. Only pixels on my bottle layer that were brighter than level 160 were now visible above the gnome.

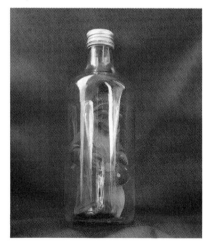

4. Using the Blend If function left me with edges that were very rough and jagged. I wanted a softer, more natural blend. To achieve this I used the Blend If sliders once again. I held down the Alt/Option key and clicked the left side of the black slider. I then separated it from the right half by dragging it all the way to the left. With the right half still at 160, I got a gradual blend between the pixels that were visible and those that were not.

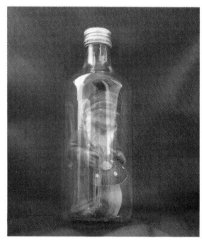

5. I wanted the gnome to shine through somewhat, even where the highlights were striking, so I lowered the opacity on my bottle layer to about 75%. As a final touch, I went over the bottle layer with the Dodge tool with range set to shadows and exposure to about 40%. With a big soft brush and repeated strokes, I dodged the areas were I felt the gnome was still shining through too much.

Exploring Photos and Effects

Now that you've gotten the basics down, it's time to unleash more of Photoshop's power. We'll introduce you to some tried and true techniques for enhancing your digital photographs. We'll also get you started on more intricate effects and illusions with Photoshop. The tutorials show you a variety of ideas, but with a tool as powerful as Photoshop, the only limit is your imagination.

Photo Editing 101

"Photo Editing 101"—Raymond Shay—Image Source: Raymond Shay

These are the basic steps in image enhancement. Almost every image you'll see in print will have had these basic steps performed. Granted, some images have had many, many more modifications done, yet these steps will be paramount in the mix. And these steps are early in the batting-order.

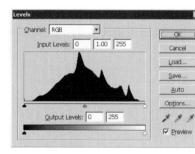

1. Here, we are going to explain to the computer what area of this image is black and what area of this image is white. You'll notice your color improve greatly as these points are defined. The color shift will lessen, the brightness of the image will be unveiled, and friends will like you better (results may vary). WE ARE NOT GOING TO MOVE THESE SLIDERS, as it's not usually needed. Here's how the big boys do it: First, click the Options button and tell the computer what you mean when you utter the word "black" or the word "white."

2. Clicking the black box next to Shadows brings up a color picker. Change the RBG value to R=12, G=12, and B=12. Then click OK. Good, I knew you could do it (all your friends were wrong). Now, let's define white. Just click the white box next to the Highlights and, in the color picker, change the RBG values to R=245, G=245, and B=245. Then click OK. TURN ON THE SAVE AS DEFAULTS! Remember, we only have to do this once. Then click OK. So, uh, what did we just do and why? Actually, we just redefined what black and white really are. We redefined black to be "almost black" and white to be "almost white." Why? Good question. In black, or in white, there's absolutely no detail. None. And those shades that are close to black or white are, by default, too extreme to contain any detail whatsoever either. So, we've set the extremes so that shades near black or white can now display detail.

3. **One-click wonder:** This next technique is a secret—an undocumented feature of Photoshop, so please don't tell anyone. With the Levels dialog box still open, place your mouse cursor on the little slider on the left side (I labeled that slider as black above), hold down the ALT key (yes, your picture will disappear), click and hold the mouse button, and slowly drag the slider to the right. You'll start seeing very small parts of the image reappear—STOP! Notice the location of the first black "glob" that appears. Release all the buttons you're holding down. The first little black glob that appeared is the darkest area of your photo. Now comes the first cool part, finally. Drag your slider back to its original position (all the way to the left). Click the little eyedropper on the left (it's supposed to look like a black eyedropper); finally, click the area of the image we determined as the darkest black "glob." WHOA!! Suddenly our image looks much better already! Oh, this is really cool...

First areas of BLACK.
Ignore any other color,
we're only looking for BLACK

Alt Drag RIGHT until BLACK appears.

Original image One click difference

4. Two-clicks to paradise: So, let's define white in the exact same fashion, using the slider on the right this time. We'll ALT + click the slider, slowly move it (drag) to the left until something reappears, return the slider, click on the right eyedropper (it's supposed to look like a white eyedropper), and finally click the white area on the image. A NOTE ABOUT CHOOSING WHITE: Some images may not contain white, so be happy with the improvement from setting only the black. Also, specular highlights, like the sparkle of a diamond or the shine of chrome, are not white. They are, for our purposes here, whiter than white. Don't use them as a white point.

First areas of white

Alt drag left until WHITE appears

Original image Two-click difference

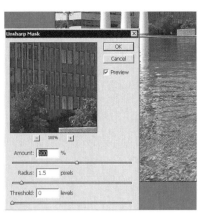

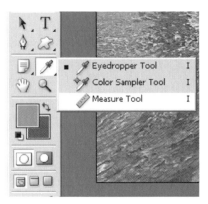

5. This step is MUCH simpler; we're just going to increase the color saturation a little bit. Color saturation is a cool term for the richness of the colors. Open the Hue/Saturation dialog box with Image > Adjustments > Hue/Saturation. Now, drag the middle slider to the right just a little. Usually a value between 4 and 15 is good. Too much and you've changed your image into a velvet painting of Elvis. Usually, between 8 and 15 are my choices. Click OK.

6. I own at least a hundred pounds of books and technical papers on sharpening. It seems it's the most written about topic in photo editing, yet *far* from the most important. Still, it needs to be done, so let's sharpen using some general settings and see what we think. We'll use Filter > Sharpen > Unsharp Mask. You'll see three sliders, Amount, Radius, and Threshold. I'll leave the descriptions of these to the Help button and just suggest a setting that's good for general sharpening. Amount = 100% to 130%, Radius = 1.0 to 1.5, Threshold = 0. Press OK. With sharpening, less is more; if you over sharpen, you'll create ghastly halos around all your dark edges.

7. This image looks just a little tilted to me, you? To straighten an image, I think best results are obtained when we can define a line on the image that should be either horizontal or vertical, and let the photo editor adjust the straightness from there. In Adobe image editors you'll find, hidden under the Eyedropper tool, a handy little gizmo called the Measure tool. Usually it's for measuring distances and angles, for text and stuff, but this little guy "talks" to the Rotate command. Let me show you.

8. Find a line on the image that should be horizontal (or vertical). With the Measure tool selected, click one side of the line, hold down the mouse button, move the mouse to the other side of the horizontal (or vertical) line, and release. In our example image, we've got choices, but the edge of the pool looks like it's level (or the water would be pouring out), so let's drag our Measure tool across there.

9. Go directly to Image > Rotate Canvas > Arbitrary. Wow! Notice that the exact angle for the tilt, which we determined with the Measure tool, is already inserted! Just click OK. Now, our image is straight. Just crop off the corners, and presto! We're straightened.

10. Okay, let's do a side-by-side—whaddaya think? After you get a grip on these steps, it will take literally only a couple of minutes to do, will greatly improve your images, and will increase your popularity with the opposite sex. Well, it'll improve your images anyway.

Before Photo Editing 101 After Photo Editing 101

Black and White with Hue/Saturation

Image > Mode > Grayscale is how most of us would go about turning our color photos into black and white. But the easiest way is not always the best way. In this quick photo trick, we'll take a brilliant color photo and in a few easy steps, turn it into a rich black and white image.

"Black and White Conversion"—Dan Cohen—Image Source: Dan Cohen

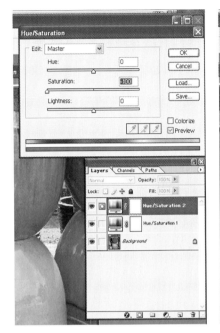

1. First I created a new Hue/Saturation adjustment layer. I didn't do anything with it at first; I just clicked OK. Next, I created an additional Hue/Saturation adjustment layer, but this time I moved the Saturation slider all the way to the left (−100). My image was now desaturated or grayscale. The problem was it looked flat, without a wide range of tones—basically just gray. To get a more dynamic and dramatic looking black and white image, there was one more step to take.

2. First I changed the Layer blend mode for the first adjustment layer (Hue/Saturation 1), to Color mode. Then I double-clicked on the layer to bring up the Hue/Saturation dialog box. By moving the Hue slider to the left or right, I altered and adjusted the tones to look the way I thought was best. Once I found the range I liked, I made small adjustments to tweak it even finer. I also adjusted the Saturation slider for more slight tweaks.

3. Finally, I added a little sharpening and a little levels adjustment, and voila!

Editable Noise

Here is a fun trick that I haven't seen anywhere else and, when described to him, caused my advanced Photoshop instructor to raise his eyebrows and say, "Show me." My goal here is to combine image elements from disparate sources and massage them into some sort of compatibility. Noise adjustment is one of the ways to achieve this.

"Editable Noise"—Gregg Schnitzer—Images Source: Murat Cokal—www.sxc.hu

1. Part of a train station ceiling and an art globe were on their own layers and gross adjustments to placement, color, brightness, and contrast had already been done. Now I wanted to add a bit of noise to the globe layer.

2. I added a layer right above the globe layer, filled it with 50% neutral gray, clipped that layer to the globe layer (Layer > Make Clipping Mask), and changed the Layer blend mode to Overlay. (The layer should look like this before changing the blend mode to Overlay.)

3. Tutorials seem to have a point in common where the fun starts. This is it! There are some obvious issues like different light angles, but I adjusted the noise before doing the light angles. I wanted the size of the noise components to be smaller, so I Free Transformed the clipped layer to a smaller size. I wanted the noise around the edge of the globe to wash out in the hit so I got a big fuzzy-edged brush and painted the edge with the gray I sampled earlier. The layer can be in Overlay or Normal mode for this part. Here it is in Normal mode with the edge of the noise feathered with gray.

4. Back to Overlay mode and I dropped the gray layer's opacity to about 75%. I had many options at this point as I could have used filters and change colors and… Well, you get the idea. This one was fun to play with, and as I went on to do the light angles, I used the same layer for some dodge and burn. There were more layers to be added and I could make a final decision on the noise levels at any time.

Removing Dust and Scratches

"Old Man"—Greg Schnitzer—Image Source: US National Oceanic and Atmospheric Administration

My goal is to fix the dust and scratch noise on this old photo without doing laborious cut and paste or using the clone tool. I want to maintain the clarity, focus and detail of certain image components (e.g., facial features) so using a filter won't work for this job.

1. First, I duplicated the layer, then I turned off the top layer. I then selected the bottom layer and applied the Dust and Scratch filter using a 10-pixel setting and threshold of 0. That took care of the spots I wanted to remove.

2. When I turned the top layer on again, I could have either simply erased the noise in the image or masked it out. I decided to use the Eraser with a brush that was no larger than I absolutely needed and feathered the edge to about 50%. If I had wanted to spend more time on the image or have more "undo" options, then I would have masked the artifacts out.

3. As always, there are many ways to skin a cat. This is just one, but it has its moments. A nifty twist on this was to use the Dust and Scratches filter on the top layer instead of the bottom layer. That way I got the super smooth texture over most of the image and masked in where I wanted the sharply focused parts such as eyes or hair or...

Sharpening with High Pass

This lovely seashell image was lacking only one thing—detail. Photoshop offers numerous ways to sharpen an image and bring out its hidden beauty. In this section we'll use the High Pass filter to give greater control to the finished image.

"Sharpening with the High Pass Filter"—Dan Cohen—Image Source: Dan Cohen

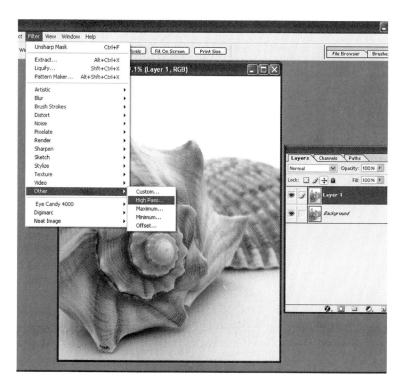

1. A softer method of sharpening that I find very effective is to use the High Pass filter. First, I created a duplicate layer. Then, I selected Filter > Other > High Pass. This brought up the dialog box and filled the image with a dirty gray fog.

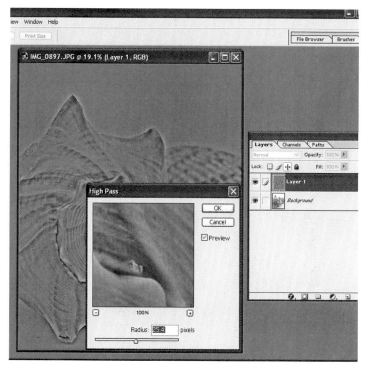

2. The radius slider control ranges from 0.1 to 250 pixels. I find that somewhere in the middle works for most purposes. Lower values are better for images with lots of detail and texture. This is a very flexible method and easily can be adjusted to taste.

3. After clicking OK, I changed the duplicate layer's blend mode to Soft Light. As if by magic, the fog lifted and a sharper image was created. By adjusting the opacity of this layer, more or less sharpening can be achieved. For a more intense sharpening effect, try the Overlay mode instead. You can also use Hard Light. Between adjusting the Radius slider and the Opacity slider, you have unlimited control at your fingertips!

4. Bonus Step: By choosing Image > Adjustments > Invert on the top layer, you can use this method to create a very nice "soft focus" effect, too!

Photo Restoration 1

"Photo Restoration"—Bob Schneider—Image Source: Jack Tanksley

Restoring old photos requires a bit of skill and a lot of patience, yet it's one of the most rewarding techniques you can learn. Bring history alive again using some of Photoshop's most basic tools.

1. I chose this image as an original because it's typical of many of old photos: a good image that's showing some aging, minor scratches, and lots of artifacts that need to be removed. Some old photos are in need of major repair work that might require replacing missing areas with pieces of other images. I haven't addressed that in this tutorial, but these techniques are useful in all restoration.

2. Photo restoration is generally a job that requires patience. You almost always need to work over the entire image, and usually, as in this case, most of it will be done in small steps. You can use the Healing Brush tool, but I prefer using the Brush tool, which mimics the conventional way of restoration: brushwork and airbrushing.

I began by working on the men. I used a small, soft brush set at 40 to 50% opacity, and with one finger on the Alt key, which toggles your tool to the Eyedropper, I began the process. With the Eyedropper, I picked up tone that was as close to the density I needed as possible. Usually that's just to the side of or above or below the actual area to be retouched. I brushed that on using multiple strokes because that gives a less obvious result than using a single stroke at 100% opacity. It's a much better blending technique. Both men were retouched this way, but this image shows only the finished work applied to the man on the left.

3. In this step, work was done on the truck. The larger areas involved afforded an opportunity to work a bit quicker. I masked the truck body area around the Fatima sign with Quick Mask, inverted it, and brushed in a medium tone picked up from that area at 100% opacity. On another layer, I used a large, soft brush at 10% opacity, black and added that tone to the lower portion of the selected area, building up the density gradually. I repeated this procedure using a light gray tone, again picked up from the truck body, and "airbrushed" that tone onto the upper area. All the areas on the truck large enough to be masked were done the same way. The cab's canvas top was also done in this fashion, with touch ups and accents finished with a small, soft brush at low opacity. I added some noise using Filter > Noise > Add Noise, about 3%, to match the grain in the original photo. This image also shows the retouching on both men.

4. The retouching on the Fatima sign is all freehand brushwork. On a separate layer, I used a hard-edged brush at 100% opacity and traced over the lines on the original. I picked up the line density from the original and adjusted the brush size to match the original type. I added another layer, put it below that one, and brushed in tones behind the new lines matching the existing densities. I selected Filter > Blur > Gaussian Blur for the type lines at 1 pixel, and added 3% of noise overall.

5. Work on the sample bag required some freehand rendering also. Using a small, soft brush at 20% opacity, I "airbrushed" over the spotted areas. I concentrated on just restoring the shapes that existed in the original and avoided adding anything new. It's important when restoring old photos to remain as faithful as possible to the original image. To begin simulation of the bag design, I created an oval shape on another layer, filled it with a light gray, and reduced the opacity of that layer to about 35%. I further lightened or darkened areas of the oval with the Burn and Dodge tools to have it conform to the bag wrinkles.

6. I was unable to find an example of the Fatima font, so I used one that seemed fairly close to restore the bag lettering. I used the Warped Text (Layer > Type > Warp Text) feature to shape the lettering and Transform > Scale and Transform > Skew to create the proper size and angles. Normally you might find an image of the proper cigarette package that could be placed in the image, but due to copyright constraints I decided to render in the pack. I rendered the package and added in some suggestions of the Fatima image. The type was added in the same way as described above.

7. This is the final result. The background was retouched using the same technique that was used on the men, a small, soft brush at about 40 or 50% opacity brushing over all the scratches and spots. Noise was added at about 3% to every area that was brushed to match the film grain.

Photo Restoration 2

In our second photo restoration tutorial, we get some quick relief using the Healing Brush tool (for practice, see the Healing Brush tutorial in the first chapter). With a portrait photograph, your subject may be much simpler than a group shot and the Healing Brush will give you just enough control to beautifully de-age a family heirloom.

"Granny's Fix"—Megan Harmon—Image Source: Megan Harmon

1. My first step was to use Image > Adjustments > Levels and Image > Adjustments > Curves to lighten the original image and show the details. As you can see, this photo has a sepia tone and was printed on very heavy paper, resulting in a stippling effect, which I wanted to keep. When restoring a photo, you want to keep it as accurate as possible.

2. I made a duplicate of the background layer. Then I chose the Healing Brush (hidden with the Patch tool and the Color Replacement tool). Keeping brush properties at Normal and Source as Sampled and selected Aligned, I started with the smallest brush possible, usually as wide as the scratch you are working on. Much bigger than this and the changes will be too noticeable. I started with the large crease on the nose.

3. I sampled (ALT + clicked) an area near the crease. Using small strokes, I ran the brush over the crease coming down the nose. If you see a noticeable line where you worked, sample from a slightly different area and go over a few different areas of the crease, always using small strokes. The larger the stroke, the more noticeable the result.

4. I continued on in this fashion throughout her face, hair, and dress. Some areas of a photo may work better with the Clone Stamp; again, use a very small brush and small strokes. Each picture is different, and it's up to you to decide what works best. The background and edges had some tricky spots, tears, and scratches that were too close to the edge to use either tool on, as I wanted to keep the exact oval shape of the original. My solution? The Circle Custom Shape tool, skewed to match the original shape, to create a perfect edge, and to hide any blemishes. Had this been a square or rectangular photograph, you could just crop, no need for any shapes.

5. Finally, to fix the faded area of the background to the left, I made a new layer, under the shape layer. I took a color sample from the right, and using a normal paintbrush set to 40% opacity, painted over the faded area. I didn't get too precise; instead, I painted in the largest area, then selected Filter > Blur > Gaussian Blur. I finished it off by adding in some noise, about 6.5%, and presto! Finished background, with the same texture.

Distortion and Perspective

"Distortion"—Ivo van der Ent—Image Sources: "Beautiful Girl Drinking Coffee 3" by Ralf Hettler © istockphoto.com/Ralf Hettler and "One IBM Plaza"" by konkrete © istockphoto.com/konkrete—www.istockphoto.com

*f*or truly realistic composites, using the Distortion feature of Photoshop's Transform tool gives you more control over straight Perspective. In a few steps you can start blanketing the world with shameless promotions and outrageous advertising, just like the big boys.

1. I created an image of a coffee ad using one of the source pictures. Then I copied it into the skyscraper image file. Because the ad was way too big to work with, I selected Edit > Transform > Scale to scale the image down to about the size of the building (holding down Shift while scaling maintains the ratio between width and height). It's important to start with a rather big source image when using the Distort command, to avoid loss of detail.

2. Before distorting I drew a quick grid on a separate layer to help me visualize the perspective. This is very helpful if the background has no grid of its own. In this case, the windows of the building provided me with all the information I needed to align my image properly.

3. The Distort command can be found in the Edit > Transform menu. Once activated it shows eight control points around the coffee ad. Moving a corner point enabled me to move the corners of the image around individually. Moving the center point on the side enabled me to move the entire side of the image. I dragged each corner point to its designated place on the building. It's important to keep moving the points around until you are completely satisfied with the result.

4. Applying the Distortion (pressing Enter) is the point of no return. If the distortion is not entirely correct, a second distortion is very difficult because the distorted image is not strictly rectangular anymore, making it harder to control. The best option would be to start over again with the rectangular image.

5. To finish off the image, I applied a drop shadow to the coffee ad, then used the Blur tool on parts of the image to match the partially blurred office building. Finally, I adjusted the brightness and color of the ad image to match the atmosphere of the background.

Tip

Use Ctrl + and Ctrl – to zoom in and out if necessary when in Transform mode.

Impossible Perspective

"Small Bananas"—Jeff Birtcher—Source Images: Jeff Birtcher

No pill or cream can replace good old diet and exercise. Eat less and you'll lose weight. We've taken that concept to a whole new level. Now, you can have the whole pot roast, or cake, or, as in the example, banana. Granted, it's an itty-bitty banana, but you can eat the WHOLE THING! Not convinced it will work? I suppose it depends on your perspective.

1. I masked out the banana from its background and pasted it above the hand image. I used Edit > Transform > Scale to scale down the banana amusingly small.

2. I added a layer mask to the banana layer and masked out areas of the fruit that the fingers would cover had they actually been holding it. I zoomed in close for detailed work to make the edges of the mask clean.

3. The shadows and highlights on the banana needed to match the hand a little better, so I added a layer, grouped it with the banana layer (so it would only affect the banana), and used a semi-transparent black brush to lightly add shadows and a semi-transparent, white brush to lightly add highlights. Painting this on a separate layer allowed for more control over the shading.

4. I added a shadow to the hand of the banana. I like to use the Layer > Layer Style > Drop Shadow option to get the basic shape of the shadow and then manipulate it as a new layer to fit it in. I softened the edges, distorted its shape slightly, and lowered the opacity to make it more realistic.

Tip

If you've added layer styles and want to manipulate each part of the style as a separate layer, right (command) click on the small "f" on the layer the styles are assigned to and select Create Layers.

5. I added a little bit of shadow on the banana from the thumb, to give depth to their spatial relationship. For this shadow, I created a new layer, painted a black strip overlapping the edge in question, and masked it until it was just barely visible.

Out of Bounds

With a few simple masks, a shadow or two, and an interesting source image, it's easy to take a flat picture and really make it "pop" out of its frame.

"Loose Lizard"—Heather Flyte—Image Source: "Iguana on Ruins" by Timo McIntosh
© istockphoto.com/Timo McIntosh—www.istockphoto.com

1. This image had just the type of focus I was looking for, sharp in very front and soft in the background. I chose Filter > Sharpen > Unsharp Mask and sharpened the head slightly to give it a little more focus.

2. Next, I selected the area for my border. I wanted to make sure that the head, part of the neck, and a bit of the right shoulder would overlap later. On a new layer, I selected Edit > Stroke and put a 50-pixel white stroke on my selection. The width of the stroke will depend on the resolution of the image, so adjust accordingly.

3. To add some perspective to the frame, I chose Edit > Transform > Perspective and adjusted the bounding box to give the illusion that the frame was coming forward.

4. Next, it was time to roughly mask out the overflowing background of the original photo. I added a layer mask (Layer > Add Layer Mask > Reveal All) and filled the areas I wanted to hide with black. I outlined the head, neck, and shoulder roughly since I would zoom in later for the fine details.

5. I zoomed in and selected a small paintbrush and filled in the mask close to the edge of the lizard. Paying attention to the smaller masking details can make a big difference in the final work.

6. Next, I added a layer mask to my frame layer and masked out the section where the lizard would overlap if he were actually coming out of the frame.

7. On a new layer below the image layer, I created a slight drop shadow for the border. I used the Polygon Lasso tool to select the shape within the border, filled it with black, used Filter > Blur > Gaussian Blur (set to 10 pixels) to soften the edges, and lowered the layer's opacity to 33%. I then moved the shadow layer slightly to the left to give the impression of light coming from the right.

8. I also wanted the head and neck to cast a shadow. I Ctrl (Cmd on Mac) + clicked the layer mask on the photo layer and deselected (Polygon tool while holding down Alt) all but the head and neck. With this selection active, I created another new layer, filled the selection with black, and followed the same steps for the shadow as before. I then combined my two shadow layers and adjusted them more to taste.

9. I could have left the border as plain white or added any number of effects to it. I could have added a slight bevel just to the white to give the illusion of a Polaroid Picture border, or added a gradient and bevel to give the impression of a more defined frame. The possibilities are endless.

Replacing Text

"Stop Staring"—Jeff Birtcher—Image Source: Jeff Birtcher

When I'm looking for a good sign to edit, I look for something with as many unique letters as possible. This may be one of the best signs I've ever found... 14/26 letters.

1. First, I copied the background to have a backup of the original layer. Using the Clone Stamp tool, I cloned the letters off of the face of the sign. I also wiped out the bullet holes and the balloon hanging off the post from some old party.

2. Next, I copied and pasted each individual letter to a new layer, keeping the letters I planned on using visible. I usually copy each letter, because they can come in handy when creating new letters, but in this picture, only the letters that will be used in the final image are visible.

3. Here I've used the G and the N to create an O and an M. I copied each letter and Edit > Transform > Flip Horizontaled the copy. I masked out portions of the letters to create new ones.

4. Next I arranged the letters into the phrase I'd chosen. Using Edit > Transform > Scale, I resized the letters to fill out the body of the sign better.

5. To give the overall picture some more depth, I tweaked various color adjustments (Image > Adjustments > Levels... Color Balance... and Brightness/Contrast). Not only does the darkened background help the sign stand out better, but adjusting the overall tone of the photo helps blend the cloned parts for a more even look.

Metal Text

**"Metal Text Effect Using Layer Styles"—
Raymond Mclean**

Bling, and dare I say, Bling. When you want to add some shine to ordinary words, look no further than the Layer Styles dialog box. In a few short steps you'll be adding shimmer and shine to ordinary flat text. Gold, silver, copper, the combinations are endless. And even if you're not sporting the Rolex and a "phat" wallet, your fonts can be pure gold.

1. I started by opening an eight by four inch 300-dpi file with a black background. With the Text tool I typed the word GOLD in white using a font that I liked and used Edit > Transform > Scale to scale the text to size.

2. The first stage for building the metallic layer style was to open the Layer Style dialog box and choose Bevel and Emboss. I used the following settings:

Style: Inner Bevel

Technique: Chisel Hard

Depth: 100%

Direction: UP

I set the Size to 25px, as this was where the highlights and shadows of the Inner Bevel met, and Soften was set to zero. I set the Angle for the lighting to 120 degrees and the Altitude to 30 degrees. I left the Highlights and Shadows at their default settings. I'm starting to get the depth I want in the text, but what about the shine?

3. Still in the Layer Style dialog box, I chose Ring for the Gloss Contour (a Photoshop default setting) and checked the Anti-aliased check box to keep things looking smooth. The Gloss Contour changed the highlights and shadows of the Bevel, giving me my first hint of a metallic surface.

4. I then chose to use the Contour setting, which is situated just under Bevel and Emboss. I used the default settings (Linear Contour, Range 50) and checked the Anti-aliased check box to keep the edges smooth. This added even more metallic shine to the bevel. Time for the color.

5. I chose the Color Overlay setting in the Layer Style dialog box and changed the color to a shade of orange (R-247, G-170, B-59). I left the blend mode set to Normal and the opacity at 100%. I chose a darker color than I wanted the final gold to be, because I was going to use the Satin setting to lighten certain areas of color.

6. For the Satin settings, I used white for the color and Screen for the blending mode and I set the opacity to 50%. I set the Angle to 19 degrees, and changed the Distance to 45px and the Size to 56px. I chose the Half-Round Contour and checked the Invert check box.

Using these settings for the Satin component of the style lightened some areas of the original orange color but left some of that original color intact, giving a more diverse color range for the final gold color.

Tip

Now that I had a new layer style I made sure to save it, so that I did not have to create it from scratch again. For the silver text I used the same settings but set the Color Overlay to 70% gray.

Try using different colors and blend modes for the Color Overlay settings to create different types of metal.

Easy 3D Text

"Tempus Fugit"—Heather Flyte

The first thing anyone does while trying out a new 3D rendering program is to "extrude" his or her name in three-dimensional space. Admit it, you've done it. Here's a quick and easy trick to give you the same effects without the expensive, memory hogging programs.

TEMPUS FUGIT

1. I started with a blank white canvas, then selected a readable font for the lettering. I tried to keep the letters spaced a little wider than if I were working with flat text; the dimension will take up a lot of the space in between the letters. Once I had a slogan and a font I liked, I rasterized (right-clicked on the layer and selected Rasterize Layer) the layer.

TEMPUS FUGIT

2. I then selected Layer > Layer Style > Bevel and Emboss. The only adjustment I would have made to these parameters would have been if I wanted to change the direction of my light source. In this case, I didn't, so I kept the default settings and clicked OK.

TEMPUS FUGIT

3. Next, I selected Edit > Transform > Perspective and pulled the left side out, as if the text were seen at an angle. This would heighten the effect of depth in the next step.

TEMPUS FUGIT

4. Next, I "extruded" the text into three dimensions. I simply duplicated my text layer repeatedly, keeping very little room between the layers. An easy way to achieve this is to select the text layer, hold the ALT key and then the arrow key in the direction of the extrusion, in this case, the right arrow key. This duplicated the layer and moved it one "notch" to the right. I continued duplicating until I achieved the depth I desired.

TEMPUS FUGIT

5. Ultimately I wanted the text to be readable, and with the ease of the "extrusion," it's easy to get carried away. Too much depth will result in text that is hard to read, and therefore, useless.

6. For an added touch, I chose Filter > Render > Lighting Effects and, using the default settings, added a slight spotlight to my text. This helped give the text some added depth. I slapped it on a gritty background and realized that not much time flew while completing this effect.

Note

It's a neat little trick that you can try with all sorts of symbols and dingbats.

Fog and Smoke

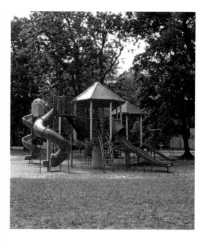

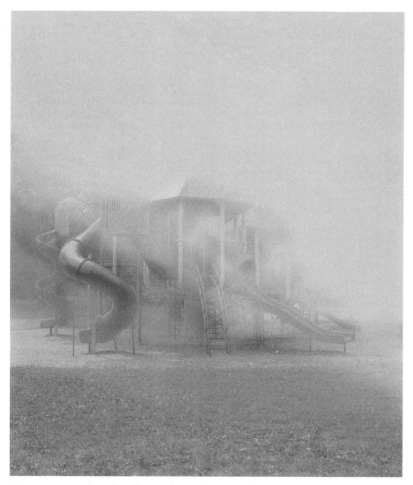

"Creating Fog and Smoke Effects with 3D Clouds"—Jeff Birtcher—Original Source: Jeff Birtcher

Where there's smoke, there's fog, right? Well that's what's happening at this mild-mannered playground. Creating realistic atmospheric effects is a snap with the right techniques. Here are two methods to add instant mood to your plain snapshots.

Note

Smoke rises up from the bottom, while fog rolls in from above. Keep this in mind when using these techniques to make your image more realistic.

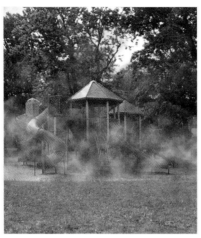

1. I created a new layer above the snapshot. Then, I chose a light gray and a dark gray as the foreground and background colors. Keeping the new layer active, I selected Filter > Render > 3D Clouds, and presto—instant clouds. You can select Filter > Render> Clouds repeatedly to get the cloud pattern you prefer.

2. Next, I added a layer mask to the cloud layer and, using different shades of gray, started painting on the mask to allow the playground to peek through and give the cloud layer depth.

3. Just as in step 1 for smoke, I used the Filter > Render > Render> Clouds on a new layer above the image. This time, I chose two shades of gray that are very similar in hue. After using the 3D Clouds filter, I added some dark gray areas on the bottom for depth.

4. Since fog fills in from the top, on this layer mask I made sure the bottom portions of the original image were more visible. The darker the gray you paint with on your mask, the more of the bottom image shows through.

Rainy Days

"Rainy Lighthouse"—Chris Blakley—Image Source: "Outer Banks, North Carolina 10" by John Siebert—stockxchange—www.sxc.hu

Turning a beautiful day into a dark downpour was once only within the power of Mother Nature. Now, using the power of Photoshop's custom brushes you can take all your sunny-day shots and toss them into a tumultuous torrent.

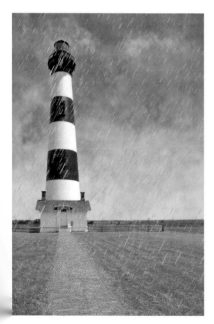

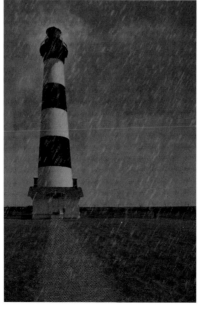

1. To begin turning this daytime lighthouse image into a dark, cloudy, and rainy image, I masked out the sky so that only the lighthouse and ground were visible.

2. I created a custom brush to create the clouds. I started a new file with the dimensions about 500 pixels square. I drew a gray fluffy shape with a soft brush and not much pressure. Then, I selected Edit > Define Brush Preset and used the following brush adjustments:

Size Jitter: 0%

Minimum Diameter: 100%

Angle Jitter: 100%

Roundness Jitter: 13%

Minimum Roundness: 100%

Scatter: 134% (both Axes)

Texture with the default settings

Smoothing

Once the custom brush was defined, I created a new layer and added a light to dark gray gradient and moved that layer behind the lighthouse. Then, I painted in the clouds on a layer above the gradient layer. I added a slight Gaussian Blur for a more natural look. I also painted a small amount of clouds in front of the top of the lighthouse.

3. Next, I created another custom brush for the raindrops. This time, I used an angled line about 100 pixels long and used these settings in the Brush Palette:

Size Jitter: 100%

Minimum Diameter: 0%

Angle Jitter: 0%

Roundness Jitter: 0%

Scatter: 100%

Smoothing

I then painted over the entire image in two different layers with the newly made brush. I added another slight Gaussian Blur on one of the layers for a three-dimensional feel.

4. I selected the lighthouse layer and chose Image > Adjustments > Levels to make the overall composition darker. Finally, because the lighthouse light would be reflected faintly off the clouds, I selected Filter > Render > Lighting Effects using Omni Light and changed the color to a faint yellow. I applied it to the clouds layer, and my stormy scene was complete.

Stormy Weather

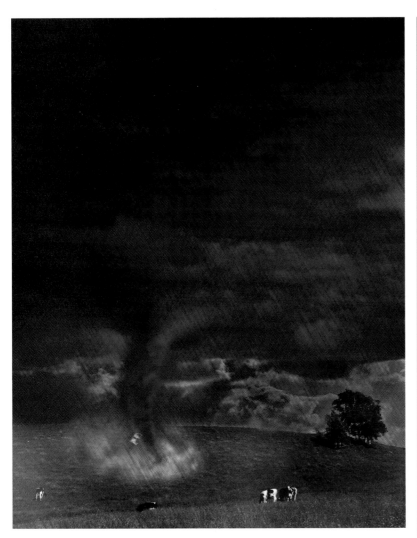

Here are some great techniques for taking those happy sunny photographs and giving them a meteorological meltdown. From storm clouds, tornado debris, and driving rain, this final composite image is convincing enough to make Dorothy wince.

"Something Wicked This Way Comes…"—Christopher Ross—Image Source: "Stormy Meadow" by Don Wilkie © istockphoto.com/Don Wilkie—"Solitude/Before the Storm" by David Virtser © istockphoto.com/David Virtser—"Happy Field" by Lise Gagne © istockphoto.com/Lisa Gagne—www.istockphoto.com

1. I loaded up the original photograph and duplicated the background layer, because I never like to work with my original photograph directly. I loaded my other source images, and to make things easier, I gave my layers logical names. From the bottom to the top, I renamed my layers: background, happy field, beach, and heavy clouds. I turned off visibility for all layers but happy field.

2. First, I wanted to darken the happy field layer. To do this, I created a new Curves adjustment layer by selecting Layer > New Adjustment Layer > Curves, named it darken, placed it directly above my happy field layer, and adjusted the curve until I achieved an overall darker tone. To ensure these layers stayed together, I linked the adjustment layer by clicking in the box just to the right of the layer thumbnail box.

3. I worked with my heavy clouds source image next. I created a layer mask for the heavy clouds layer and masked out the hillside in this layer, using a large, hard-edged 100% black brush to paint on the layer mask. I softened the boundary layer by gradually selecting fuzzier brushes with less and less opacity values. I made a number of passes at this until I was satisfied with the gentle transition from heavy clouds to those on the happy field layer. With the heavy clouds layer mask still selected, I selected Filter > Blur > Blur More to help soften the edges of the cloud transition. I wanted to bring these dark clouds closer to the horizon to enhance that heavy feeling, so with the Move tool I dragged the layer and its associated mask down.

4. I filled in the upper atmosphere with the same heavy clouds. To do this, I duplicated my heavy clouds layer, then chose Edit > Transform > Flip Vertical, and positioned it so that it matched perfectly with the existing heavy clouds layer. I wasn't concerned with the obvious mirroring effect this step created; I would be touching that up later. With the heavy clouds layer copy selected, I "Merged Down" and preserved the layer mask to consolidate my heavy clouds layers into one.

5. Using the Clone Stamp tool and a large brush with very soft edges, I touched up the mirroring effect in the heavy clouds layer on a new layer: heavy cloud touchup. Once I was happy with the touchup, I merged the layer down, this time applying the layer mask, to consolidate my clouds in a single layer.

6. I wanted to gradually darken my clouds as they got higher in the atmosphere. With the heavy clouds layer selected, I selected Layer > New Adjustment Layer > Curves and selected Use Previous Layer to Create Clipping Mask and created a gradually darken adjustment layer. I selected a curve from the pop-up dialog that matched the darkness and density I was looking for in the highest portion of the cloud layer (even though the entire layer will be affected). Then, with the gradually darken layer mask selected, I chose the Gradient tool and set my foreground and background colors to the default black and white. By drawing a line from the upper left to the lower right, I created a gradient that specifies how to apply the gradually darken adjustment layer. If I'm not satisfied with the angle or rate of this gradation, I can redraw the line until I'm satisfied.

7. By activating visibility and repositioning my beach layer, I began to add some low level clouds as you would see in a real storm front. Clearly the existing cloud cover in the beach layer does not come close to the colors of my heavy clouds layer. I changed this by adding a new curve adjustment layer as I did in previous steps. I altered both the RGB and blue color curves to achieve similar colors.

8. Adding a layer mask to my beach layer allowed me to gently blend the lower level clouds into my hillside.

9. Time to bring in the tornado. I started by creating a new layer—tornado—and then pressed "D" to set my background and foreground colors to their default white and black settings. Then, using the Rectangular Marquee tool, I selected a square area and ran Filter > Render > Clouds to fill my selection area with clouds. In order to get the general funnel shape of a tornado, I ran Filter > Distort > Polar Coordinates with the Polar to Rectangular option selected. Depending on the distribution of the clouds, I may end up needing to run the Polar Coordinates Filter multiple times. Eventually I had a straight tornado funnel. Using Filter > Distort > Shear, I distorted the funnel into a more familiar tornado "S" funnel shape.

10. Using Filter > Stylize > Wind, with a Stagger setting, I began to add the swirling turbulence to my funnel. With the application of Filter > Blur > Motion Blur I added to the feeling of swirling motion. Finally, I positioned and masked the tornado funnel.

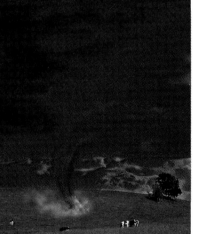

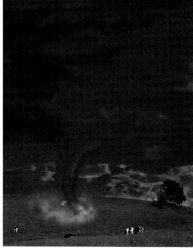

11. I changed the colors of my tornado by manipulating the RGB and blue curves with Image > Adjustments > Curves. To add some swirling dust and debris to the funnel, I created a new layer and used the Elliptical Marquee tool to select an area around the base of the funnel. Once selected, I softened the edges by choosing Select > Feather, with a value of 50 pixels. Then I filled this selection with more Filter > Render > Clouds. By placing this layer behind my tornado funnel and adjusting the opacity and color curves, I began to form a dust cloud around the base.

12. I continued to add cloud filled ellipses at various angles and opacities until I achieved the appropriate feel to the swirling dust cloud. Unfortunately for the cow beneath the tornado funnel, I copied and pasted it on to a new layer. After careful masking, rotating, and motion blurring, I moved the cow to its new position in the tornado funnel for an increased tornado effect.

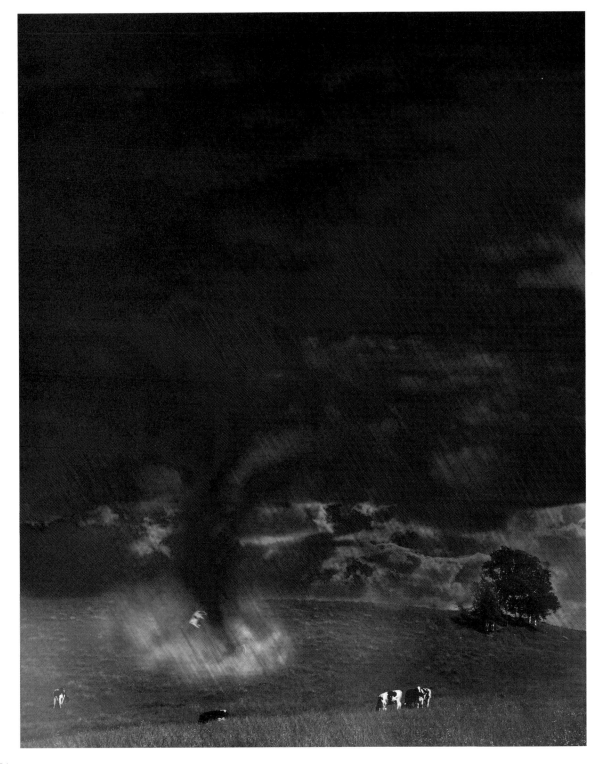

13. Now, it's time to let the rain streak in. I started by creating a new layer—named driving rain—at the very top of my layer stack. I selected Filter > Render > Clouds to fill my new layer with natural looking random clouds. I added some pixel noise to this random cloud image by selecting Filter > Noise > Add Noise and applying 10%, Gaussian, monochromatic noise to the layer. Using the Rectangular Marquee tool, I selected an area with roughly the same aspect ratios as my document, approximately 1/10th the height and width of the image. Then I scaled (Edit > Transform > Scale) this area up until it filled the entire layer, effectively increasing the size of the individual pixels.

14. By applying Filter > Blur > Motion Blur with an angle of –50 and a distance of 100 pixels, the pixel noise streaks and resembles the raindrops in a torrential rain. I chose the Overlay layer blend mode and decreased opacity to 80% to give the driving rain layer the desired effect.

15. To replicate ground fog, I created a new layer at the very top of my layer stack and filled with Filter > Render > Clouds. I set the Layer blend mode to screen and dropped opacity to 30%. With some final adjustments and touchups we have one serious storm on our hands.

Ice Storm

"Icy"—Jeff Davis—Image Source: Kenn Kiser—www.morguefile.com

"Honey, don't forget, Mom wants to come visit us!" Ahhggg! I can't believe that … "woman" is coming here. My mother-in-law and I *really* don't get along. I can't tell my wife her mother can't come to see us! What should I do… what should I do? Aha! Photoshop To The Rescue! I will write "mom," letting her know I can't wait to see her… but, I'll include a picture of our home. A little reverse psychology!

1. I took a picture of our home, then I turned the image on its side by going to Image > Rotate Canvas > 90 degrees CW (clockwise). I then chose Filter > Stylize > Wind. I selected a method of "wind" coming from the "right." I then turned the image back to the normal position by using Image > Rotate Canvas 90 degrees CCW (counter-clockwise).

2. The Wind filter creates a nice icicle effect; however, that is not enough! I added an icy look to the image using the Plastic Wrap filter. This is a filter that easily can be overused and rarely will you want to apply the filter to the entire image. (For instance, it wouldn't look realistic applied to the sky.) I selected the windows, flag, some of the grass, the chairs, some of the siding, and some of the leaves. Then, I applied the Plastic Wrap filter (Filter > Artistic > Plastic Wrap). As each source image is different, experiment with the variables. I used a highlight strength of 8, detail of 8, and smoothness of 10 for this particular image.

3. This might be sufficient for an icy look with some images, but I took it a step further. To give an overall chilly/frosty look to the image, I created a new layer above the image. Using the Rectangular Marquee tool, I created a small rectangle in the center of the image. Making sure that the colors were default black and white, I chose Filter > Render > Clouds.

4. Next, I selected Edit > Free Transform and while pressing on the Alt button (or option button for Macs), I grabbed an upper corner and stretched the small rectangle so it filled the entire image. You might want to go beyond the image to give you room to move the cloud layer around.

5. The clouds were too high in contrast, so I wanted to even them out a bit. Using Image > Adjustment > Levels, I worked with the lower bar labeled Output Levels and moved the left-hand triangle over to the right until I had a nice even shade of light gray. Then I changed the blending mode of the clouds layer to Screen. This gave it a nice foggy look, but I'm still not at the Big Chill yet.

6. I chose Layer > Layer Style > Blending Options, and in the box labeled Blend If, I clicked on the down arrow and changed gray to red. I changed the way the blending is done from the Underlying Layer. While holding Alt (or Option for Macs), I clicked on the lower left-hand triangle, splitting it in two. I gradually moved 1/2 of the triangle to the right and watched how the image changed. I repeated the steps for Blend If for the green and blue settings.

7. Now, all I have to do is e-mail this and Mom will *never* want to visit! (insert evil laughter here)

Note

With some images, the "icicles" created by the Wind filter will be overkill. You may want to reduce some of them using the Clone tool or perhaps clicking on Edit > Fade Wind. (Important: If you try Fading the Wind filter effect, you must do so *before* you rotate the image 90 degrees counter-clockwise, returning the image to the normal position.)

Flooding

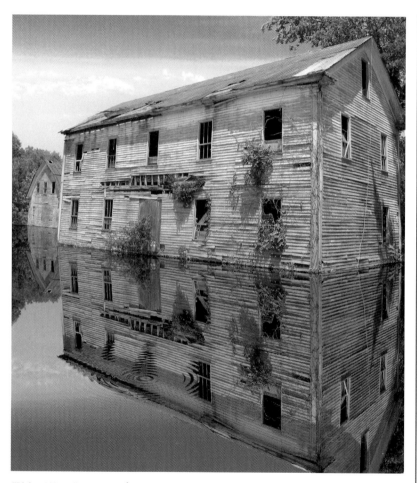

The old folks have long since moved away, and that new-fangled hydroelectric dam is all set to drown the valley in one hundred feet of water. We're talking serious flooding here, so let's get down to it. One of the quickest ways to create the illusion of a flooded landscape is to create the reflections of the landscape in the surrounding water. As you'll see, there's no need to create the water at all—just create the reflections and work from there.

"Rising Water"—Brian Kelsey—Image Source: Jason Dubin © istockphoto.com/Jason Dubin—www.istockphoto.com

1. To create believable reflections, I worked with each of the different planes of the house, barn, and landscape separately. But don't worry, the reflection technique is the same for each separate plane.

2. I selected the dominant plane of the image—the front of the house. I drew a selection around this area (including the roof), then copied and pasted the image onto a separate layer. Then, I flipped the image vertically and aligned the top-right corner of the reflection with the bottom-right corner of the house. Technically, this is the first reflection, but of course it doesn't look quite right.

3. To fix things I needed to skew the reflection to align with the bottom of the house. I selected Edit > Transform > Skew and dragged the left top edge of the reflection to align with the bottom left edge of the house. Bingo—now that looks like a reflection!

4. Now time to do the same for the side of the house. Again, I drew a selection around this area, then copied, pasted, and flipped the image vertically. I aligned the left bottom corner of the side of the house with its reflection and skewed the image to make the right corners align.

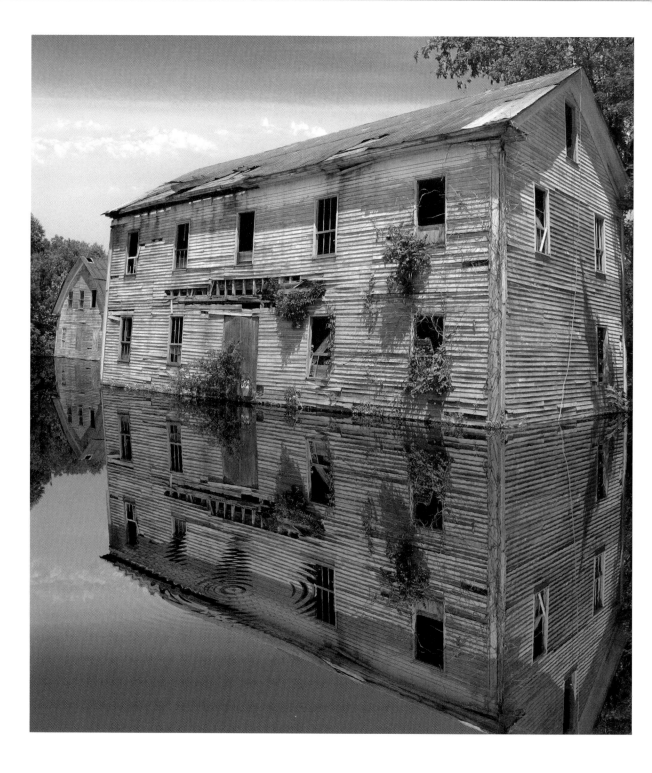

5. I used this same process to create a reflection for all the farther elements of the landscape—the barn and clouds. I selected each element separately, copied, pasted, flipped vertically, and then skewed to match. Because of the particular geometry of this image, it was necessary to add more blue sky to the reflection at the bottom of the image. I painted in the proper shade of blue to match. The reflection essentially done, I merged all the layers, leaving just the reflection layer and the original background image.

6. Now for the really fun part—transforming this mirror-like reflection into something resembling the imperfect reflections one gets off water. To accomplish that I needed to make the reflection layer a bit duller and darker, with a shift toward the blue, and a slight rippled effect. I started by selecting the reflection layer and used Filter > Blur > Gaussian Blur at around 1 pixel. Then I darkened the reflection by decreasing brightness by 40% and decreasing contrast by 30%.

7. Next, I adjusted the color balance (Image > Adjustments > Color Balance) by increasing blue by 10% and increasing cyan by 10%. Finally, I applied the Ripple filter (Filter > Distort > Ripple) at 100%, using the medium setting. And there we have it—the farm's a flooding and you'd better head for the hills!

Got Fire?

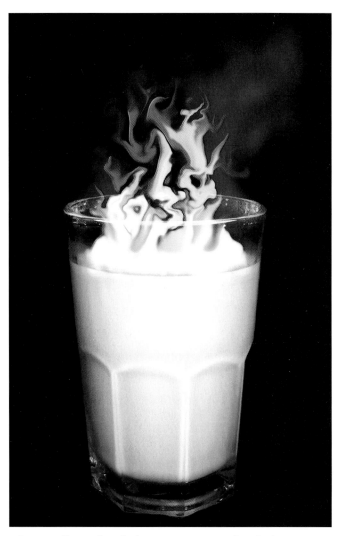

"Flaming Milk"—Rob Loukotka—Image Source: Rob Loukotka

A nice glass of warm milk has helped many relax and fall asleep. However, we have no patience for such boring milk. Follow along in this tutorial to create your own five-alarm dairy drink.

1. First, find a nice source image, preferably with a dark or black background. The process used in this tutorial works best on black backgrounds, although you must keep in mind fire on a bright white background wouldn't look very good. I chose milk, because I have never witnessed milk set on fire.

2. I created a new layer above the first layer. Using a small brush, I painted in a white blob where I wanted the fire to "burn" from.

3. Next, I created another layer and filled it completely with black. I put this layer behind the white blob layer. Then, I linked the two layers, and clicked Merge Down from the Layers menu. This made one layer—the white blob on a black background. Although this isn't necessary, it makes the following steps easier to see.

4. Using the paintbrush, I set the opacity to 30% or 40%, and painted in some very basic flames.

5. I then chose Filter > Liquify. This tool enables you to warp images easily, and is great for creating ocean ripples or flames. Using the Warp tool in the Liquify workspace, I smudged the white into some flame shapes. I tried to be very chaotic, as fire is very chaotic. I pushed and pulled the flames into different shapes and sizes.

6. I used the Turbulence tool in the Liquify workspace to add waves to the flames. Using this tool will make all of the flames very chaotic and more organic looking. I also used some of the Twirl tools to create little flaming licks of fire. Chaos is the key, so go crazy. Also, use as much gray as possible, and keep the bright white to a minimum.

7. Now to add color. I selected Hue/Saturation from the Image > Adjustments menu and checked Colorize. I brought the saturation up to 60%, and made the flames a nice, bright yellow color. I also brought the lightness down just a bit, to get rid of any bright white.

8. I duplicated this layer, and chose Hue/Saturation once again. I changed this layer to a bright red. I tried to keep it orange-red, not purple-red, because I haven't seen many purple fires, have you?

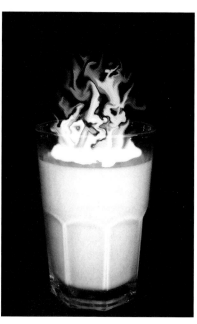

9. This is the fun part! I set the red fire layer to Overlay. You now have fire. But what good is fire on its own? Now to make it burn from something. Like milk.

10. Again, I linked two fire layers together and choose Merge Layers from the Layers menu. I set the fire layer to Screen. This should make the fire appear to be on top of the glass of milk. Next is making the fire appear inside the glass.

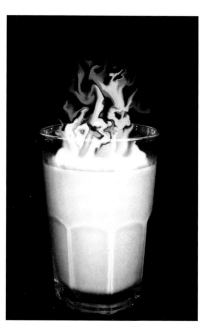

11. Using the Eraser tool, I erased some of the hard edges of the fire on the bottom, making it appear to blend. I set my Eraser to 50% opacity. I also used the Smudge tool to make the base of the fire look more realistic. Fire is not a solid object, so having it fade from its source looks much nicer. It now appears finished! But fire is nothing without smoke.

12. To complete the flames, I created a new layer on top for the smoke. Using the paintbrush, I chose white and set the opacity to 5% and decreased the flow to around 30%. I lightly painted in some smoke, layering the painting to give the smoke some depth. For added realism, I added reflections on the glass. For this effect, I used my brush again, but set its mode to Overlay. I painted over the glass with yellow and red, which made the glass appear to be reflecting the flames! Now go ahead, take a drink of some flaming milk.

Impressing Your Friends

In this section you'll go even further with your Photoshop skills, creating digital images that will have your friends asking "how did you do that?" Whether coating a frog in chocolate or dressing up your pets, using the techniques described here can help you achieve photo-realistic results. Enjoy the images and the secrets behind them.

Crumpling Paper

Another popular photo-realistic effect is creating the illusion of paper. Used as backdrops for graphic designs or websites, getting the texture and, in this case, wrinkling just right is easy. Your typical Dear John letter, not so easy.

"Dear John"—Raymond Mclean—Image Source: "Textures"—www.imageafter.com—Letter by Paul Shuttleworth

1. First, I opened my wood background image and added a new transparent layer. I then selected the Gradient tool and selected the black to white gradient. I set the gradient type to Linear and the gradient's blend mode to Difference.

Then I started adding gradients to the new layer by dragging the Gradient tool at different angles, lengths, and positions within the image, until I had produced the texture shown above.

2. Next, I used the Emboss filter on this layer. I set the filter's lighting angle to 120 degrees, the height to 11 pixels, and the amount to 500%. I now had a texture layer that I could use to create a crumpled effect.

3. I duplicated the texture layer and blurred it using Gaussian Blur to create the displacement map that I would later use with the Displacement filter. To save the image for use with the Displacement filter, I saved the blurred image as a PSD file using Save As and named the file, map.

4. Next, I turned off the blurred layer and added the non-crumpled Dear John letter to a layer above the original non-blurred texture.

Dear John,

By the time you are reading this I will be on holiday with your credit card. I'd like to say how sorry I am but quite frankly I'm not.

We're just not into the same things anymore and to be honest I doubt we ever were. You're a Pisces, I'm a Taurus, you like mauve I like puce, you like Celine Dion and well...no ones likes Celine Dion.

I don't even know you anymore. You've changed ever since you got the internet. I mean how many porcelain figures do you need.

I've decided to move on and it'll be good to date others again especially as I was getting bored with the intimacy you and some of your friends provide.

I would, however, like to keep in contact. this may be difficult, with your brother. Please don't be bitter and don't stalk me like you did the other time. I know it was you in that wig and dress. I still care for you although the sight of you makes me physically ill and your dulcet tomes make me want to cut my ears off.

So take care of yourself and remember I am the kids mother. So whatever you get for them I want half.

Well bye you freak.

Susan

P.S. bear in mind I will always love you (just in case I run out of money)

5. I then used the Filter > Distort > Displace filter on the Dear John letter setting the horizontal and vertical scales to 20%. After I set the scale levels, I clicked OK and located the displacement map I had saved earlier and clicked the Open button to run the filter.

6. I then made a selection from the distorted letter's layer by Ctrl + clicking the layer, and I added a layer mask to the texture layer below to hide the area of texture that I no longer needed. I then set the letter's blend mode to Overlay.

7. I placed a levels adjustment layer above the texture layer, giving it the same layer mask that I had added to the texture layer. I used it to decrease the highlights and shadows and then increased the mid-tones.

Above the levels layer I added a hue/saturation layer again with the same layer mask. I set the mode to Colorize, set the saturation level low, and adjusted the hue to add a slight tint of color to the letter.

8. I turned off the background layer and used Merge Visible to merge the letter, texture, and adjustment layers into one layer. I then turned the background layer on again. And finally I rotated the merged letter layer and added a drop shadow.

Then I cried because she'd left me.

Fun with Plastic Wrap

"Rubber Duck"—Craig Musselman—Image Source: John Siebert—stock.xchng—
www.sxc.hu

... the filter that is. I don't want any angry letters from parents. Photoshop's most misused filter (next to the lens flare) gets a bad "wrap." But when used correctly with the right amount of finesse, creativity, and these quick-and-easy instructions, you'll be wrapping up everything from the cat* to your mother-in-law**. This tutorial is primarily aimed at intermediate to advanced users.

*Please do not use actual plastic wrap on an actual cat.

**Or actual mother-in-law.

1. I created the box for my plastic-wrapped duckie completely by hand. In a brand new file I stacked seven rectangles using the Shape tool, alternating between light gray, black, medium gray, and back to black. I then added two trapezoids at the very top center of the package (the tab where it would hang in the store). I drew half of the outline for the hole, then mirrored it, making it symmetrical. I then merged all my shapes into one layer.

2. Now, for the first bit of filter work, I chose Filter > Blur > Gaussian Blur and added a slight blur to the image (in this case three pixels), then chose Filter > Artistic > Plastic Wrap and with all the settings at their maximum amounts, applied it twice.

3. As pretty as the "snowflake" is, I needed to remove that from my background. So I roughly selected the two black areas where it's most noticeable and using Image > Adjustments > Brightness and Contrast, blacked them out.

4. I duplicated my layer. Then, on a new layer, I traced out two concentric gray shapes in a rough shape of the duck. I merged the new shapes onto one of my background layers, leaving the original background layer separate.

5. I chose Filter > Blur > Gaussian Blur again for the top layer and then hit it with Filter > Artistic > Plastic Wrap. Once I had the effect on the new gray areas, I removed all the background from that layer only, leaving just the gray duck outlines. Why did we keep it in the first place? Having that background in place allowed me to get the desired plastic effect.

RUBBER DUCK

6. To create the label, I made a new Text Layer with my title, merged the text onto a black rectangle the same size as the top part of the background, then hit it with Gaussian Blur and Plastic Wrap again.

7. Time to encase the little ducky. But also, I wanted to add a bit more shine onto the packaging. Using the Paintbrush tool with a large soft brush and Airbrush selected, I airbrushed two white diagonals onto a separate layer above all the others. I then set this layer to 25% opacity—the effect of which you'll see in the next step.

8. I placed two copies of the duck over the top of the gray outline layer. The top duck layer got "hit" with the ever-present Plastic Wrap filter. I then set its blending mode to Hard Light. The second duck stayed as is.

9. To finish, I just added some dark airbrushing around the duck, but further touches could include your face reflected in the plastic, drop shadows for the package, and various transparency effects, if you had a proper background.

Tribute to Warhol

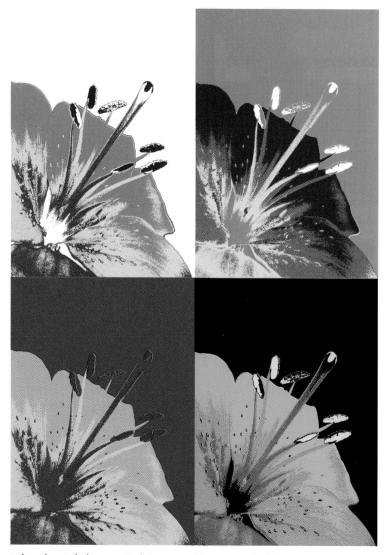

Imitation is the sincerest form of flattery, or, at least it's as sincere as I'm capable of getting. With this in mind, I'm here to use my 15 minutes of fame to show you how to "Warholize" a picture so you can create your own tribute to one of the kings of pop art, Andy Warhol.

"Lilies ala Warhol"—Kim Hudgin—Image Source: Kim Hudgin

1. Nothing too cluttered is the rule here. An image with a single subject and an even background will lend itself very well to this technique, whereas a photo with several different points of interest and a textured or uneven background will leave you with a busy, yet colorful, mess. Usually Warholizing is associated with portraits, but I've chosen a flower photo that's been hanging around on my hard drive for a while. I always make a duplicate of my background layer to work with so I have an "untouched" original in my layer menu in case I screw up.

2. To convert the image to grayscale, I chose Image > Adjustments > Channel Mixer and clicked the monochrome box in the lower left corner of the pop up. Then I adjusted my channels as follows: Red +50/Green +88/Blue −116. I'm after a grayscale image with definite black and white areas and a range of grays in between. Each image will be a bit different so don't be afraid to play around with different Red/Green/Blue values to achieve the desired effect.

3. At the bottom of my Layers Palette I chose Create a New Fill or Adjustment Layer (that's the half black, half white circle at the bottom) and chose Posterize. In the levels box of the dialog box, I entered 5. That means my image will be broken down into 5 distinct color blocks from light to dark.

> **Tip**
>
> When choosing a level value, try to stay in a range between 3 and 5; too few color blocks and the image will lack definition and too many color blocks will make it busy.

Next, I set my background layer to invisible and created a new layer on top. With my new layer selected and only my grayscale and posterize layer showing, I pressed the ALT key while I clicked on Merge Visible in the Layer menu at the top of my workspace. This created a merge of my grayscale and posterize layers in the new layer I selected while keeping the original grayscale and posterize layers intact. I named the new, merged layer "color" and made four copies of it named color a, color b, etc. This left me with five copies of my merged, posterized image, four to use in my final "mosaic" and one as a back-up.

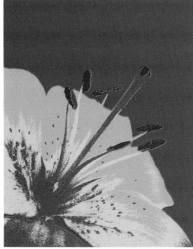

4. In my Tools Palette, I chose my Magic Wand tool, and in the tool options, I set the tolerance box to 0 and made sure the Anti-Aliased, Contiguous, and Use All Layers boxes were unchecked. I like working from the lightest portion of the image to the darkest; it's not a hard and fast rule, but I find it easier to choose colors that will make a more effective final image when I work this way. I chose a nice shade of pink as my starting color.

Now, using the Magic Wand tool, I clicked on the lightest part of the image. I used the Paint Bucket tool to fill this area with pink.

5. I repeated this for each section of my image, selecting different foreground colors as I went. Experiment is the word to keep in mind during this process. Color combinations that normally would be considered odd tend to work very well with this technique, so don't be afraid to play around a bit. If a color doesn't look good just hit Step Backward in the Edit menu and try a different one. The image was now completely filled with colors that I was satisfied with.

6. At this point I selected my color a layer, went to my Select menu, and chose All. Then I chose Edit > Copy. Next, I selected File > New and opened up a new canvas. This automatically opened up a new window the same size and dpi as the layer that I just copied. With my new canvas selected, I chose Edit > Paste, and my color a layer was transferred to a new home of its very own. I saved the file under a new name and repeated the process with the other color layers from the original image.

After I saved all my color layers as individual files, I opened up a new file, then opened up each of my "Warhol lily" files and copied and pasted each one onto my new canvas. Using the Move tool, I positioned each of the images where I wanted them on the canvas and used the arrow keys to nudge them into place.

7. My "Lilies A La Warhol" is now complete and ready to brighten up the wall next to my computer.

Whitening

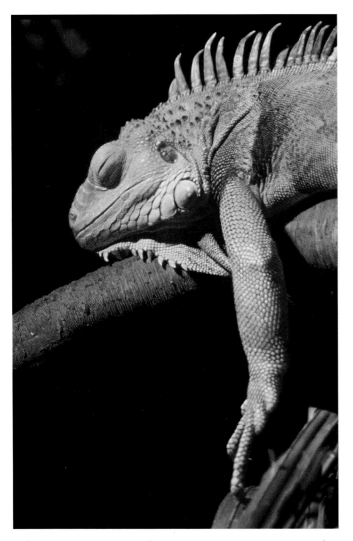

There's more to just creating an albino effect than painting on white. In fact, that's the last thing you'd want to do to achieve depth of color and slight shifts in hue. Using Photoshop's Variation Image Adjustment, we'll tweak the colors of this normal iguana to create an image of something truly exotic.

"White Iguana"—Craig Musselman—Image Source: "Hangin' Loose" by Jan Tyler © istockphoto.com/Jan Tyler—www.istockphoto.com

1. I duplicated the original image three times using Layer > Duplicate Layer and fully desaturated the top layer (Image > Adjustments > Desaturate).

2. With Image > Variations, changing the hues of an image is just a click away. I made the second layer turquoise using the following variation adjustment pattern (cyan: 9 clicks, blue: 7 clicks). (Shown here with the top layer set to invisible.)

3. I made the third layer orange using the following variation adjustment pattern (yellow: 10 clicks, red: 6 clicks).

4. Here's the magic—the resulting whitening comes from changing the blending modes of all the layers. For the top (desaturated) layer, I used blending mode: saturation, opacity 78%. For the turquoise layer, I used blending mode: screen, opacity 82%. And for the orange layer, the settings were blending mode: normal, opacity 82%. The opacity settings are flexible depending on your original source image's coloring and density. Feel free to play around with the setting.

I then merged the layers together using Layer > Merge Visible.

5. I made a duplicate of the result and set the top copy's blending mode to Multiply, and merged the layers again. I cut out the resulting iguana and set him on a copy of the original background.

6. I used Image > Adjustments > Color Balance to help give the newly pasted iguana the same color cast as the background, and there you have it: a beautiful and rare specimen.

Aging a Modern Photo

f or years, photographers have used Photoshop to get the most out of their images. By brightening colors, sharpening focus, and adjusting hues, brilliant images can bloom from even the most mundane photos. But, you can also do the reverse, carefully distressing an image and aging it by decades. This classic shot from the New Jersey seaside is an excellent example of "history in the making."

"Aging Lucy"—Lisa Schneider—Image Source: Lisa Schneider

1. My original photo was rather poor quality; there's only so much you can do to improve a picture like this. Since Lucy was once an old Victorian home overlooking the beach at Margate, New Jersey, aging her image back to earlier times seemed a natural.

2. I added two background layers which I would need later. The backgrounds needed to be larger than the photo and successively larger than each other. The first would be a pale mocha (beige) color. I increased my canvas by 200 pixels over the image size and filled with the mocha color. Then I put a layer behind that and increased the canvas again, by 100 pixels wide and 200 pixels high. I filled in with a dark brown color.

3. I hid the dark brown layer for now. I chose the Equalize Layer blending mode to add somewhat more depth to the colors. I then selected Edit > Fade Equalize and chose 80% to soften the effect.

4. I selected Image > Adjustments > Channel Mixer, and used the Monochrome setting. Next I used Image > Adjustments > Hue/Saturation and selected Colorize. I set the hue to about +30, saturation to about +43, and lightness to –17. This added some depth and a sepia tone to my monochromatic image.

5. Then I chose Image > Adjustments > Selective Color with Neutrals on the relative setting. I set the cyan to +10, yellow to +11, and black to −12. This added a slightly greener tone to the sepia, which I think looks more naturally old than a mostly brown sepia.

6. I duplicated the layer at this point and hid the original, in case I made a mistake. Since emulsion on old photos tends to fade in from the corners and edges, I took a large, soft brush and erased along the edges at about 14% opacity and 50% flow.

7. On a new layer, using a very small, hard brush at around 66% opacity and 100% flow, I selected a dark color from the image and made small "dust" marks on the image. Then selected a lighter color and made some small white scratches on the image, making sure to keep them subtle, but noticeable.

8. Now I wanted to add some "grainy" texture to the image. I selected Filter > Noise > Add Noise and set the noise at 20%, uniform. I also hid the light mocha layer, since I didn't want noise on the border.

9. Most old photos are a bit "foxed" so it was time to do some damage. I unhid the border (mocha color) to add a coffee ring. On a new layer I selected a darker brown color, set the layer blending mode to Overlay and used a very wet brush (the default brush "Drippy Water") to paint a semi-circle in the corner of the image. The dark brown color will lighten in Overlay mode. I then added a new layer and added some more white scratches using a 1-pixel hard brush.

10. In order to make the image look torn, I drew a dark jagged line (selecting a dark color from the image) with a small, 3-pixel brush to define the rip. Then I used the Smudge tool at about 55% strength to push it a bit. I drew a pure white line right above it and again smudged it out to the border.

11. Then, I unhid my dark brown background layer and took a "chunk" out of the rip I just made. I put a layer mask on the light mocha border layer and hid some pixels in a rather jagged fashion. I then outlined the jagged edges with a very thin white line.

Note

You can play around with the distressed look of your image. I finalized the picture by adding a few more rips and added an extra splotch and stain here and there with the wet brush. I softened the borders of the picture border, since well-handled photos rarely have crisp corners. The finished effect is quite convincing and worthy of a rare photo archive.

Stone Rocks!

Using some simple texturing techniques, you can turn any ordinary object into something that really rocks!

"Rock Guitar"—Raymond Mclean—Image Sources: "Guitar" by Ray Mclean and "Rock Textures"—www.mayang.com

1. First, I selected the guitar to remove it from the background. I used the Pen tool to draw a path around the guitar. I used a levels adjustment layer and increased the mid-tones to make the darker areas easier to select. I then made the path into a selection, feathering it by one pixel. The reason for using this method of selecting was because the guitar is very curvy and the Pen tool is ideal for drawing curves.

2. Having selected the guitar, I dragged it into a new blank image, rotated it, and placed it at the top.

3. I then selected separate areas of the guitar, again using the Pen tool. I drew paths around the pick guard, input jack, neck, bridge, and tremolo arm—making sure that each separate element was created as a new path.

4. I then dragged my first rock texture into the image, placing it above the guitar layer. I made a selection of the guitar by Ctrl + clicking its layer. Then I Ctrl + Alt + clicked the paths in the Paths Palette to subtract those shapes from the guitar body selection. I then feathered the selection by one pixel. Using the resulting selection, I added a layer mask to the rock texture layer.

5. The next stage was to make the contours of the guitar appear on the new rock texture. I duplicated the guitar layer and desaturated it. I then changed the stone layer's blend mode to Hard Light.

6. I used a levels adjustment layer above the desaturated guitar, giving it the same layer mask as rock layer so that it only affected the area of the rock texture, and increased the highlights and mid-tones until the contours looked okay. I then added a hue/saturation adjustment layer to the rock layer and increased the saturation.

7. To add a new rock texture to the pick guard, I dragged in a new rock image placing it on the top of the layer stack. I made paths for the pickups using the Pen tool and separate paths for the strings and controls using the Line tool and the Ellipse tool. Next, I turned the original pick guard path into a selection, and using the same method used for the first rock texture subtracted the new paths from the selection and added a layer mask to the new rock texture.

8. The rock layer's blend mode was then set to Multiply. Again, a levels adjustment layer was added and using the new selection, a layer mask was added to the adjustment layer. The highlights and mid-tones were increased and shadows decreased. Finally for this texture I used a soft-edged, black brush on the layer mask to expose the screws, tremolo arm, and pickup selector.

9. Similar methods were used to add textures to the guitar's neck, pickups, and controls. After a bit of experimentation I found the Exclusion blend mode worked best for the neck texture and Multiply for the pickups and controls texture. No levels adjustment layers were needed for these textures. I decreased the opacity on the pickup and controls texture layer to about 80%. I then added hue/saturation adjustment layers to both new texture layers and increased the saturation.

10. To make the background I made a new layer above the background layer and filled it with white. I then used the Lighting Effects filter to add lighting and color to the new layer. I used the default lighting effect 2 o'clock spotlight, altering the direction of the light to 8 o'clock to match the direction of the lighting in the original picture.

I then used Hue/Saturation to change the layer's color to one that I liked. To give the image a bit more depth I added a small amount of monochromatic noise to this layer and then used Gaussian Blur.

11. I then added drop shadows to the guitar, making two separate shadows—one for the body and another for the neck.

12. The text on the controls was not very clear so using the Healing Brush tool I removed the original text and then added some new text. The smallest three strings were not really visible in the original photograph so I re-created them using the Line tool to create selections, which I filled with a shade of gray. I added some color to the bridge and input jack by selecting them, and on the first rock texture's layer mask filled the selections with dark gray.

13. I duplicated the image, turned off the background and shadow layers, and used Merge Visible to merge the guitar and its new textures into one single layer. I made a selection from this new layer and added a layer mask. I then used a soft-edged, black brush on the mask to soften the guitar's outline.

Finally I turned the background layers and shadow layers back on and used a levels adjustment layer to increase the contrast of the image.

Turning to Stone

"Bust of Rolf"—Anders Jensen—Image Source: Brad Harrison, Rolf Jensen

Medusa could do it with just a glance. The Electric Light Orchestra did it while you were gone. Now, you can give your friends and family members a virtual statue in their honor with this easy "turn to stone" technique. After all, Bob Dylan said everyone must do it.

1. I added a layer mask and masked out the background. Only the parts I wanted to turn to stone were left unmasked. I didn't have to take care about masking out the hair, since no single hairs should be visible in the end result.

2. I used the Smudge tool with Strength set to about 30% to get rid of his facial texture. I carefully worked along his natural lines with short strokes to get a smooth surface. His most characteristic facial lines and eyes were left untouched, while small wrinkles and spots were removed by repeated smudging. I used the same technique on his hair. This step can be very time consuming, but the end result will be worth it.

3. I wanted the head to look like it was carved out of a single block of stone so I needed to do something about his haircolor. I used the Eyedropper tool to select a skin color from his forehead and painted his hair using a brush with mode set to Color.

4. I used the Clone Stamp tool to give him new eyes. On a new layer, I cloned parts from his forehead over the old eyes and used the Burn tool with mode set to Shadows and Exposure set to about 30% to make the shadows look good. The Burn tool was also used to add the outline of a carved iris in each eye. Mode was still set to Shadows but this time I used a smaller brush and had Exposure set to about 70%. I used the Sponge tool in Desaturate mode to get rid of oversaturated colors that my use of the Burn tool had caused. Finally I merged the eyes layer with the face layer.

5. To make the face look less organic, I selected Filter > Other > High Pass. The image I worked with was very large so I used the maximum radius, 250 pixels, in order to not let the filter affect the face too much.

6. I selected Image > Adjustments > Hue/Saturation tool to decrease the saturation to about –60 and the Image > Adjustments > Brightness/Contrast tool to increase the contrast to about +30. I wanted the highlights to stand out even more, and I used the Dodge tool with mode set to Highlights and Exposure set to about 50% to achieve that. I dodged the areas where I wanted extra highlights, especially his nose, lips, chin, and forehead.

7. I thought the shadows were a bit too dark and used the Dodge tool to lighten them. I set the mode to Shadows and Exposure to about 50% and worked with a big, soft brush over the shadows. I paid special attention to the hairline to make the transition between the hair and the skin less dramatic.

8. Finally, I wanted to add the stone texture to the face. I used a photo of granite as my source, pasted it on a new layer, and grouped it with the face layer. I set the layer blending mode to Multiply and decreased the layer opacity to about 35%. I then used the Hue/Saturation tool to change the hue to a green color I liked. I wanted to give the face an even more distinct tint of green without showing more granite texture so I created a new layer which I grouped with the face layer. I set the layer blending mode to Color and decreased the layer opacity to about 40%. I picked a mint green color to match the green granite and filled the layer with it.

Heavy Metal RULES!

The frog theme is becoming apparent, and although we've already urged you not to dip frogs into chocolate, or perform major orthodontic surgery on them, once again we stress that chroming an actual frog would be, well, cruel. But with a little masking, a little painting, and some "dodgy" techniques, your favorite amphibian can shimmer and shine.

"Chromed Froggy"—Anders Jensen—Image Source: "Red Eye Rainforest Tree Frog" by Rob Stegmann © istockphoto.com/Rob Stegmann—www.istockphoto.com

1. I copied my original image to a new layer and used a layer mask to mask out everything I didn't want to turn into metal. I decided to keep his cool red eyes, so I masked them out as well.

2. I desaturated the masked-out frog and used Image > Adjustments > Brightness and Contrast to make it lighter. Contrast was set to about +50 and brightness to +30.

3. I wanted to get rid of his skin texture. Instead of using the Smudge tool, I used a normal paintbrush. I used the Eyedropper tool to pick grays from the frog and carefully painted directly over the old skin with both opacity and flow set to about 50%. I varied the brush sizes and hues of gray along the way until I matched the tones of the original while obscuring the texture. The smoother surface would help make the metal effect look more realistic.

4. I thought the frog looked too gray so I added some color back in. I picked a light blue color and used a big paintbrush in Color mode to paint all over the frog. Next, I added some shadows with the Burn tool. I used a big, soft brush and range set to Shadows and worked my way over the frog.

5. Now that I had my shadows, I used the Dodge tool to add highlights. Once again I used a big, soft brush but range was now set to Highlights. I repeated the dodging with a smaller brush size on areas where I wanted an extra shiny effect.

6. The painting I did in step 3 made the frog look a bit too blurry so I wanted to add some subtle contrast back in. I copied my frog layer and selected Filter > Sharpen > Sharpen. I then set the layer blending mode to Multiply and decreased the layer opacity to about 50%. And there's my heavy metal frog.

Metal-ization

Mother Nature has developed many forms of protection for her creatures: the porcupine's quills, the jellyfish's sting, the skunk's rapier wit. But in this tutorial, we wanted to "level up" this beetle's normal defenses.

"Metal Beetle"—Craig Musselman—Image Sources: "Suit of Armor" by Stephan Rothe © istockphoto.com/Stephan Rothe and "Big Black Bug" by Michel Mory © istockphoto.com/Michel Mory—www.istockphoto.com

1. I cut pieces of the rim of the knight's knee guard to construct the frame for the middle of the bug, shaped them with Filter > Liquify, and then placed the main plate behind the new frame.

2. After lightening the plate behind the frame, I used the Clone Stamp tool to clone some more highlights, and then added a dent from the armor which I rounded a bit with Liquify and placed onto the bug at 74% opacity.

3. To make the face, I cut out the knight's knee, made two more copies, and then rearranged and trimmed them to match the correct shape.

4. To make the back of the beetle, I used an enlarged version of the plate from the middle and then shaded it with shadows from the front of the knee I had cut out from the head.

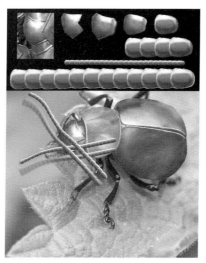

5. To create the antennae, I needed a bead-shaped piece, so I used the knee again, cloned in the missing triangle, and Liquified it to improve the shine. After making a big stack of the beads, I shrank it to shape and then curved the structure with a large Liquify brush. Radial Blur created the vibration effect.

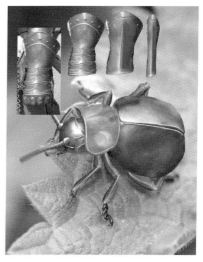

6. For the legs I cut out the glove and used Liquify and the Blur tool to smooth the interior. I narrowed the result and then pasted two copies into each of the six legs. I resized the pieces and used Liquify to mold the glove pieces to the shape of the bug's legs.

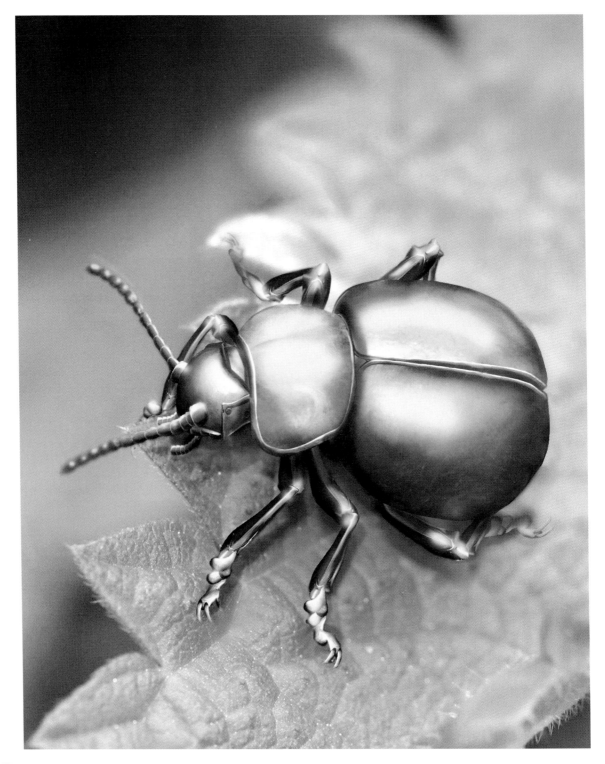

7. To create the bug's toes, I used the bug's head again, Liquified it into a teardrop shape, and then duplicated and rearranged the teardrop shapes into the shapes of the toes.

8. The general shape of the bug was complete, so I placed three shading copies on top of the image. The first was an opaque black copy set to overlay at 21% opacity. Layer two was a regular copy set to luminosity at 41%. Layer three was set to linear dodge at 49%.

9. For color, I added two new layers. I airbrushed some green from the leaf over the darker areas of the bug and set the layer to vivid light at 46% opacity. On the second layer I airbrushed some sky blue on the lighter areas and set the layer to hard light at 46%.

10. I needed more contrast on the darks of the legs, so I made a fourth shading layer from my original metal bug, set the layer to vivid light at 53%, and erased everything not on the legs. On top of that I used a soft, white paintbrush and airbrushed in some stark highlights on a new layer set to 75%.

11. For shadows I airbrushed in some dark gray shadows on a layer set to Multiply at 75%, and erased anything covering the highlights.

12. After merging the image, I cleaned up some rough edges with the Smudge tool and proceeded to make a duplicate copy which I placed on top, applied some Gaussian Blur, and erased all the areas that were to be in focus.

Personal Money

"Personal Money"—
Cynthia Rhiley

In this tutorial, you'll learn how to add a new face to a silver coin. Keep in mind, this is just one way to do it—there are always other ways depending on the source images you start with, and who you ask how to do it. Be open to trying new methods.

1. I opened up the coin image and created a new layer under Layer > New > Layer. I opened the image of the guy, selected the entire image, and copied him under Edit > Copy. Switching back to the coin, I pasted him into a new layer using Edit > Paste. He was facing the wrong way so I chose Edit > Transform > Flip Horizontal to turn him around, and lowered his opacity in the Layers Palette to about 33%.

2. The man was considerably bigger than the lady he was replacing. I selected Edit > Transform > Scale and grabbed one of the little squares at the corners of the Transform tool to adjust his size and line him up with the original face. He didn't match exactly, but that's okay.

3. I needed to remove the man from his background. I selected the Magic Wand tool from the toolbox and clicked on the black portion of the image. Then, under Select, I chose Inverse. Then, in my Layers Palette, I clicked the little box with the circle in it, and all that black disappeared. Don't worry too much about slightly jagged edges for this project; many of them will be removed later, and whatever remains will add authenticity.

4. I wanted to create a nice looking silhouette. I snipped away a simple curve that loosely followed the line of the guy's shoulder. I didn't get too fancy with it. I was looking for a simple balanced line here, as if I were creating a historical bust of him.

5. I set this layer aside for a while. The original face on the coin was still visible in the bottom layer. Because I like to keep the original image available for quick comparisons, I duplicated the coin layer (Layer > Duplicate). Next, cloning—I chose a small Clone Stamp and used Alt + Click to choose a source to clone from. I resampled new clone sources often to avoid too many repeating patterns and fuzzy textures as I stamped away the original face on the coin.

6. Patience was important in this step. I tried to choose clone sources of similar textures and light/dark values to those I was cloning away. The human eye is very good at recognizing patterns and out of place anomalies in texture and gradation; sloppy cloning will give you away faster than any other mistake in your editing. I zoomed in close to clone, zooming out often to check my work.

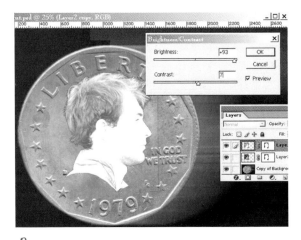

7. I switched back to the topmost layer, the replacement head. I needed to remove his color. Using Image > Adjustments > Hue/Saturation, I turned the saturation levels way down.

8. Next, I duplicated this layer, and using Image > Adjustments > Brightness/Contrast, increased the brightness and contrast in the hair to make it better match the values in the original coin. I didn't worry about that white face—I was about to mask that all away. Depending on your source images, you'll need to play with these values a bit.

9. I masked away everything but the hair in this layer, went back to the original new face layer, and duplicated him again. I adjusted the brightness and contrast in this layer to achieve a monochrome effect that blends well with both the hair layer and the coin layer. This is where saving the original coin layer (background) for comparison really comes in handy. Once I had a good blend, I clicked the little eye icons in the Layers Palette to turn all layers off except this layer and the hair layer. Under Layer > Merge Visible, I merged just these two.

10. I turned the background copy layer back on and duplicated the replacement face layer twice. Turning one copy off, I adjusted the brightness of the other copy to black. I set the layer properties to multiply, and moved it down. Using the Free Transform tool, I offset it downward and adjusted the opacity until the new multiply layer matched the darkest values in the coin layer. This gave the face depth, as if it were embossed.

11. Now, to make him look like he belongs on the coin, I added noise (Filter > Noise > Add Noise), sharpened (Filter > Sharpen > Sharpen), then median cut to 3 (Filter > Noise > Median), then sharpened again. Under Image > Adjustments > Hue/Saturation, I removed the color the noise had added, and under Filters > Stylize > Emboss, I toggled the controls until I ended up with my desired result.

12. Next, I selected the "turned off" copy of this layer—the face I hadn't filtered—and turned it back on. I adjusted the brightness and contrast of this layer (about −5 and +75 respectively for this image), and duplicated it. I set the first layer's opacity to about 40%, and its duplicate to about 50%. I set the upper dupe layer's properties to soft light, and adjusted the opacity.

13. At this point, I added some highlights. I created a new layer and set its properties to Dodge. Using a very small airbrush, and looking at the original photos for reference, I added highlights, being careful to note which direction the light was coming from in the original coin image. I softened these highlights with a Gaussian Blur (Filter > Blur > Gaussian Blur) and adjusted the opacity until the highlights in the new face matched up with the highlights in the coin.

14. I duplicated the flat looking, embossed layer and turned off all layers except that copy and those uppermost layers—normal guy, soft light guy, and dodged in highlights. The details were a little sharp in this new merged image, but that was okay. I Gaussian Blurred just a bit to match them to the coin—I used 1.5—and then turned down the opacity until I achieved a good blend with the original embossed layer below.

15. I turned the shadow layer back on. I duplicated the merged layer, and moved it down beneath the embossed layer. Using brightness and contrast again, I turned it black and pulled it down. I used Gaussian Blur to about 4, and adjusted the layer opacity until it matched the darks in the coin image—about 60 percent. I added highlights to the top of the image the same way—duped the layer, turned it white, and adjusted the opacity until it matched the highlights in the coin (about 90 percent). I then pulled it up to highlight the top edges of the relief.

16. I softened those too-sharp edges using a layer mask. On the embossed layer, I added a mask, and gently blended the edges into the highlighted and shadowed areas, making sure to remove all sharp lines.

17. I turned the merged face layer back on. It should have looked pretty good at this point, but some of the facial details were too light and ill-defined. To remedy this, I added a multiply layer and used a soft, very tiny airbrush to draw the details back in. I focused on just a few specific areas—the eyes, brows, mouth, and the shadow behind the ear.

18. I was not happy with the texture. It seemed too soft compared to the texture in the coin. To remedy this, I duped the merged face and sharpened him several times until he matched. Then, I added a layer mask and used it to smooth out the raised areas of the face for authenticity.

19. To finish our coin, I added a new layer, set color at 20 percent, and filled it with a grayish green shade to even the colors in both the coin and the face. And finally, at long last, I was done.

Stitches/Wounds

"Cookie Cutter Accident"—Raymond Mclean—Image Source: "Skin" by
Dawn Turner—www.morguefile.com

This poor unfortunate fellow tripped and fell on an unsupervised bunny-shaped cookie cutter. I will not tell you exactly where the wound is, but he did fall backwards and he wasn't wearing any pants at the time.

1. I opened the skin image and using the Custom Shape tool drew a path using Photoshop's Rabbit Custom Shape. I then created a new blank layer and with this layer active stroked the path with a black, soft-edged brush.

2. I then started adding a layer style to this layer. The first thing I added to the layer style was a bevel with contour and texture elements. For the structure of the bevel, I used an outer bevel set to smooth. I left the depth at 100% and the direction at down. I set the size to 65px and set soften to zero.

For the shading I increased the lighting's altitude to 65 degrees to add more highlights to the bevel. I then set the Highlight and Shadow mode to Overlay, and changed the highlight color choosing a highlight color from the skin image.

To roughen up the bevel I added a contour using the rolling slope descending contour, then added the texture using Photoshop's Cloud Pattern, scaling the pattern until I got a texture I liked.

3. Next, I added some color and shading to the inner area of the layer style. I started by using Pattern Overlay and used a rust pattern with its blend mode set to Normal to add a bit of shading to the inner cut. I then used Color Overlay and chose a reddish brown color and set the blending mode to Overlay.

Finally I added an inner shadow to add some depth to the cut.

4. To make the wound look as though it had started healing, I used Gaussian Blur on the bunny layer, making sure that Preview was checked so that I could see the healing process in action.

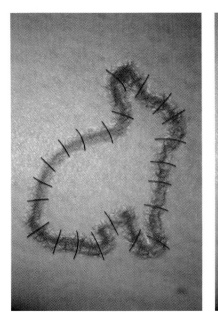

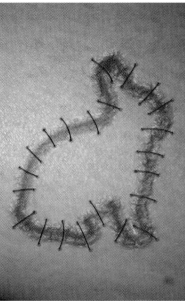

5. To create the stitches, I started by creating paths where I wanted the stitches to be, and on a new blank layer stroked the paths with a small, brown, soft-edged brush. I changed the color dynamics in the Brushes Palette, setting the Hue, Saturation, and Brightness Jitter settings to 10% to add a little texture to the stitches.

To this layer I added a layer style with a slight drop shadow and inner shadow to add some depth and shape to the stitches.

6. To make it look as though the stitches were entering the skin, I created a new blank layer below the stitches layer, and copied and pasted my wound layer style to this new layer. Then, with a small, soft-edged brush, I painted small holes in the ends of the stitches. Again I used Gaussian Blur to partially heal these small wounds.

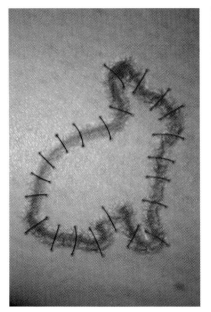

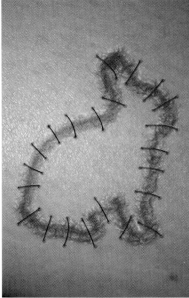

7. The next stage was to add selective blurring to my cuts and stitches to match the blurring on the original skin image. To do this I started by duplicating the background skin layer. I then turned off the background layer and chose Merge Visible to merge my cut and stitches layers with the skin layer. I then duplicated this new merged layer and applied a Gaussian Blur to this duplicate layer, setting the amount of blur to match the most blurred areas of the skin image.

I then added a black layer mask to this new layer, and painted onto the mask with various shades of gray until the blurring matched.

8. This left me with an image that was too blurred, so I selected the blurred masked layer and used Merge Down to merge it with the unmasked merged layer to create a single layer. I then sharpened this new layer using the Unsharp Mask filter until the image came into focus.

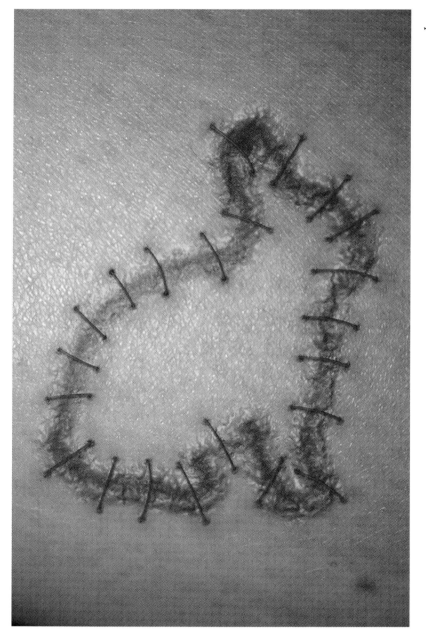

9. To finish the image I added a new blank layer set to multiply and painted on it with a low opacity, red, soft-edged brush to add a little redness around the wound. I also used the Dodge and Burn tools on the stitches to add some extra shading.

Sketch Effect

"Angle Sketch"—Dan Goodchild—Image Source: Dan Goodchild

As everyone is usually disappointed with the "artistic" filters in Photoshop, I wanted to find a way to achieve something a little more realistic. Here, in a few quick steps you can take your ordinary photographs and turn them a little "sketchy."

1. I duplicated the original image layer and desaturated it. (Use whichever method you feel most comfortable with, but personally I always use the Channel Mixer.) I hit monochrome, then removed the reds, and compensated with the green and blue.

2. I duplicated the desaturated layer and inverted it. I changed the layer mode of the new, third layer to Color Dodge to reveal an almost pure white canvas (don't worry if there are a few pixels showing). I then applied the Gaussian Blur filter, until the outlines of the image were clearly defined.

3. I merged the top two layers, and changed the blend mode of the resultant layer to Luminosity to reveal the colors of the original image. Sometimes it's better to stop here for a good color pencil drawing, but you can continue on using standard Artistic/Sketch filters to reveal more color in different ways. In this example, I added Film Grain (and a little more Gaussian Blur to remove the pixelation).

Chocolate Coating

"ChocoFrog"—Brent Koby—Image Sources: "Frog" by Rob Stegmann
© istockphoto.com/Rob Stegmann—istockphoto.com—"Chocolate"
by Jeff Prieb—www.sxc.hu

While we wouldn't recommend covering a real frog with melted chocolate, you can get that same luscious effect using only a few simple tools in Photoshop. This tantalizing tree frog is just one of the many things you can cover with chocolate, or gold, or silver—just a few adjustments in color and you can create a world of sumptuous encasements.

1. First, I duplicated the layer of the original image. Then, using the Eraser tool set to 100%, I simply erased the background out of the duplicate layer, extracting the frog. Then I used Image > Adjustments > Desaturate to desaturate the frog.

2. I selected the cut out frog and on a new layer above it, I filled in the selection with the Paint Bucket using a dark brown foreground color. On this top color layer, I changed the blending mode to Hard Light and merged it with the extracted frog layer.

3. I then took the Smudge tool with a small brush set to 70% strength, and smoothed out the frog simply by clicking and dragging the tool around the entire surface of the figure. While doing this, I also pulled down some basic "drips" on ridges or overhanging areas of the frog using the Smudge tool.

4. Next, I needed to add some highlights to the figure and the "drips." I used a small brush with white as the foreground color and painted in the areas where I wanted the highlights to be. Keep in mind the direction the light is coming from in your original image.

5. Using the Smudge tool set to 70% strength, I smudged and cleaned up the brush strokes following the paths of the ridges and drips on the frog. Already it's looking pretty delicious. But we're not there quite yet.

6. Using the same method as in Steps 4–5, I added softer highlights around the edges of the figure and added more highlights within the body of the figure as well.

217

$7.$ I decided I needed to replace the frog's eyes with chocolate, too. I used a basic source image of a piece of chocolate which was in a similar perspective as the frog's original eyes. Then I extracted the chocolate from its background, and using the Free Transform tool, I resized the chocolate to sit in the frog's eye socket.

$8.$ Using the Brush tool set with a black foreground color and 25% opacity, I brushed in some shadow where the chocolate eye meets the frog's eye socket. I then switched to a white foreground color and painted in some highlights around the top edges of the eye, giving the chocolate eye some depth. I repeated both steps on the other eye.

$9.$ Finally, after cleaning up the edges of the chocolate frog, I was ready to place him back into his natural habitat.

Liquid Spill

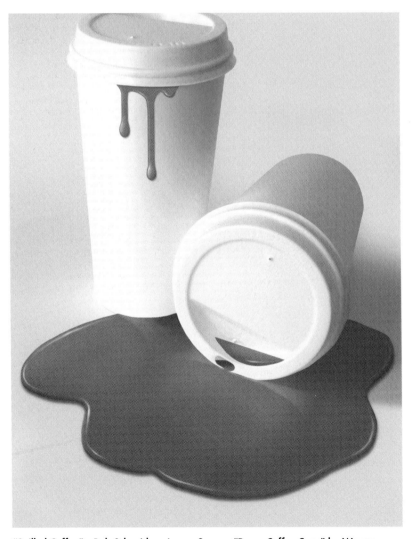

So you want to simulate liquid spills? Here are some fundamental skills you'll need for creating realistic highlights and shadows on a fluid surface.

"Spilled Coffee"—Bob Schneider—Image Source: "Paper Coffee Cups" by Wayne Stadler © istockphoto.com/Wayne Stadler—www.istockphoto.com

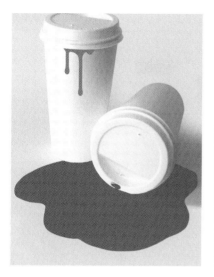

1. We can add some interest to this original photo by adding a coffee spill and a few drips. Using Quick Mask, I created a spill shape, inverted the selection, and then, using the Fill tool, added a coffee color to the selection—cream and sugar please. Using the same procedure, I added a few drips to the side of the vertical cup also.

2. Keeping the selection active, but hiding it with Control + H, I used a soft-edged brush at 10% opacity to add a soft shadow to the edge of the spill with multiple strokes. I only added this darker tone to the shadow side of the spill. I added a new layer and, with the spill selection still active, I filled it with a 50% gray color. I placed this layer under the spill layer and moved it to simulate a shadow cast by the spill. I reduced the opacity of this layer until it looked light enough to be realistic and used Filters > Blur > Gaussian Blur to soften the edge.

3. To add some highlights, I opened a new layer and with a small brush stroked on some white at 40%, just above the edges of the spill. It's not important to fuss over these strokes. With a large, soft brush at 10% opacity, I brushed on a light, soft reflection on the left side of the spill.

4. Using the Smudge tool at 40%, I stroked the added highlights and shaped them into smoother forms, paying particular attention to the ends to fade them off. (Command/Control + clicking on a layer will give you a selection of anything on that layer.)

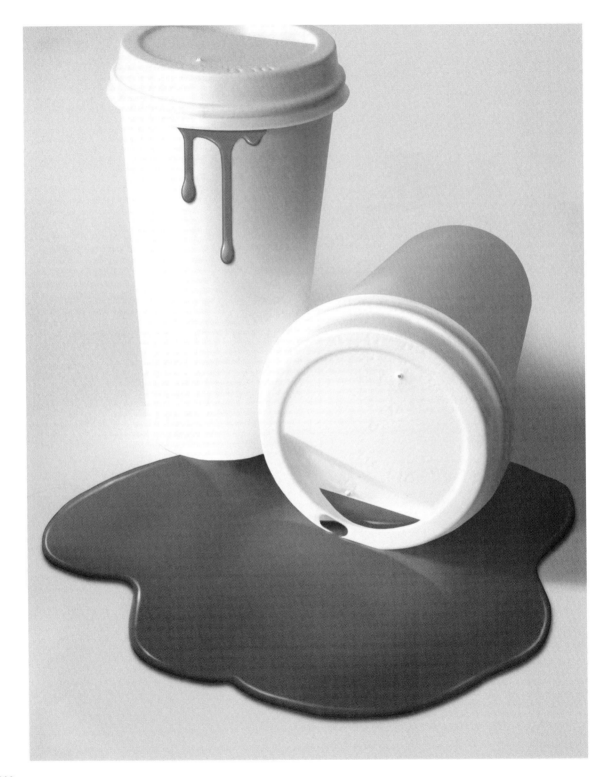

5. I added a new layer and brushed on a small streak of white into some of the previously highlighted areas at 70% opacity. Then I used the Smudge tool at 40% to shape them into the brightest area of the reflections. Using a very large, soft brush, I added a soft shapeless cup reflection onto the surface of the spill. It seemed logical that there might be some coffee puddled into the cup lid recess, so I used Quick Mask to create a shape and filled it with some coffee color.

6. Activating the spill selection again, I added some shadows cast by the cups. I used a medium-sized, soft brush and added the shadow by stroking on the color at 10% opacity and gradually built up the density. Using the low opacity enabled me to create a softer shadow edge as it recedes from the cup. Using the same methods as previously described for highlights, I added some highlight area to the small coffee puddle on the lid.

7. I activated the drip selection by Control/Command + clicking on the drip layer. Then I used a small, soft brush to add some shadows to the drips. Inverting the selection, I added some cast shadows. I decided to use a different method to create the highlight areas. To begin with, I moved the selection area just a bit to the right. Then, using a small, soft brush I stroked on some white at the usual 10% opacity on the left edge of the selection. I used the Smudge tool at 40% to shape the highlights where needed. On another layer, I added stronger whites and Smudge tooled them into smoother transitions.

Modern Art

This tutorial will help you to bring modern elements of today's world into the classical paintings of yore. Some techniques will vary depending on the original artwork you choose; however, the ideas behind the techniques demonstrated will help you modify your own source images to match the brushstrokes and colors of your chosen painting, creating a new, modern masterpiece.

"Modern Art"—Alison Huff—Image Sources: "Living Room"—www.morguefile.com—
"Art and Literature" painting by W. Bouguereau—wetcanvas.com

1. My first step was to find suitable source images. It's very important to match the angles and lighting of the various elements you plan to incorporate; you want the finished piece to look naturally posed. I found that the angles of the chair and the position of the figure were a good match for each other. The lighting was pretty decent, too, although I would make some subtle modifications later.

2. I singled out the element that I wanted to incorporate into the modern scene on a separate layer, and placed it roughly where I thought it looked best, sizing it down slightly to better match the surroundings. Correct proportion is important when trying to create realism in any image.

3. My next goal was to create the illusion that the figure was seated on the chair. To do this, I lowered the opacity of the figure layer so that I could see the chair beneath it. This allowed me to remove the portions of the figure that would be covered by any objects from this viewpoint. I then swept a low-pressure Blur tool around the edges of the entire figure to get rid of the "cut out" appearance.

Note

The following steps are where your individual techniques may differ among paintings. A great deal of those steps are found through simple trial-and-error, running the modern element through a succession of various filters until its image is beaten into submission and finally becomes one with the painting. Your best friend is going to become the Edit > Fade option in the toolbar; using this will allow you to fade each filter to create changes that are as dramatic, or as subtle, as you need them to be.

4. I ran the Artistic > Dry Brush filter, followed by a fade in Overlay mode, 80%.

5. I brushed over the areas with the brightest reds using the Sponge tool to lower their saturation. I then altered the hues slightly to better match the paint on the figure through Selective Color.

6. I ran the Filter > Noise > Despeckle filter and adjusted the color balance slightly toward yellow/orange to warm the background. I used Selective Color again to soften the neutrals and blacks using the Black slider only.

7. I applied the Filter > Artistic > Watercolor filter followed by a fade in Normal mode. I cleaned up and blurred some of the edges on the figure even farther to blend in better with the backdrop. I began adding a little bit of the shadows cast by the figure onto the chair and floor using the Paintbrush tool in Multiply and Color Burn modes.

8. I needed to alter some of the shadows on the figure. Again, I took a soft paintbrush in a warm black shade, medium opacity, Multiply mode to the areas where shadows would fall on her clothing. I went over some areas with the same paintbrush in a very low opacity Color Burn mode to add a little more depth.

9. I applied a Smart Blur to the living room layer. Using Adjustments > Hue/Saturation, I lowered the overall saturation and the lightness very slightly.

10. Next, I flattened the image to merge the working layers and applied a Filter> Brushstrokes > Crosshatch to the entire image and faded it in Lighten mode. This caused my red hues to become much bolder, so I tweaked the saturation to tone them down.

11. I ran the image through the Fresco filter (Filter > Artistic > Fresco), and faded it to about 20%. My final touch-ups were adding a little more shadow to the arm of the chair and the floor.

12. Finally, I cropped it to bring more focus to the subject.

Water Spray

"Leaking Hose"—Chris Blakley—Image Sources: Chris Blakley

"Water, water, everywhere and not a drop to drink." In this tutorial, we find an ecologically sound way to create realistic spraying water without having to open up the local fireplug.

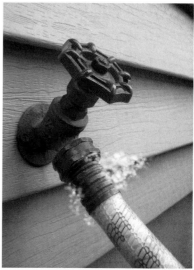

1. First, I masked out the actual hose. That way, I could put some of the spray behind the hose. To select the rounded top part of the connector easily, I used the Pen tool.

2. Now that the hose was separated from the background, I can start creating the misty spray. Water is very random and because of this unique quality, it is difficult to make it look realistic just by drawing with hard brushes. To re-create this scattered placement of water drops, I customized a brush to be very random as well. I selected a soft pixel brush to edit. I then went into the Brush Palette and made the following adjustments to that brush:

Size Jitter: 100%

Minimum Diameter: 14%

Scatter: 167%

For texture, I added the first choice in the default listings (the blue bubble-like texture) with a scaling of 100%

Depth: 100%

Under Other Dynamics, I changed the Flow Jitter to 67%

Then I checked the Smoothing option below that.

3. I made the foreground color #F8F8F8, and the background color #C5C7D6. Then, I created a new layer on top of the hose and drew with the customized brush. It took a few tries to get it just right. After that, I created another layer below the hose, then drew some more water droplets.

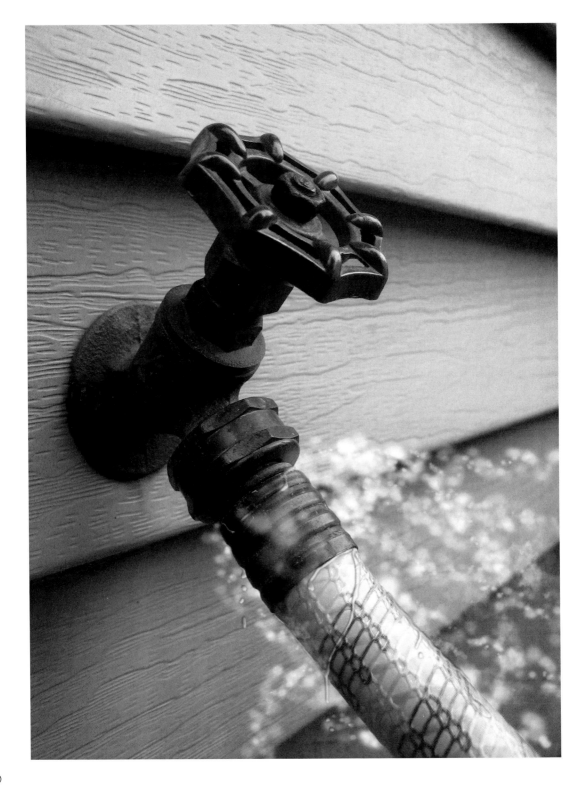

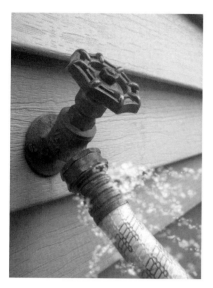

4. It's starting to look like water spray, but it is a little too bright. Instead of adjusting the brightness/contrast, I changed the blending mode to Overlay. On the layer above the hose, I lowered the opacity to 80%, and on the layer below the hose, I changed it to 60%. Now where it used to be pure white, it is duller.

5. The brush strokes still look a little too much like brush strokes. I also wanted to add some motion to it, so I duplicated both water layers, added a Gaussian Blur to the upper set, and a Motion Blur to the lower set. For the Gaussian Blur, I used a radius of 4.8 pixels. For the Motion Blur, I used an angle of –31 degrees, and a distance of 48 pixels. When the layers were duplicated, the white areas became very bright again, so I changed the opacity of the layers with the Gaussian Blur applied to 50%.

6. Finally, I added one more layer above the hose, drew a few more brush strokes to make some of the water spray in focus, and lowered the opacity to 88%. When water sprays out of something like a hose, there is normally some water that flows and drips, so I created another layer right above the hose layer. I drew the water flowing down the hose, and dripping in certain spots using a hard, black brush at 14 pixels. Once I was happy with the placement of the water, I changed the blending mode to Screen. Then, I adjusted the layer styles. I checked the Drop Shadow, Inner Shadow, and Inner Glow. For the drop shadow, I used the following settings:

Blend Mode: Normal
Opacity: 31%
I unchecked Use Global Light
Distance: 0px
Size: 6px

For the Inner Shadow:
Blend Mode: Overlay with White
Distance: 11px
Size: 7px

For Inner Glow:
Blend Mode: Normal
Opacity: 40%

I checked the solid color option, and chose black.

After that, I just adjusted the levels, contrast, and brightness of the overall image.

Creating the Cover

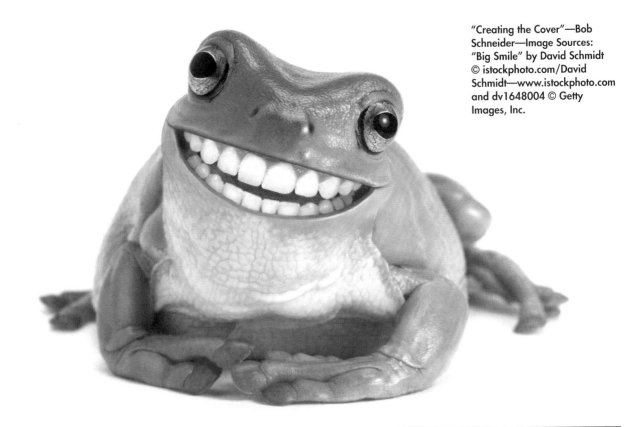

"Creating the Cover"—Bob Schneider—Image Sources: "Big Smile" by David Schmidt © istockphoto.com/David Schmidt—www.istockphoto.com and dv1648004 © Getty Images, Inc.

There he was, staring up at you from the bookshelf, and you thought, "golly, I need to know more about this frog!" Well, here we have his complete biography, from his humble beginnings to the glories of fame. Follow in his footsteps and enjoy this rags to riches story of the star of *I've Got a Human in My Throat!*

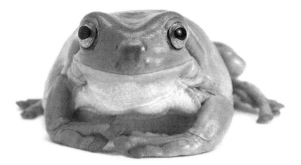

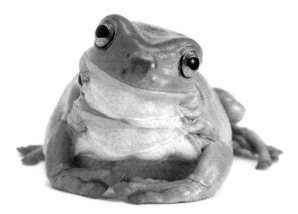

1. The first step was to improve the overall color and quality of the image. Since it only needed a bit of tweaking, I chose to use simple adjustments by increasing the contrast (Image > Adjustments > Brightness and Contrast) and adding some cyan and green with the Image > Adjustments > Color Balance Palette.

2. In order to provide some room for the big smile, it was necessary to raise his head and sit him up more. I selected and copied his head to a new layer, moved it higher, and gave it a tilt to increase the "cuteness factor."

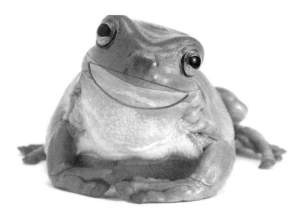

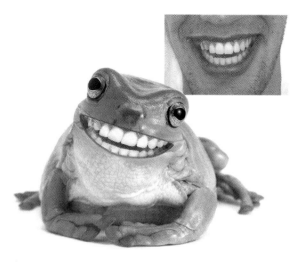

3. I added an outline guide for the smile shape so the new chest area could be positioned sensibly. I selected, and copied to another layer, the chest area of the frog and used Edit > Transform > Distort to enlarge and shape it to fit. I used the Eraser tool with a soft brush to trim off excess areas.

4. I used Quick Mask to select the smile source and again used Edit > Transform > Distort to shape the smile to fit the smile guide. However, the left side of the smile was going to need some work.

5. I used the Lasso Select tool on the right side, flipped it horizontally, and rotated it into position. I used the Brush tool to change or remove some highlights on the teeth and gums to avoid a mirror image look. Some other minor touchups were also done using the Brush and Eraser tools to make the smile fit the guide area properly. I then brightened the smile using Image > Adjustments > Levels and removed some yellow from the teeth with the Color Balance Adjustment.

6. On the left and right sides of the replaced throat were remnants of the original image that needed to be removed and simplified. I could find no areas of the frog that could be used for this purpose, so I decided to render them. Using Quick Mask to create the shapes and the Brush tool with color picked up from various frog areas, I brushed in a base tone and then added shadows and highlights to give those areas form. It was just a matter of keeping those shapes as simple as possible and smooth and soft to match the rest of the frog body. When they were finished, I used Filter > Add Noise, set to about 2%, to simulate the frog skin texture.

7. I felt the frog's eyes had become too green from the color manipulation. I selected them from the original with Quick Mask, inverted the mask, deleted the background, and pasted them into this image. Using the Eraser tool, I trimmed the top of the frog's head to create the illusion of raised eyebrows, which I think helped the overall look. I used the Brush tool to blend the transition of the new throat on each side of the mouth and used the same tool to remove the remnants of his original frog mouth and clean up some dark areas above the upper "lip."

8. With the Brush tool set at 10% opacity, I added a bit of a highlight on the upper lip, cleaned up a few artifacts on the lower right teeth, and accented the corners of the smile. I also lightened the dark area on the frog's nose and accented the nostrils a bit. A few minor details to finish the image off—I added a slight highlight to the left front leg and a bit of shadow to the left of the throat. It probably wasn't necessary, but those areas looked just a bit too flat.

Canvas Earth

"Tiki Dude"—Kim Hudgin—Image Source: Kim Hudgin

I've always been one to indulge the lazy side of my nature. This trait is very apparent when it comes to searching for source photos to put together an image. If you're like me and just don't have the patience to search for hours on end for the "perfect" source photo, then this tutorial is for you. Now join me while I show you how I used three uninspiring photos that I took and transformed them into a 1950s tiki lounge behemoth.

1. I decided on my canvas size, keeping in mind that I was going to have to build up above my base image, and then opened up my original version of source photo 1 in a new window. Then, using the tried and true copy and paste technique, I imported photo 1 onto my new canvas. After using Transform to resize my photo, I aligned it in the bottom right-hand corner and duplicated the layer. On the layer 1 copy I used the Horizontal Flip option found in the Free Transform menu and aligned it in the bottom left-hand corner so that the two layers mirrored each other. After I had them placed where I wanted them, I merged the layers and named the new layer, mouth.

2. Now it was time to define the mouth of my tiki and make the layer's name make sense. First, I used the Burn tool set on Highlights and used that to draw out where I wanted the mouth to be and then filled it in. Then I made another pass with the Burn tool, this time set on Mid-tones, over the same area. Now it was time to switch to the Healing Brush to give it some texture. For this, I opened up my original version of photo 1 and used the mountainside as the source; then, I activated my tiki canvas and passed the Healing Brush, set on Normal, over the darkened area of the base.

3. It's time to build the rest of Tiki Boy's head, and most of it comes from this photo. For the nose, I used the area outlined in red and copied and pasted it onto my canvas. A visit to the Rotate function in the Free Transform menu and I had it aligned the way I wanted it, and then I gave it a quick clean up using the Eraser tool to get the shape needed for my image. Yes, I do realize that some consider it blasphemy to erase, but I'm way too lazy to fiddle with layer masks, and I do have 25 cracks at the Step Backwards option, so I like to live on the edge.

I now had half of a nose that Caesar would be proud of, so, in the interests of balance, I duplicated my layer and used Horizontal Flip to create the other half. After some fiddling, I got my two halves lined up so that they looked respectable and I merged the layers into one which I creatively named "nose." I then used the Healing Brush and the Cloning tool to get rid of any seams that made me unhappy.

4. The part of the source photo circled in blue is what I copied and pasted onto my canvas to create the upper lip that bridges the gap between the teeth. The Rotate function is my best friend, and I visited it yet again to get this new piece roughly where I wanted it. Another quick Eraser clean up and it was soon time to duplicate the layer, flip it horizontally, and merge the layers to get that gap filled in. Since the shape wasn't quite right when I placed it over the gap, I then used the Distort, Skew, and Scale options in the Free Transform menu to get it to fit the way I wanted it to. Once I had a decent fit, I again used the Healing Brush and the Cloning tool to blend out any seams that offended my delicate sensibilities. This lovely cleaned up layer was now renamed, lip.

5. Now it was time to build up from my base and define the sides of my tiki. To do this, I used the area in the source photo that's circled in yellow. If you didn't already guess, I copied and pasted the cliff onto my canvas and erased any unwanted pixels. The Rotate function came in handy once again to allow me to position my new piece where I wanted it, and I also used the Scale function to get it to the size I desired. Since my new layer was now covering the glorious nose and lip I had created, I decided it was best if I moved it behind those two layers to make sure I had positioned it properly. Now that I had it in the right place, I duplicated the layer, horizontally flipped my layer copy, and positioned it on the opposite side of the base. Again, inspiration struck and I named these layers face side left and face side right. He was finally coming together.

6. My tiki can't see! To remedy this I took a journey through my hard drive and stumbled across source photo 2 in my Things That Seemed Interesting to Take Pictures of At the Time folder. Using the Lasso tool, I selected the cave section of the photo and some of the rock around it to give me a bit of working room and copied and pasted it onto my tiki canvas. A pass with the Burn tool set on Highlights and then another pass with it set on Mid-tones, and the rock around the cave was now closer to the color of the rock in the rest of my image.

The next step was using the Healing Brush to give the rock around the cave a similar texture as the rest of my image. I activated source photo 1 in my workspace and used that as my Healing Brush source; then I went back to my tiki canvas and activated my newly imported cave layer and used the Healing Brush on its Normal setting on the rock around the cave. It blended in much better with the rest of my tiki, and it was just a matter of using the handy tools in the Free Transform menu to get the cave layer into the shape and position I wanted it.

I positioned my layer copy where I wanted it and merged the two layers which now became my eyes layer.

7. Yes, my good, old friend source photo 1 was back. He needed a top for his head and where better to find it than my original source? The same portion of photo 1 that made up the sides of the tiki face would now provide a regal headdress for my image. Using the same techniques as before, I added the new piece to the head and used the Healing Brush and Cloning tool to clean up any seams.

8. Well, the tiki is coming along, but he needs a dramatic backdrop. I again went on safari through my hard drive and dug up source photo 3 in my Uninspired Photos of Very Large Rocks folder. Photo 3, although uninspired, at least had a promising sky that I could use. Using the Lasso tool, I selected the sky and copied and pasted it on to my tiki canvas as a layer behind the elements of the face and the base. Using the Eraser tool, I removed some of the old sky that was still clinging to my base layer and my headdress layer. After the pesky off-color pixels were eliminated, I dropped the opacity of the Eraser tool from 100% to 45% and made a pass along the edges of the base layer and the headdress layer to soften the lines a bit.

At this point I noticed that there were still a few gaps in his face, so I set about filling them in. I switched to the Healing Brush and used the Replace setting to fill in the holes. I then switched the Healing Brush setting back to Normal to blend my patch job.

9. Okay, time to add some pizzazz. It needed a bit of color, so I clicked on the Burn tool and started working on the base. I wanted those cliffs to recede a bit, so I made a few passes on them alternating among the Highlights, Mid-tones, and Shadows settings until I got the tone that I wanted. Next, it was time to darken the face a bit because I wanted the tiki to look more like volcanic rock. Back to the Burn tool I went, but this time I only used the Highlights and Mid-tones setting. I used this tool on all the different layers of the head, and I only avoided the cave eyes and the teeth because I had other plans for them.

10. I had now achieved the volcanic rock effect that I was after, but there was still something not quite right when I looked at it. Finally, it hit me. There's snow in the caves that make up his eyes—not really fitting for a peeved tiki god. I copied and pasted the snow areas into a new layer and used Image > Adjust > Channel Mixer, and also the Color Balance item to alter the coloring. Playing with the settings allowed me to turn my ice into fire and give my tiki guy some "lavaly" eyes.

11. He was looking a bit more menacing, but the sky was too happy. Selecting the sky layer, I chose Image > Adjustments > Variations. I selected Mid-tones from the option and moved the slider to Coarse, and then I selected the Darker option from the choices running along the side. Now my sky looked menacing… at least on one side. The left side was exactly what I wanted, but the right side still looked a little fluffy, so I used the Rectangular Marquee tool and selected the left side of my sky and copied and pasted it into a new layer. This new layer moved over to the right side of my canvas, over the wimpy looking part, and I then merged them together. Using the ever so useful Healing Brush and Cloning tool, I played with the clouds until they no longer had a defined "mirror image" look.

12. I saved a flattened copy of my tiki canvas and did my final tweaking. I used the Smudge tool at approximately 20% opacity and smudged over all the outside edges of the cliff face and tiki head to soften the lines a bit. I repeated this on the lines of the caves that make up the eyes. Then, with the setting of the Healing Brush on Normal, I did a final pass and blended any odd bits that jumped out at me.

For the final step, I switched to the Burn tool again and alternated between the Mid-tones and the Highlights settings to add depth and shadow to the face and the base. After all this repetition, I finally have my tiki god done and my three lackluster source pictures have served me well. Now it's time for me to kick back, have a mai tai or two, and listen to some cheesy, retro lounge music. Aloha.

Writing on the Wall

"Graffiti—The New Wallpaper"—James Goheen—Image Sources: James Goheen

With every cable channel having their own designing show, we're predicting the arrival of "Pimp My Powder Room" and giving you a comprehensive tutorial of adding graffiti or other images to walls and surfaces. Using layer masks and blending modes, you can create the illusion that you stayed up all night shaking those paint cans.

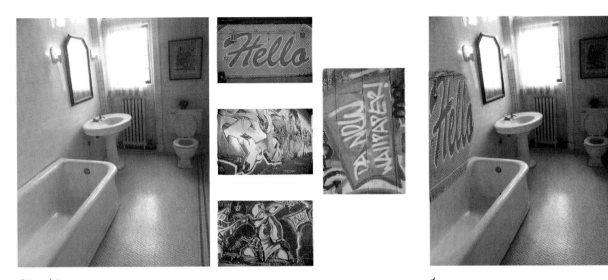

Original Art

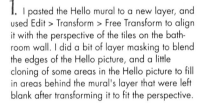

1. I pasted the Hello mural to a new layer, and used Edit > Transform > Free Transform to align it with the perspective of the tiles on the bathroom wall. I did a bit of layer masking to blend the edges of the Hello picture, and a little cloning of some areas in the Hello picture to fill in areas behind the mural's layer that were left blank after transforming it to fit the perspective.

2. I wasn't too happy with the contrast differences between the two layers, so I added a levels adjustment layer to the original bathroom layer. This brightened the overall base image.

3. By inserting the mural over the background bathtub, I lost some of the spectral highlights around the rim of the tub. To correct this, on the levels adjustment layer, I used the Alt/Cmd key, and click-dragged the White (highlight) arrow in the Underlying Layer slider, to split the arrow. This caused it to blend all brightness values gradually between my chosen values of 190 and 255. This allowed the brightest colors, those nearest pure white, to blend with the colors of the overlying layer. The result: The highlights from the tub's rim, previously covered by the Hello mural, now showed through. Finally, I set the layer's blend mode to Overlay, to reveal some of the wall's original pattern. It's now a painting transferred to the bathroom wall, complete with the faux brick pattern from the original mural.

4. I added the SulkyDevilDude mural as a new layer to fit along the far wall. Once in place, I set opacity to 75%, and blend mode to Overlay. I then used, alternately, the Pen tool and the Polygonal Lasso tool to create selections around the window, bathroom fixtures, etc., wherever I didn't want the mural to show. I then added a layer mask, set to Reveal All, and filled all the selected areas of the mask with black. This hid the selected sections of the mural, creating the illusion that it's behind the fixtures. A few touchups were needed so I used a 1-pixel brush with low opacity to gradually add black or white, as needed, to the mask.

5. The rear wall is not perfectly flat. Most noticeably, the tiles around the recessed window, and the radiator, are on different planes from the wall. To create the illusion that the SulkyDevilDude mural follows the features of the wall, I used the Polygonal Lasso tool to select those areas individually, then used Freehand Transform to increase their height by just a few pixels. This offsets these selected areas slightly, making it look like the painting flows through from one plane to the next.

6. To add a bit of perspective to part of the SulkyDevilDude that's painted on the floor, I used the Polygonal Lasso tool to create a selection around the areas of the mural that overlapped the floor, then used Skew Transform to shift everything within the selection to the left. This created a more natural, realistic transition from wall to floor.

7. For the floor painting, I pasted the Wallpaper mural to a new layer, set opacity to 75%, and blend mode to Hard Light. This gave the colors a bit more saturation than with the Overlay blend mode. I didn't like the angles or perspective here, so I used the Free Transform tool to resize and reshape the layer's image to better match the perspective and lines of the bathroom floor. Then, using the Polygonal Selection tool, I roughly blocked out the top area of the mural that overlapped the fixtures, then added a layer mask set to Reveal All. On the layer mask, I filled the selection with a black-to-white linear gradient with the Gradient tool. This blended the Wallpaper mural with the area of the SulkyDevilDude mural that flowed onto the floor from Step 6. Before proceeding, I saved this selection to a new channel for further editing.

8. The floor mural overlapped the bathroom fixtures. Using the Pen tool, I created paths around the areas of the sink and toilet where the floor mural overlapped, then created a selection from those paths. On the layer mask, I filled the selection with black to mask out those parts of the mural. I then deselected and used a medium-sized, soft-edged brush, painting on the layer mask with black or white, to touch up some of the edges of the newly filled black areas of the mask.

9. I wanted to remove the tops of the W in the word "new," where they overlap with the bath-tub. Using the Lasso tool, I created a selection around the white paint to be covered, feathered the selection by about 20 pixels, then moved the selection to an area of blue-painted wall and copied the selection to a new layer using Layer by Copy. I was then able to move the new layer's content to cover the tips of the W. I set this new layer's opacity to 100%, and blend mode to Normal.

10. To fill the rest of the wall where I started with the Hello mural, I used the same methods described above: positioned the mural on a new layer, masked out any areas that over-lapped features or fixtures that shouldn't appear painted, and set blend mode to Overlay.

Aging Gracefully

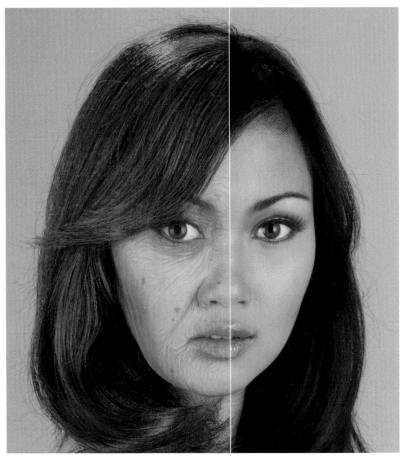

"Aging Using Burn and Dodge"—Bob Schneider—Image Source: "Look" by Hans Doddema © istockphoto.com/Hans Doddema—www.istockphoto.com

There are several ways to approach aging a face. Airbrushing in wrinkle detail, overlaying wrinkles from other images, exaggerating existing wrinkles, etc. In this attempt I'm going to use the Burn and Dodge tool to create the wrinkle detail with an occasional assist from the Brush tool. This beautiful young lady has few existing wrinkles, so all of them will be created from scratch.

1. A good aid in doing this sort of job is to have some reference images as guides, or, as in my case, simply look in the mirror. To make the before and after comparison easier I drew a line through the center of her face and started work on the left side.

2. First, I reduced the youthful skin color a bit. I selected the left side of the image, desaturated it slightly, lightened it slightly, and removed some red using Image > Adjustments > Color Balance. Then I used Filter > Liquify to create some sag on the lower portion of her face and a bit on her chin.

3. Graying the hair was the next step. I masked the hair and her eyebrow using Quick Mask, inverted it, and desaturated it to about –50. I then used Image > Adjustments > Levels to bring it to the gray color level until it looked "right." It seemed just a bit flat so I increased the contrast +30. There were a few areas of the hair that still looked dark so I used a small paintbrush with the gray color to add some depth.

4. I brushed on a brownish tone under her eye to help create the aged look. I started the wrinkle process around her eye by using the Burn tool at 30% and created some dark wrinkle lines. Using the Brush tool with a very small tip, I added some capillaries to her eye. I wanted to make her look fairly old but tried not to overdo it and make her zombie like.

I had a few source images and used them as a guide in placing the wrinkles.

Tip

I used the ALT key to switch to the Dodge tool so I could alternately stroke dark lines for the wrinkle shadows and create highlights.

5. At this step I added a smile/jowl line by using the Brush tool with a soft tip and 10% opacity. I like to build up the density gradually rather than try to get it in one stroke. I also brushed in some darker color on the side of her face to suggest a more drawn look. I continued adding wrinkles with the Burn/Dodge tool, trying to emulate the slight face sagging aging brings on.

6. The final basic wrinkles were added in the same way and a few longer softer ones were added to the side of her face in the darkened area created in the last step. I enhanced some of the existing work around the eye. Using the Burn/Dodge tool, I added more detail to some of the wrinkles and created smaller wrinkles.

7. I also used the Brush tool to remove most of her eyelashes and create a sagging eyelid. Finally, I added a few touches around the mouth, added some fine lip hairs, and using the Brush tool, toned down some of the highlights on her lips to give them a drier look.

A few final age spots and this lovely lady has aged 50 years in less than an afternoon. Won't she be delighted?

Clowning Around

Unless you suffer from coulrophobia (an intense fear of clowns), you'll enjoy this great technique. Put away those expensive grease paint sets; now you can clown around using layer masks and Image Adjustments. All you need is a great face and a little imagination, and the possibilities are endless.

"Timmy the Clown"—Anders Jensen—Image Source: Timmy Jensen

1. I duplicated the original image layer twice and named the two new layers "red" and "white." (I made the white layer invisible and worked on the red layer.) I selected Image > Adjustments > Brightness and Contrast and increased the contrast on my red layer to +30 and decreased brightness to –30. I then used Image > Adjustments > Color Balance with Tone Balance set to Shadows and moved the upper slider to +50 to get a nice red color.

2. I added a layer mask to my red layer and filled it with black so I could use a white brush to make the red visible again. I didn't want the color to look too perfect though, preferring a homemade look over a professional airbrushed look, so I picked a very scattered brush. I then used the Shape Dynamics Brush Controls to set size jitter to 100% and minimum diameter to 30%. With a big brush size I painted with white on my layer mask to make the red visible. I used the Blur tool with high pressure to blur the mask where the edges were too sharp. I wanted his eyes to still look normal so I used a normal brush and black color to mask out the red eyes.

3. I needed to make some image adjustments on the white layer. I made it visible again and increased its contrast to +10 and its brightness to +50. I also decreased saturation to about –80 to get rid of his skin color still showing.

4. I added a layer mask and filled it with black, just as I did earlier with my red layer. I used the same scattered brush and shape dynamics settings as in Step 2 to make white paint visible on his nose and around his mouth and eyes. I didn't bother with the edges this time, since the white areas will be outlined with black paint later.

5. I wanted the white areas to have more of a paint feeling to them. I created a new empty layer and grouped it with my white layer. I then used the scattered brush with a big brush size and dotted here and there over the white areas. I used the Blur tool to make the scattered dots less sharp and lowered the layer opacity to about 80% to make them more subtle.

6. I created a new layer above the others for the black outlines. Using my scattered brush at a much smaller size, I painted the outlines. I used the Blur tool to make the edges softer and lowered the layer opacity slightly to about 90%. Done!

Wicked Witch

"The Wicked Witch"—Mike Brucato—Image Source: "Eve With an Apple" by Oleg Prikhodko © istockphoto.com/Oleg Prikhodko—www.istockphoto.com

Photoshop's Liquify filter is almost a photo manipulation program on its own. Between warping, bloating, and puckering, you can distort an image photo-realistically until its original shape is unrecognizable. Watch as this lovely young woman gets the Wicked Witch treatment.

1. To preserve the source image, I first duplicated the background layer and worked on the copied layer. I loaded the layer into the Liquify filter and clicked on the Show Mesh option. To create the Wicked Witch, I used the Forward Warp tool, the Pucker tool and the Bloat tool for my distortions. To distort the areas I was interested in and not the surrounding areas, I used the Freeze Mask tool to paint over the areas I wished to preserve.

2. I used the Forward Warp tool to shape the eyebrows and add wave to the forehead hair. For the eyes, I first cloned away the hairs covering them and applied the Pucker tool to squint them.

3. With the eyes completed, I next changed the shape of her head and body. With a very large brush, I distorted her face inward at the temples and lower face, and reshaped her jaw and neck. Then, I sagged her cheeks and extended her chin. I gently nudged the areas from several points rather than using one continuous movement to minimize excessive distortion of the pixels.

4. To correct any noticeable distortion, as in her chin, I used the Healing Brush tool and sampled on an area of her cheek that I did not distort. This brought the texture back nicely. I also cleaned up the area of distortion under her chin with the Clone Stamp tool and replaced the top of the apple with a section I copied from the source image.

5. I selected her mouth, copied, and pasted it as a separate layer. I then enlarged its scale and applied a mask to the layer. In the mask layer, I used a soft, round brush at 30% opacity to blend out the edges into her face. To create the gap between her teeth, I painted over a tooth with a color sampled from the corner of her mouth. Next, I pasted a copy of her tooth in a separate layer and elongated it by using the Clone Stamp tool.

6. I placed a drop shadow effect under her new tooth with the Layer Style menu. On the new mouth layer, I opened the Liquify filter and distorted the corner and bottom lip slightly with the Warp tool. I tried several versions by using the Reconstruct tool and undid anything I didn't like, until I was satisfied with the results.

7. I copied her nose and surrounding skin and pasted the selection to a new layer. With the Liquify filter, I used the Warp tool to carefully stretch it out and downward. I masked any unwanted area with a brush set on 30% opacity, and gave her new elongated proboscis a drop shadow. I resurfaced her nose using the Healing Brush tool.

8. Using a brush size slightly larger than the effect I wanted to achieve, I used the Bloat tool to swell each of her knuckles and finger joints, giving them a bony appearance.

9. I next loosely selected her hands, and copied and pasted them in a new layer. I created her long talons by lengthening her fingernails to a point with the Warp tool. I then masked away the distorted parts of her fingers, revealing the undistorted image in the layer below.

10. I added some shading above and below her eyes, and around her face to add contour. I sampled shadow colors from her face using the Eyedropper tool. I also stained her teeth by painting a yellow and brown color on a separate layer above them. I applied a Multiply mode to each layer and adjusted the opacity until I achieved the desired result.

11. On a new layer, I created the warts on her chin and nose. I used the Clone Stamp tool with a hard-edged brush. I sampled from areas of her face to copy the color and texture and to create the general shape. I used the Clone Stamp tool with a small, soft-edged brush set on 30% opacity to blend the colors together. I added a drop shadow and some hairs to finish them off.

12. In a new layer, I painted over her skin with a blue tone and used a Soft Light blending mode, adjusting the opacity and hue to achieve the final result. I then returned to the Liquify filter to add more wavy areas to her hair.

13. I made the final touches like adding a drop shadow from the apple against her new chin, painting hairs in with a 1- or 2-pixel brush, and adding the spooky looking background.

Note

I created the background using several layers, masked around the figure. I used the following layers from bottom to top: Golden color layer set on Hard Light blend mode; Gradient Fill layers from dark to transparent set on Multiply blend mode; A blurred Rendered Clouds layer using black and white set on Overlay blend mode.

For the misty sky, I added a layer of blurred rendered clouds set to Lighten mode. I painted a moon layer using a soft, round brush and added some texture to the surface. I used an image of a tree branch that I photographed against a clear sky. I desaturated the image, increased the contrast, and pasted it in a separate layer. I applied the Darken blend mode to create the silhouette over the full moon.

Tattoos

Listen, tattoos don't look great on just any body. It's an artform that needs the right canvas to truly be beautiful. Before spending hundreds of dollars on non-reversible skin printing, why not take a photo of yourself and Photoshop yourself that new tattoo? Then you can see if it's the tattoo that won't work, or if it's just you.

"Old Tattoo, Faded Beauty"—James Goheen—Image Source: "Eagle" by Lionel Gosseries—www.sxc.hu—"Body Builder" by Alexander Briel Perez— © istockphoto.com/Alexander Briel Perez—www.istockphoto.com

1. I pasted the eagle image as a new layer and masked out all of the background. I saved the mask as a selection (Selection > Save Selection), as I'll be using it later. I then reduced the opacity to 50%, and used Edit > Free Transform to shrink, shape, and position the eagle on the model's chest.

2. I wasn't quite happy with the positioning, so I used Edit > Transform > Skew to shift the right side of the eagle up, just a bit.

3. I then set the eagle layer blend mode to Overlay, and reduced the opacity to the point that it was almost completely invisible. This provided a base for the next step. The base will give a bit of density to the tattoo "ink."

4. I duplicated the eagle layer, set the blend mode to Hard Light, and increased the opacity to 25%. To create an inked "outline," I loaded the selection created from the layer mask in step 1. With the selection active, I added a 1-pixel stroke, creating my outline. I did this to both eagle layers to build up the effect.

5. The eagle was still looking very much like a photo, albeit a very faded photo. To blend it and make it look more like an aged tattoo, I added texture to the eagle layers with the Filter > Noise > Add Noise filter (2 pixels, Gaussian, Monochromatic), then softened both eagle layers with a very slight Filter > Blur > Gaussian Blur (Blur setting 1 pixel). The difference is subtle, but effective.

6. The only thing bothering me now was the intensity of the white feathers. I wanted to dim the brightness a bit, to let more of the skin's natural color through. On the top eagle layer, I drew a selection around the areas I wanted to change, taking care not to include dark areas or the black outline. Then with a large, soft brush set to a very low opacity, I painted on the layer mask to gradually reduce the color intensity within the selection area (100 pixels, 5% opacity).

Selecting Fur

"Restoring Soft Fur"—Bob Schneider—Image Source: "Mother's Love" by Philip Dyer
© istockphoto.com/Philip Dyer—www.istockphoto.com

Using images that contain soft fur and inserting them into a different background is a common problem. I've been unhappy with all of the masking procedures I've tried and found they require just as much effort as using a more conventional approach, which I've used here. Using the following steps you'll be able to blend your furry friends into all sorts of exotic backgrounds.

1. I used the Eraser tool with a soft-edged brush and removed all of the existing background, leaving some of the dark areas between the pieces of fur showing. I prefer this method to masking for this type of procedure. I vary the softness of the brush tip and the Eraser opacity as needed for the area being worked on.

2. Using the Dodge tool at 50% and a small, soft brush, I lightened the dark areas of fur. This provided a good basis for creating the fur effect in the next step.

3. I added a dark background layer at this point to aid in seeing the results of this step. Using the Smudge tool at about 40%, with a small, soft brush, I pulled the color outward from the edge in some areas and pushed it inward in others to simulate a fur texture. I alternated the curve and angle of the stroke to simulate the natural arbitrary texture of a fur edge. It's important to vary the length of the strokes. A repeated stroke gives a longer and thinner result. A repeated stroke at a lower value results in a more natural and softer look. This is a bit trial and error, but the Smudge tool gives me plenty of leeway for correction by re-stroking.

4. In this step I used a very small Brush tool, picked up some local color from the fur area where I'm working, and stroked on some thin longer hairs at about 80% opacity. I used the original as a guide as to where the longer hairs were concentrated but added some over most of the contour at various lengths. I tried to simulate the natural texture of hair by varying the shape and direction and crossing them over each other occasionally. This image shows the "raw" starter strokes. I put these strokes on several different layers to make the following step easier with any hairs that cross.

5. The finishing touch is made with the Smudge tool at about 40%. I stroked the length of each added hair to smooth and shape it. I pulled each outer tip out to point, faded it a bit, and smudged the inner portion of each hair to blend it into the existing fur. Repeated strokes give a much better effect.

Losing Your Head 1

Somewhere there's a picture of you and your "ex" that you can't get rid of. You'd like to just remove him or her from the picture, but he or she is wearing the funniest t-shirt ever and that's the memory you'd like to preserve. Fret no more! Now you can remove the miscreant and keep his or her fabulous wardrobe. But be warned, removing people from photos doesn't actually make them disappear from the real world, no matter what you see in the movies.

"Disappearing Businessman"—Megan Harmon—Image Source: "Businessman Talking on Cell Phone" by Sang Nguyen © istockphoto.com/Sang Nguyen—www.istockphoto.com

2. I made a duplicate layer of our image and began masking out his head and hands. Since the background is bright white, I just painted them out, and added a layer mask to even up the edges. As you can see, I left in some parts; these will be painted or cloned over, so for now we'll let them be.

3. On a new layer, I sampled some color from his shirt and painted the collar area. I ended up with a pretty plain blue area, in the shape I felt the collar would be. Now we needed shading and highlights. I clicked on the layer thumbnail in the Layers Palette, instead of working on the layer mask, and locked the transparent pixels. I used a very large brush, set at 15% opacity, and with the very edge of the brush began filling in the shadows and highlights. I followed up by selecting Filter > Noise > Add Noise for some slight texture and Filter > Blur > Gaussian Blur to even out the noise.

1. In this tutorial we're going to make our own Invisible Businessman. This picture is ideal because of the plain white background and simple stance. I elected to also take out the cell phone and sunglasses, so we can concentrate fully on the man. The same techniques used throughout this tutorial can also be used for the cell phone and glasses, however. Ready? Let's go!

Tip

Transparent Lock? Instead of working on the layer mask and perhaps having to mask out some of the shading, I turned off the pixels that hadn't yet been painted on that layer. That means no matter where I used that brush on the layer, the painting only showed up on the area that I'd already painted.

4. I moved on to the arm that was raised and repeated the same procedure, just as with the collar, again just guessing how the jacket sleeve and shirt sleeve would lay. Remember to keep the jacket sleeve and shirt sleeve on separate layers.

5. On the other hand, I'd already masked out the hand that was showing over the background, but there were still fingers on the jacket where his hand was resting on his hip. On a new layer, I cloned out those fingers and rebuilt the pocket.

6. After rebuilding the final sleeve, our man was coming together, but missing a few key elements. A bit of stitching around the collar and a tag (painted on a new layer, white paint, fake lettering with a 1-pixel brush) finished our invisible businessman off nicely.

Ghosting 1

Apparitions don't have to be restricted to people. In this section we'll take an ordinary snapshot of a pair of boots and transform it into a ghostly memorial.

"Creating Ghostly Images through Cloning and Transparencies"—Jeff Birtcher—Original Image: Jeff Birtcher

1. Starting with the original photo, I selected the boots and copied them to a new layer. I also created a mask around the boots for later.

2. After changing the picture to grayscale, I cloned out all trace of the boots from the picture. I used the original picture for the cloning sources.

3. Then it was time to bring the boots back into the picture. Using the created boot layer from step 1, I adjusted the Transparency to 42% and lowered the Fill to 82%, making the boots translucent enough to see through, but not enough to lose details.

4. I experimented with leaving and removing the shadows and decided to leave them in. After discussing with a friend, it was decided that even ghosts cast shadows, since they are themselves visible refractions of light, in theory. So it was time to bring on some shadowing for positioning. I created these shadows by using a relatively medium-sized brush with feathered edges at about 30% opacity.

Ghosting 2

"The Dancing Ghost"—Andrew Kieniksman—Image Sources: "Ballet on Pink" by Matthew Scherf © istockphoto.com/Matthew Scherf and "English Cemetery" by Lance Bellers © istockphoto.com/Lance Bellers—www.istockphoto.com

According to Internet sources, you can buy special cameras and film that allow you to capture images of ghosts. As tantalizing as it may sound to hang out in your local cemetery in the middle of the night with an expensive (and suspect) camera, we've decided to take a more logical approach to those "images from the beyond." In a few short steps you can transform anyone into a ghostly apparition, all while remaining nice and warm behind your own desk.

1. The key to any good photo manipulation is good source images. Whether you take them yourself or purchase them from a stock image Web site (such as www.istockphoto.com, like these images), you've conquered half the battle with nice clear snapshots. I thought the English graveyard would make a nice backdrop for our ghostly picture and the ballerina would work well dancing among the tombstones. I used the Lasso tool to select around the ballerina and then copied and pasted her into a new layer above the original graveyard picture.

2. Although ethereal in nature, most ghosts don't appear with a large pink glow around them. I used the Magic Wand tool with a Tolerance setting of 15 to select the areas around the ballerina and deleted the excess background. I cleaned up the outline and cleared any stray pink left over with the Eraser tool. Then it was time shrink our little dancer down to size. I selected Edit > Transform > Scale to resize the ballerina into proportion with the graveyard.

3. Now that my prep work was finished, I could finally start turning the ballerina into a ghost. I reduced the opacity of the dancer's layer to 50%. This made her transparent, but still left most of the details visible. I changed the blending mode of the ballerina layer to Luminosity. This faded out her color, while giving her that ghostly glow.

4. I'm almost there. I added a slight blur to soften the features. Though Gaussian Blur is most popular, I found that Radial Blur works best on our dancer with the added bonus of giving her a bit of an aura. I set the Blur amount to 5, using Zoom method and Best quality. Finally, I selected Image > Adjustments > Brightness and Contrast and increased the contrast +10 for a little fine-tuning. And there she is, our ghostly ballerina dancing among the tombstones.

Creating Motion

"Barrel Racing"—Joan Charmant—Image Source: "Barrel Racing II" by Trista Weibell
© istockphoto.com/Trista Weibell—www.istockphoto.com

Looking at the original photograph, there's no doubt there's some serious movement taking place. But how can we exploit this fantastic shot to give the illusion of extreme motion? In this section we'll take this race to a whole new level. We'll make this rider appear to guide her horse around the barrel at the speed of sound. This step-by-step technique is so effective, it will make your head spin!

1. As a first glance, I tried to find the center of rotation. The barrel looked like a good contender. I wanted the girl and horse to be the focal point of the image. I duplicated my image layer and masked them precisely, so once the rest of the scene was finished, I could just ease them back in.

2. As a preparation, I also reconstructed the background where the subject was. As some massive blurring was on the way, I needed to have color information everywhere. I used the Clone tool to do some quick cover up of the areas left by the horse and rider. There was no need for accuracy since everything would be blurred in further steps, and ultimately, the subject would be in front of it.

3. I did the same two steps of extraction and reconstruction for the barrel. Since it is not undergoing the same motion as the other areas, it needed to be treated separately. At that moment, I had two layers of extracted elements and one layer of reconstructed background.

4. I roughly selected the ground and copied it into a new file for convenience. Then, I stretched it vertically, selecting Edit > Transform > Scale and used a 1000% scale for height, keeping the width untouched.

5. This step was probably the most time and computation power consuming one. Still working with the overstretched ground file, I started by duplicating the layer. I selected Filter > Blur > Radial Blur. From the Radial Blur dialog box, I selected the Spin Blur method and used the area where the barrel was as a reference for a center. I used 15 pixels as the Blur "amount," and set the quality to "good."

6. Then it was time to take the stretched-out ground back to the original file. I dragged the stretched and "spin-blurred" layer onto the original image and downsized it back to its normal size. Here, a quick switch on the barrel layer visibility told me if the center of rotation had been well spotted, or if I needed to go back to step 5.

7. From the viewer point of view, the motion is mostly horizontal. I roughly selected the background and copied it in a new file. I duplicated the layer and selected Filter > Blur > Motion Blur with a value of 150 pixels at a 0° angle. This setting actually depends on the size of the picture. Here, it was roughly 7% of the width.

8. The very left side of the image should be moving toward the viewer. I selected a small portion of the left side of the original background and copied it into a new layer. I then selected Filter > Blur > Radial Blur. From the Radial Blur dialog box, I selected the Zoom Blur method, with the center far to the right. There's a whole lot of blurring going on, but just wait, it will all come together.

9. I put all the background layers into a Layer Set, and dragged it back onto the original file, above the ground layer. I added a layer mask to each background layer and with a soft brush, masked the edges of each layer to allow the edges to blend together.

10. Then it was time to add the finishing touches to the image. I chose the barrel layer and selected Filter > Blur > Motion Blur with a value of 100 pixels. And the blurring was complete. I dragged the main subject back into the file, on top of all the other layers. A little fine-tuning of the masking and some detail touches on the dust flying from the ground and I had a photograph that gives the illusion of pure motion.

Losing Your Head 2

Once you've mastered the art of making your image subjects "invisible" you can add elements that enhance the illusion. In the second of our invisible tutorials, we incorporate a refreshing addition to give the illusion depth.

"Headless Drink"—Jeff Birtcher—Image Sources: Jeff Birtcher

1. I used the Clone Stamp tool to start extending the background over the boy's head. I also copied and pasted pieces of the wall to conceal him, using pieces from each side. I did all this work on a separate layer so I could preserve the original.

2. I selected Edit > Transform > Distort to adjust the perspective of the new pieces to match the line of the existing wall. The lines of perspective on the siding shifted as I moved the copied selection down over the boy's face. Once I had all the background pieces in the right place, I used a layer mask on the cloning layer to reveal the cup.

3. After extending the walls further into the head space, I used pieces of the shirt to create the interior of the collar. I used the white band around the arm to re-create the neckline and copied a patch of the shirt for the inside. I darkened the area to give the illusion that the shirt was empty and selected Edit > Transform > Flip Horizontal to help hide any recognizable patterns in the cloth.

4. Next, I added the water from the second source to the picture; this just adds to the "headless" illusion. I used a layer mask to blend the images together, hiding the parts of the water source covering the cup and shirt. By giving the water layer some transparency, one can view a little bit of the shirt and background through the water, adding to the realism.

Animal Dress-Up

Millions of dollars a year are spent on pet clothes, from a bull dog's sweater to the chic little bonnet on the Bijou. No one has yet to ask the pets whether they like dressing up, so until they ring in, here's an easy way to costume the little darlings without all the wiggling and whining. This tutorial works on children too.

"A Dog's Life"—Mike Brucato—Image Sources: "Dog's Paw" by Ivar Teunissen © istockphoto.com/Ivar Teunissen—"Groovy Baby" by Leah-Anne Thompson—www.istockphoto.com © istockphoto.com/Leah-Anne Thompson—"Pups" by Andrew Hyslop © istockphoto.com/Andrew Hyslop—-www.istockphoto.com

2. I knew that I was going to change the background of the source image. So, with the Magic Wand, I selected the white background around the baby source picture, inverted the selection, and copied and pasted it into a new layer. I used Layer Matting to remove the white matte and softened the edge with the Blur tool. I temporarily placed the selection against a neutral background layer while I worked on it. I didn't care for the Hawaiian motif on the guitar, so I cloned and airbrushed it off. I completely masked the head and other body parts which might interfere with the placement of the puppy's parts. I covered the tips of the fingers with the Clone Stamp tool and by copying parts of the ukulele and pasting them over the fingers to re-create the frets. Similarly, I reconstructed the top of the ukulele to remove the hand and cleaned up the collar and neck area. I also cloned areas surrounding the leg to make it narrower.

1. I selected sources with similar perspectives and lighting. I compiled the necessary components that I needed, including the head, legs, and open paw. I placed them in separate layers and used Image > Adjustments > Levels and Hue/Saturation on each to match the source image. I also selected the bandana from the original image and copied it into a layer to use later.

3. I resized and positioned the puppy's head where I thought it would look best. I painted a shadow layer beneath the head with a soft airbrush at about 30% opacity, and applied a Multiply blend mode to the layer. I adjusted the opacity of the shadow layer for the desired effect.

4. I positioned a copy of the pup's arm over the child's arms and legs. I had to add to the size of the pup's arm using the Clone Stamp, matching the direction of the hair, so that it covered the entire child's skin beneath it. (The leg is shown before masking to the shape of the child's leg.)

5. I carefully masked the leg to cover the exposed skin area. I used two sources to create the raised hand. I positioned the open paw behind the guitar layers and created the remainder of the arm as I did with the first arm. I blended the two sources together by applying a mask to the arm layer and faded the edge into the paw. I used part of the fur from the brown leg source to blend in with the leg and arm to give the limbs a patchy look.

6. I then placed the bandana on top of the pup's head. I resized and positioned it as closely as possible and used the Warp tool to fit it to the pup's head and neatly around the ears. In a separate layer, I applied shading using a soft airbrush at 30% opacity to the area of the bandana where it wrapped around the head and applied a Multiply blend mode to the layer. I adjusted the opacity of the layer to achieve the desired result.

7. The limbs were a little flat looking, so to give them some contour, in separate layers, I painted in shading and highlight with a soft airbrush using a Multiply blend mode for the shading, and an Overlay blend mode for the highlights. I referred to the original source image as a guide for shading and highlight placement.

8. For the final touches on the pup, I sampled hair colors and went back and painted little hairs around the arms and legs and drew in whiskers using a 1 or 2 pixel brush set at varying opacities. In separate layers set on Multiply blend, I added drop shadows on the ukulele, open paw, and near the leg. I added additional shading and highlights where needed.

9. I shot a picture of a storefront to replace the neutral background layer. I tried to match the perspective and lighting angle of the subject as best as possible. For the cast shadow, I quickly outlined the newly dressed pup with the Lasso tool, and then in a new layer directly above the background layer, filled the selection with a dark color sampled from the sidewalk. I used the Distort tool to pull the shadow in a direction away from the perceived light source. I used Filter > Blur > Gaussian Blur to soften the shadow and lowered the opacity of the layer. I applied a mask layer to the shadow layer, and applied a gradient fill to gradually fade the shadow as it went into the background. To finish off the composition, I placed the basket in the foreground.

Tip

On the finished image, I applied a hue/saturation adjustment layer to reduce the saturation slightly, and a Photographic Filter adjustment layer to give the entire composition a unifying warming tint.

Unnatural Hybrid 1

"Jack Dawg"—Chris Johnson—Image Sources: "Jackdaw"—Zoltán Csaba Zsíros—stock.xchng—www.sxc.hu and "Carrion Crow" by—Steve Irwin © istockphoto.com/Steve Irwin—www.istockphoto.com

Now this is what I call a bird dog. Ever wanted to create your own biological creations without all that messing around with genetics, engineering and, let's face it, organic substances? Well now you can. Here's the first of two examples to give you the blueprint for creating some of the creatures Mother Nature forgot.

1. First, I used the Lasso tool to make a rough freehand selection around the dog's head. I copied this and set it as a new layer on the jackdaw image. Looks quite bad, doesn't it? Time to get it fixed. I used Edit > Free Transform to resize the dog head layer to get it the right size, and in the right position. To make this easier, I lowered the opacity of the dog layer to about 40% to get a view of both layers at the same time.

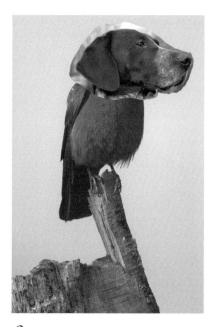

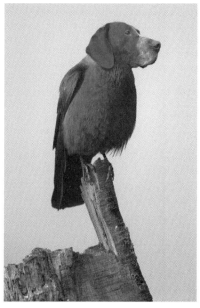

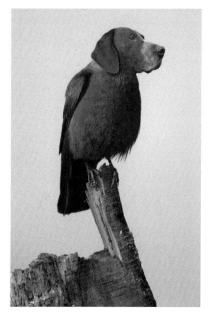

2. Once the dog's head was in the right position, I applied a mask to the layer and masked out everything I didn't want in the final picture. I used a 100% opacity black brush to mask out all around the dog's head and a soft, lighter brush to start to blend dog and bird together. At this point, I duplicated the dog head layer and hid this new layer for later. I went back to the original dog layer and it looked far too dark. As a preliminary color match, I used the Image > Adjustments > Hue/Saturation to lighten up the dog's head.

3. Next, I added some more texture to the dog's head. I did this in two stages. First, I made a new layer and cloned from the light part of the bird's body all over the dark part of the dog's head. It looked rough until I lowered the opacity of the new layer to about 25% and again set this layer to layer blend mode Dodge. This gives a base texture. The second stage was to set another new layer and use the Clone tool set at about 40% to clone individual bits of feather texture onto the dog. I added some shadow under the dog's ear to match the wing. To do this, I used the Burn tool to darken the areas.

4. The dog's ear in particular was looking all wrong. To fix it, I cloned from the body of the bird onto a new layer, the exact outline of the ear. Because the ear is in a position where it would be in the most sunshine, I set this new layer to layer blend mode Dodge and set the opacity to about 75%. This gave it a brighter finish than the rest of the dog's head. Parts of the dog were looking a little washed out—the eye and the nose—so I used the duplicate dog layer I made earlier. I masked out everything but the eye and nose, and since this layer wasn't brightened earlier, it wasn't washed out and added contrast to the image.

Unnatural Hybrid 2

"Zeebraffe"—Jeff Birtcher—Image Sources: Jeff Birtcher

In this second tutorial, using some quick masking and pasting, you can combine two animals to achieve the new hybrid. Seeing this on the savannah should confuse a lion or two.

1. Using the Clone Stamp tool on a separate layer, I erased the head of the zebra by re-creating the rock and dirt in the background. Even though the focus of the image would be the animal, I wanted the background to be as seamless as possible.

2. I masked out the head and neck of the giraffe and positioned them on the zebra's body. I used Edit > Free Transform to get the angle and scale in proportion to the zebra.

3. I copied the pattern from the midsection of the zebra and pasted it over the neck of the giraffe, fitting it to the shape of the shoulders and neck. I kept copying and pasting, making sure the stripe pattern blended together until I had the entire neck covered.

4. Now I fit the same stripes to the head and a piece of the underbelly to fit the chest area between the front legs. I also extended the shadow beneath the zebra on the ground to reflect the new longer neck.

Creating Your Own Illusion

"Calling the Kettle Black"—Brian Kelsey—Image Source: Brian Kelsey

Sometimes all the elements necessary for the creation of a clever Photoshop image are just lying around right at our fingertips. And now with the ease of digital photography, it's possible to shoot all the source images we need without leaving the comfort of our own homes. Such was the case when I decided to create a visual rendition of the old saying "Like the pot calling the kettle black"—and I never even had to change out of my bathrobe.

1. The key to this kind of project lies in pre-visualizing the finished image and then shooting everything accordingly, taking special care to match lighting and perspective. For this image, I visualized an anthropomorphically-correct pot and kettle having a heated discussion on my kitchen counter—so off I headed into the kitchen with my digital camera.

I started by shooting a background photo of my kitchen counter, then grabbed the stars of the piece, my teakettle and (substituting for a pot) my sauté pan. I photographed each utensil, keeping in mind my pre-visualized composition, and taking care to match the lighting and perspective.

2. Next I needed to photograph the human elements for my pot and kettle—their arms, legs, eyes, and mouths—and I didn't have to look any further than the mirror. A few quick shots later—again keeping in mind the necessary lighting and perspective—and I had all the source images I needed. Now I was ready to put all the bits together.

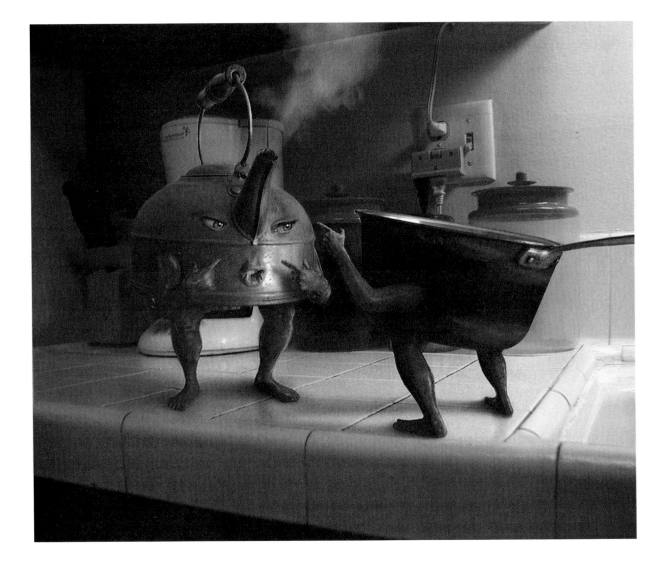

3. To start, I drew a selection around the source images of the pot and kettle, and pasted them onto separate layers over the countertop background. And because the pot and kettle have been photographed with an eye for the proper lighting, they fit seamlessly into the image. But since the best pot I could come up with was a sauté pan, I had to paint in the black lower portion of the pot and use the Clone tool to match the burnt metallic look of the source.

4. Next I went to my source images of the human body parts and drew a selection around each of the bits that I needed, and then pasted them on to their own layer. I decided to distort the arms and legs a bit to achieve a better fit, but it was pretty much a straightforward cut and paste job. With that, the basic image was done—now I could concentrate on the finishing touches that would blend everything together.

5. I started by turning my attention to the kettle's lips and eyes. I used a soft-edged layer mask to blend the edges, tweaked everything with Edit > Transform > Distort, and added the copper color to the exposed skin using the Color Balance and Hue/Saturation under Image > Adjustments.

6. The kettle's arms and legs were trickier to render in all their metallic glory. I used the Blur tool to selectively remove any body hair without losing the limb's highlights and shadow, and then again used the Color Balance and Hue/Saturation adjustments to achieve the correct copper color. I added a nice Drop Shadow behind the left hand, then used the Burn tool to emphasize shadowing overall. Finally, I used just a touch of the Plastic Wrap filter to add a metallic reflective quality.

7. Next I turned to the pot's arms and legs, repeating the previous process in much the same way, but this time I also cloned a bit of the metallic spottiness from the pot onto the limbs. And with that, the stars of my little drama were complete—but they still didn't look like they were standing on my kitchen counter.

8. What was missing, of course, were the shadows and reflections that these two quarreling kitchen wares should cast on their surroundings. So to darken the counter, I used a combination of the Burn tool, Drop Shadow, and brightness/contrast adjustments until the shadows looked right. And for the reflections, I copied and pasted portions of the legs, flipped them vertically, then blurred and lowered their opacity.

As a finishing touch, I thought Mr. Kettle should be "steaming mad" at the accusations being leveled against him, so I photographed the kettle at a boil and pasted the resulting steam on to another layer, using the Screen blending option. And there you have it. Quite a contentious little scene—but you'll be relieved to know that the coffee maker stepped in and broke up the fight before it got too ugly.

Index

License Agreement/Notice of Limited Warranty

By opening the sealed disc container in this book, you agree to the following terms and conditions. If, upon reading the following license agreement and notice of limited warranty, you cannot agree to the terms and conditions set forth, return the unused book with unopened disc to the place where you purchased it for a refund.

License:
The enclosed software is copyrighted by the copyright holder(s) indicated on the software disc. You are licensed to copy the software onto a single computer for use by a single user and to a backup disc. You may not reproduce, make copies, or distribute copies or rent or lease the software in whole or in part, except with written permission of the copyright holder(s). You may transfer the enclosed disc only together with this license, and only if you destroy all other copies of the software and the transferee agrees to the terms of the license. You may not decompile, reverse assemble, or reverse engineer the software.

Notice of Limited Warranty:
The enclosed disc is warranted by Thomson Course Technology PTR to be free of physical defects in materials and workmanship for a period of sixty (60) days from end user's purchase of the book/disc combination. During the sixty-day term of the limited warranty, Thomson Course Technology PTR will provide a replacement disc upon the return of a defective disc.

Limited Liability:
THE SOLE REMEDY FOR BREACH OF THIS LIMITED WARRANTY SHALL CONSIST ENTIRELY OF REPLACEMENT OF THE DEFECTIVE DISC. IN NO EVENT SHALL THOMSON COURSE TECHNOLOGY PTR OR THE AUTHOR BE LIABLE FOR ANY OTHER DAMAGES, INCLUDING LOSS OR CORRUPTION OF DATA, CHANGES IN THE FUNCTIONAL CHARACTERISTICS OF THE HARDWARE OR OPERATING SYSTEM, DELETERIOUS INTERACTION WITH OTHER SOFTWARE, OR ANY OTHER SPECIAL, INCIDENTAL, OR CONSEQUENTIAL DAMAGES THAT MAY ARISE, EVEN IF THOMSON COURSE TECHNOLOGY PTR AND/OR THE AUTHOR HAS PREVIOUSLY BEEN NOTIFIED THAT THE POSSIBILITY OF SUCH DAMAGES EXISTS.

Disclaimer of Warranties:
THOMSON COURSE TECHNOLOGY PTR AND THE AUTHOR SPECIFICALLY DISCLAIM ANY AND ALL OTHER WARRANTIES, EITHER EXPRESS OR IMPLIED, INCLUDING WARRANTIES OF MERCHANTABILITY, SUITABILITY TO A PARTICULAR TASK OR PURPOSE, OR FREEDOM FROM ERRORS. SOME STATES DO NOT ALLOW FOR EXCLUSION OF IMPLIED WARRANTIES OR LIMITATION OF INCIDENTAL OR CONSEQUENTIAL DAMAGES, SO THESE LIMITATIONS MIGHT NOT APPLY TO YOU.

Other:
This Agreement is governed by the laws of the State of Massachusetts without regard to choice of law principles. The United Convention of Contracts for the International Sale of Goods is specifically disclaimed. This Agreement constitutes the entire agreement between you and Thomson Course Technology PTR regarding use of the software.